DATA

Directions in Art, Theory and Aesthetics

An anthology edited by **Anthony Hill**

NEW YORK GRAPHIC SOCIETY LTD.
Greenwich, Connecticut

© This collection Faber and Faber in Great Britain, 1968

SBN 8212-0294-4
Library of Congress Catalog
Card Number 68-12368

First published in 1968
by Faber and Faber Limited
24 Russell Square, London WC1
Printed in Great Britain
by Shenval Press, London, Hertford and Harlow
All rights reserved

Designed by Richard Hollis

Editor's foreword

DATA is the first English publication of its kind since **Circle: international survey of constructive art**, published by Faber and Faber in 1937.

In the interim only one other English publication has appeared devoted to **abstract** art; this was **Nine Abstract Artists**, published by Alec Tiranti in 1954. Common to all three publications, two international and one local in scope, is that the initiative lay with the artists. For **DATA** material was collected by inviting artists and other specialists to contribute on any theme of their choice, and while the artists contributing are primarily spokesmen for their own personal views, put together they comprise a cross-section of related movements in present-day plastic art, namely the **constructive, concrete, kinetic, structurist** and **synthesist**.

In the context of these 'related movements' we find 'cross-connections' which are simply the existing similarities and differences of emphasis. But as such these cross-connections are complex and, like movements (as well as individuals), subject to change: which is why at any given moment they are not easily charted. So the choice of artist contributors was made with the intention of exploring **polemical** issues in the field of abstract art.

With the emphasis more on polemical than descriptive writing, in general, the reproductions serve to parallel the texts, rather than to illustrate the themes discussed. As a result a second, purely visual, survey was provided.

I feel I need say nothing by way of introducing the five 'guest' contributors, except that each presents ideas no less challenging than those of the artists, their contributions being somewhat in the spirit of personal manifestos.

These contributors are specialists representative of interrelated fields of interest to plasticians: **philosophy, mathematics, physics, engineering, sociology** and **urbanism**.

With deep regret I realised that **DATA** would go to press following the deaths of its two most distinguished contributors, L. E. J. Brouwer and Georges Vantongerloo.

Although there is a section of notes on all the contributors, it would seem appropriate to add here a few words on Brouwer and Vantongerloo, each of whom had expressed an interest in this anthology. Brouwer was one of the giants of 20th century mathematics. His doctrine of **intuitionism**, once so controversial, is now held to be an integral part of the foundations of mathematics and his work in topology has long been recognised as a supreme achievement.

Brouwer was a compatriot of Mondrian (for a period each lived in Laren) while Vantongerloo, born in Belgium, was to become a close associate of Mondrian's, first as a founder member of De Stijl, and later in Paris.

Vantongerloo stands out as one of the most original and independent artists of our time. His sculptures, **'Constructions dans la sphère'** of 1917, remain among the most advanced in conception of all pioneer abstract works and continue to exert a seminal influence for us today. With the last works, those made in plastic, dating from 1950, Vantongerloo was doubtful if the term 'art work' remained useful, even in a generic sense, since they were conceived neither as paintings nor as sculptures but as a kind of 'pure research'.

Finally I thank all those whose collaboration made **DATA** possible; the artists and the 'guest' contributors, all of whom co-operated generously and enthusiastically in its realisation. Also those who helped in preparing translations: from Russian, Gillian Wise and Florence Trone; from German, Renate Matthews and Richard Hollis; from French, Gillian Wise and Sarah Whitfield and from Spanish, Edward Wright.

Contents

Introduction

The future of plastic art and the relationship of art to science emerge from this anthology as the two most characteristic themes, and that these themes are interdependent is surely significant.

While the idea of a scientific and technological art is not new, nor an exclusively twentieth century notion, it has received its maximum emphasis in **abstract** and particularly **constructive** art – the movement most consciously involved with new conceptions and whose influence still prevails in shaping all that is new in the plastic arts.

Characteristic of this development, especially in Europe, are the didactic and programmatic approaches (eg, Vasarely, Groupe de Recherche d'Art Visuel) but here the problem is to determine how much of this approach is **empirical** and how much **dialectical**.

Another theme in the anthology is the question of **synthesis**. Formerly synthesis had been understood as an idea (however vague) concerned with the integration of art and architecture. Today it extends from the simple idea of Lissitzky (dating from 1925) that 'architecture+sculpture+painting=synthesis' to the more radical notion of **l'art total**. The latter aims to remove the barriers that separate the different art-forms, and unite them in a new totality (eg, Nusberg). Although not as old as synthesis (which dates back at least to the Renaissance) **l'art total** also predates the twentieth century. Perhaps both these directions will ultimately find a place within a unified conception of art, related to science and technology, but on a deeper level than we find today which too often amounts only to a playful use of hardware.

Visions of synthesis, coupled with research into what constitutes an aesthetic experience (and how this works), provide the driving force for an increasing number of artists, who reject the idea of a visual culture which is founded on esoteric/personal expression.

But between the extremes of synthesis and laboratory research there are other directions, for example those founded on an **evolutionary** interpretation of the development of art (eg, Biederman and Lohse), programmes for the development of plastic art which are more

specific and yet less altruistic than those concerned with synthesis (Gorin, Vasarely, Constant, Baljeu) and also less dependent on the laboratory for ideas (Molnar, Groupe de Recherche). It remains to be seen if the evolutionary concepts are sufficiently impersonal, or if they are fundamentally subjective and founded on an incommunicable personal revelation.

However, to pursue these speculations it would be necessary to demonstrate that the field of modern art is indeed capable of being explored objectively, for only then could one begin to elucidate the many psychological motivations that lie behind its aims, its creators and its consumers.

At present too much authority lies with the promoters, communicators and evaluators of our visual culture, upon whom falls the task of sustaining the prestige of what many can only see as a 'cultural conspiracy'. It is these activities that take precedence over impartial investigation, so that research is looked upon as an unnecessary and unwarranted intrusion, and particularly if undertaken by the artists themselves.

My own belief is that ultimately all aspects of modern art will be open to scientific enquiry, and it is interesting to speculate how this might be achieved, as well as the effects it might produce in terms of a feedback to the artists and the public.

Anthony Hill

L. E. J. Brouwer: Consciousness, philosophy and mathematics[1]

First of all an account should be rendered of the phases consciousness has to pass through in its transition from its deepest home to the exterior world in which we cooperate and seek mutual understanding. This account does not imply mutual understanding and in some way may remain a soliloquy. The same can be said of some other parts of this paper too.

Consciousness in its deepest home seems to oscillate slowly, willessly, and reversibly between stillness and sensation. And it seems that only the status of sensation allows the initial phenomenon of the said transition. This initial phenomenon is a **move of time**. By a move of time a present sensation gives way to another present sensation in such a way that consciousness retains the former one as a past sensation, and moreover, through this distinction between present and past, recedes from both and from stillness, and becomes **mind**.

As mind it takes the function of a subject experiencing the present as well as the past sensation as object. And by reiteration of this two-ity-phenomenon, the object can extend to a world of sensations of motley plurality.

In measure of the irreversibility with which the subject has receded from an element of the object, this element loses its egoicity, ie, gets estranged from the subject, and in measure of this estrangement, mind becomes disposed to desire and apprehension, and consequently to positive or negative conative activity with respect to the element in question.

In the world of sensation experienced by mind, the free-will-phenomenon of **causal attention** occurs. It performs identifications of different sensations and of different complexes of sensations, and in this way, in a dawning atmosphere of forethought, creates **iterative complexes of sensations**. An iterative complex of sensations, whose elements have an invariable order of succession in time, whilst if one of its elements occurs, all following elements are expected to occur likewise, in the right order of succession, is called a **causal sequence**.

On the other hand there are iterative complexes of sensations whose elements are permutable in point of time. Some of them are completely estranged from the subject. They are called **things**. For instance **individuals**, ie, human bodies, the home body of the subject included, are things. Things may be, or may not be, indissolubly connected with egoic sensations. The whole of egoic sensations indissolubly connected with an individual, is called the **soul** of the corresponding human being. The soul connected with the subject-individual is rather latent, but manifest in sensations of vocation and of inspiration.

The whole of things is called the **exterior world of the subject**. Causal sequences, each of whose elements contains a thing, are called **exterior causal sequences**.

12

Causal attention allows the development of the conative activity of the subject from spontaneous effort to forethinking enterprise by means of the free-will-phenomenon of **cunning act**. The cunning act consists in this, that in a causal sequence of eventualities, a later element not conatively attainable in a spontaneous way but nevertheless **desired** (the **aim**), is realised **indirectly** by bringing about an in itself perhaps non-desirable but conatively attainable earlier element of the sequence (the **means**), and in its wake obtaining the desired element as its **consequence**. A causal sequence employed in this way is called a **useful** causal sequence. As a matter of course aim as well as means may be of a negative (averting) character. Mood and temper directing cunning acts are essentially different from spontaneous desire and apprehension.

Since (positive and negative) conative activity is mainly directed towards things, individuals included, the cunning act chiefly operates with exterior causal sequences.

By means of its cunning acts, the subject creates a **causal sphere of influence** which on the one hand it **protects** by an activity of **destroying** things endangering useful causal sequences, and which on the other hand it **extends** by an activity of **constructing** things capable of new useful causal sequences.

As a matter of course sources of disappointment with cunning acts are numerous. In the first place direct fulfilment of (positive or negative) desire through spontaneous activity is never equalled by its appeasement in a circuitous way. Furthermore causal attention meets with a certain resistance from the part of the object, so that over and over again confidence in causal sequences meets with unexpected and inexplicable deceptions, notwithstanding all effort at protection. Moreover all causal sequences are affected with inaccuracies, so that a concatenation of causal sequences need not necessarily constitute another causal sequence.

However, in spite of these disappointments, mind, once having taken to causal attention, remains in a lasting **causal tension**, impelling alternately to **causal thinking**, ie, attention towards discovering causal sequences and possibilities of creating or protecting causal sequences, and to **causal acting**, ie, acting, generally cunning acting, in consequence of causal thinking.

In this connection there is a phenomenon of **play**, occurring when conative activity or causal thinking or acting is performed **playfully**, ie, without inducement of either desire or apprehension or vocation or inspiration or compulsion.

Causal attention repeatedly leads to identification of sensation complexes originating from causal acts of the subject, with sensation complexes experienced in causal connection with other individuals. On account of this identification the latter sensation complexes are called **acts of those other individuals**. Moreover causal acts of the subject and such of numerous

other individuals influence each other in a high degree: many causal acts of many individuals even seem only to have possibility and sense as items of organised cooperation of smaller or larger groups of individuals: the share of the subject in that cooperation seems to be of no other nature than that of the individuals of the object.

Systems of causal thinking underlying such cooperative causal acts, are far more complicated than those inducing individual causal acts. Prominent amongst the former is **scientific thinking**, which in an economical and efficient way catalogues extensive groups of co-operative causal sequences. And this scientific thinking, in particular when concerned with technique, is based on **mathematics**.

Mathematics comes into being, when the two-ity created by a move of time is divested of all quality by the subject, and when the remaining empty form of the common substratum of all two-ities, as basic intuition of mathematics, is left to an unlimited unfolding, creating new mathematical entities in the shape of **predeterminately or more or less freely proceeding infinite sequences** of mathematical entities previously acquired, and in the shape of **mathematical species**, ie, properties supposable for mathematical entities previously acquired and satisfying the condition that if they are realised for a certain mathematical entity, they are also realised for all mathematical entities which have been defined equal to it.

The significance of mathematics with regard to scientific thinking mainly consists in this, that a group of observed causal sequences can often be manipulated more easily by extending its of-quality-divested mathematical substratum to a **hypothesis**, ie, a more comprehensive and more surveyable mathematical system. Causal sequences represented in abstraction in the hypothesis, but so far neither observed nor found observable, often find their realisation later on.

The organisation of a group of individuals into a cooperation consists in a wire-netting of will-transmission. At primitive stages of civilisation and in primitive man-to-man relations this transmission of will from individual to individual is brought about by simple gestures or primitive animal sounds. But in more developed organisation of the groups concerned the acts to be imposed become too much differentiated and too complicated to be indicated exclusively in such a simple way. In order to be able under these circumstances still to direct the trade by means of requesting or commanding (auditive or visual) signals, the totality of laws, decrees, objects and theories concerned with the acts enjoined upon the organised individuals, is subjected to a causal attention, the **linguistic causal attention,** and the elements of the mathematical system resulting from this causal attention, are indicated by **linguistic basic signs**. From these basic signs, by means of grammatical rules taken from the said mathematical system, the organised languages allowing the extremely differentiated and complicated will-transmissions required by civilisation have been constructed. And

these languages not only **consolidate** the wire-netting of will-transmission, but also suggest its continual **extension**. Of course, much of the stability and exactness which according to grammar and lexicon a language seems to possess is lost in practical life, because the totality of cooperations requires far more basic notions than language has to offer basic words and word connections. On the other hand stability and exactness of language is not necessary in practical life, because in every organisation routine engenders a sort of collective will, making good understanders to whom a word suffices.

In the preceding, account has been rendered of three successive phases of the exodus of consciousness from its deepest home. Of these phases the **naive** one was opened with the creation of the world of sensations, the **isolated causal** one with the setting in of causal activity, and the **social** one with being involved in cooperation with other individuals. Regression from the third to the second phase appears to be frequent and easy, but from either of these regression to the naive phase seems hard to realise, more easily a temporary refluence to the deepest home leaving aside naivety, through the free-will-phenomenon of detachment-concentration. The question arises, whether and where, on and after this exodus of consciousness, **beauty, mutual understanding, wisdom** and **truth** can be found.

In causal thinking and acting **beauty** will hardly be found. **Things** as such are not beautiful, nor is their domination by shrewdness. Therefore satisfaction at efficacy of causal acts or systems of causal acts or at discoveries of new causal sequences is no sensation of beauty.

But in the first phase of the exodus there is beauty in the joyful miracle of the self-revelation of consciousness, as apparent in egoic elements of the object found in forms and forces of nature, in particular in human figures and human destinies, human splendour and human misery.

And in the second and third phase there is beauty in remembrance of the miracle of bygone naivety, remembrance evoked either by reverie through a haze of wistfulness and nostalgia, or by [self-created or encountered] works of art, or by certain kinds of science. Such science evoking beauty reveals or playfully mathematises naively perceptible forms and laws of nature, after having approached them with attentive reverence, and with a minimum of tools. And such science evoking beauty, through its very reverence, rejects expansion of human domination over nature.

Furthermore in the second and the third phase there is **constructional beauty**, which sometimes appears when the activity of constructing things is exerted playfully, and, thus getting a higher degree of freedom of unfolding, creates things evoking sensations of power, balance, harmony, and acquiescence with the exterior world.

But the fullest constructional beauty is the **introspective beauty of**

mathematics, where instead of elements of playful causal acting, the basic intuition of mathematics is left to free unfolding. This unfolding is not bound to the exterior world, and thereby to finiteness and responsibility: consequently its introspective harmonies can attain any degree of richness and clearness.

In every cooperation in which acts of the subject are concerned, to causal attention it seems that in the system of cooperative causal acts concerned the share of the subject, considered as share of the subject individual, is of no other nature relative to things than that of the object individuals concerned in the cooperation. And this finds expression in the language of the cooperation concerned. Again, to causal attention it seems also that the non-cooperative actions of the subject, considered as actions of the subject individual, firstly are of no other nature relative to things than those of the object individuals concerned in the cooperation, and secondly neither very much differ in nature relative to things from those of a great deal of object individuals not concerned in the cooperation. And this finds expression in the language of the cooperation concerned in such a way that the part assigned to the subject individual in this language is analogous to those assigned to object individuals, whereas the subject itself is ignored in it. In this way civilised languages, mostly being cooperative languages, suggest a sameness for such totally different phenomena as acts of the subject and acts of object individuals are.

And this suggestion is intensified by the misleading terms civilised languages use to characterise the behaviour of individuals in general. It is not unreasonable to derive this behaviour from 'reason'. But unreasonable to derive it from 'mind'. For by the choice of this term the subject in its scientific thinking is induced to place in each individual a mind with freewill dependent on this individual, thus elevating itself to a mind of second order experiencing incognisable alien consciousnesses as sensations. Quod non est. And which moreover would have the consequence that the mind of second order would causally think about the pluralified mind of first order, then cooperatively study the science of the pluralified mind, and in consequence of this study assign a mind of second order with sensation of alien consciousnesses to other individuals, thus once more elevating itself, this time to a mind of third order. And so on. Usque ad infinitum. And this nonsense would still go further. In the group of individuals $I_1, I_2, \ldots I_n$, besides the primary minds of first order, $M_1, M_2, \ldots M_n$, being sensations of the subject mind of second order, for every **k** and **l** which are natural numbers $=\mathbf{n}$, the mind M_{kl} occurs, ie, the sensation experienced by I_k as a second order from I_l. Likewise, besides the primary minds of second order M_{kl}, being sensations of the subject mind of third order, for every ρ, σ and τ which are natural numbers $=\mathbf{n}$, the mind $M_{\rho\sigma\tau}$ occurs, ie, the sensation experienced by I_ρ as a mind of third order from $M_{\sigma\tau}$. And so on. Usque de infinitum. Moreover, with respect to behaviour, the variation from individual to individual, only in degree, not in essence, differs from

the variation from individual to animal, so that as a consequence of the plurality of mind, a mind would have to be assigned to animals as well.

Since there is no plurality of mind, so much the less is there a science of the plural mind. Only a psychology of man **and** animal, which as an extension of physiology, studies automatic living organisms, without mind and without free-will. To these the subject individual belongs as well, notwithstanding its special role as bearer of joy and pain, and of phenomena accompanying emotions, thoughts and acts of the subject. For in spite of its dominating position the subject has a domain of describability which, compared to that of the object, is a Città del Vaticano.

In default of a plurality of mind, **there is no exchange of thought either**. Thoughts are inseparably bound up with the subject. So-called communicating-of-thoughts to somebody, means influencing his actions. Agreeing with somebody, means being contented with his cooperative acts or having entered into an alliance. Dispelling misunderstanding, means repairing the wire-netting of will-transmission of some cooperation. By so-called exchange of thought with another being the subject only touches the outer wall of an automaton. This can hardly be called mutual understanding. Only through the sensation of the other's soul sometimes a deeper approach is experienced. And only when wisdom revealed by the beauty of this sensation, finds expression in the antiphony of words exchanged, **then there may be mutual understanding**.

Apart from the soul every exposé on the sense and essence of life is a soliloquy, and every discussion about the pluralified mind is a game of dialectics in the arena of a collective hypothesis of a non-human super-subject experiencing an objective world containing appearing and disappearing human subjects, and continuing its existence when all those human subjects will have vanished.

Searching for **wisdom**, we may find it in knowing that causal thinking and acting is non-beautiful and hard to justify, and that in the long run it brings disappointment. And in knowing that the exterior world with its innumerable individuals and with its hypertrophied cooperation is wedded to mind, its disharmonies reflecting mind's free-will-guilt.

As a consequence of this, knowing the exterior world and one's own position in it are accepted as they are, so that towards the exterior world generally only acts as reversible as possible aiming at maintenance, but no acts let alone causal acts aiming at change, are undertaken of one's free will. Repair of disadjustments, averting of danger and relief of need, all this negative intervening in human society is justified in itself and sometimes prescribed. But positive activity to change the structure of human society governed by so many unknown forces, will always be checked by the self-admonition; 'not to improve her work has Providence placed thee in this world', and only vocation and inspiration tested in detachment-concentration will be stronger than this admonition.

For the actual expansion of the already hypertrophied world co-operation (which in its trivial final aims of mass-comfort and mass-security has not got much justification) responsibility will be declined. Therefore leading positions in this cooperation will not be aspired to.

Neither can responsibility be assumed for curtailment of freedom, one's own or other people's. Therefore one will only reluctantly join a clique or union, these generally impairing liberty of action and spontaneity in conduct of life.

Power over fellow-creatures will be avoided. Firstly because one would get mixed up with limitations of other people's liberty of action. And secondly because those fellow-creatures are part of the reflex image held out to mind from its deepest home, therefore have to be respected, and must not be judged, let alone condemned, despised or rejected, even if they are enemies to be fought against.

Eastern devotion has perhaps better expressed this wisdom than any western man could have done. For instance in the following passages of the Bhagavad-Gita[2] which even in translation have conserved their electrifying power:

'A man should not hate any living creature. Let him be friendly and compassionate to all. He must free himself from the delusion of I and mine. He must accept pleasure and pain with an equal tranquillity. He must be forgiving, ever-contented, self-controlled, united constantly. His resolve must be unshakable.'

'He neither molests his fellow-men, nor allows himself to become disturbed by the world. He is no longer swayed by joy and envy, anxiety and fear.'

'He is pure and independent of the body's desire. He is able to deal with the unexpected: prepared for everything, unperturbed by anything. He is neither vain nor anxious about the results of his actions.'

'He does not desire to rejoice in what is pleasant. He does not dread what is unpleasant, or grieve over it. He remains unmoved by good or evil fortune.'

'His attitude is the same towards friend and foe. He is indifferent to honour and insult, heat and cold, pleasure and pain. He is free from attachment. He values praise and blame equally. He can control his speech. He is content with whatever he gets. His home is everywhere and nowhere.'

The categorical imperative prescribing the aforesaid attitude towards life has its counterpart in a sceptical prognosis that mankind, possessed by the delusion of causality, will slide away in a deteriorative process of overpopulation, industrialisation, serfdom, and devastation of nature, and that when hereby first its spiritual and then its physiological conditions of life will

have been destroyed, it will come to its end like a colony of bacteria in the earth crust having fulfilled its task.

All this, though timeless art and perennial philosophy continually suggest that the unknown forces governing the destiny of individual and community are not subject to causality; that in particular the ways of fate cannot be paved with causality, and that security is as unattainable as it is unworthy: that intensification of organisation increases vulnerability, that new vulnerability asks for protection through new organisation, and that thus for organisation which is believed in, there is no end of growth; finally that if the delusion of causality could be thrown off, nature, gradually resuming her rights, would be (except for her bondage to destiny) generous and forgiving to a mankind decausalised and subsiding to more modest and more harmonious proportions.

Of course art and philosophy continually illustrating such wisdom cannot participate in cooperation, and should not communicate with cooperation, in particular should not communicate with the state. Supported by the state, they will lose their independence and degenerate.

The recognition of a cooperative world captured in the delusion of causality as a reflex of mind's guilt, does not imply eternal bondage to that world. Consequently, the way along which the deepest home was left seeming to be blocked for final return, there may be wisdom in a patient tending towards reversible liberation from participation in cooperative trade and from intercourse presupposing plurality of mind. It seems that this mere tendency favours evaporation of desire and fear, so that gradually non-cooperative activity is allayed, cooperative causal acts are automatised, the world of things faints away, the joy of beauty pales, egoic elements no longer bind attention, and the home body grows more and more frugalised. What remains of non-cooperative conative activity, seizes every opportunity for a further disengaging from cooperative trade and further anachoresis of the home body. There is no hesitation to leave what is beloved, for neither beauty nor egoic alliance needs causal proximity. Though there is sadness when in a receding distance naivety vanishes for ever. But perhaps at the end of the journey the deepest home vaguely beckons.

From the above report, especially from the rejection of the hypothesis of plurality of mind, it follows that **truth** is only in **reality** ie, in the present and past experiences of consciousness. Amongst these are things, qualities of things, emotions, rules (state rules, cooperation rules, game rules) and deeds (material deeds, deeds of thought, mathematical deeds). But expected experiences, and experiences attributed to others are true only as anticipations and hypotheses: in their contents there is no truth.

Truths often are conveyed by words or word complexes, generally borrowed from cooperation languages, in such a way that for the subject together with a certain word

or word complex always a definite truth is evoked, and that object individuals behave accordingly. Further there is a system of general rules called **logic** enabling the subject to deduce from systems of word-complexes conveying truths, other word-complexes generally conveying truths as well. Causal behaviour of the subject (isolated as well as cooperative) is affected by logic. And again object individuals behave accordingly. This does not mean that the additional word-complexes in question convey truths **before** these truths have been experienced, nor that these truths **can** always be experienced. In other words, logic is not a reliable instrument to discover truths and cannot deduce truths which would not be accessible in another way as well.

The above point of view, that there are no non-experienced truths and that logic is not an absolutely reliable instrument to discover truths, has found acceptance with regard to mathematics much later than with regard to practical life and to science. Mathematics rigorously treated from this point of view, and deducing theorems exclusively by means of introspective construction, is called intuitionistic mathematics. In many respects it deviates from classical mathematics. In the first place because classical mathematics uses logic to generate theorems, believes in the existence of unknown truths, and in particular applies the **principle of the excluded third** expressing that every mathematical assertion (ie, every assignment of a mathematical property to a mathematical entity) either is a truth or cannot be a truth. In the second place because classical mathematics confines itself to **predeterminate** infinite sequences for which from the beginning the **n**th element is fixed for each **n**. Owing to this confinement classical mathematics, to define real numbers, has only predeterminate convergent infinite sequences of rational numbers at its disposal. Out of real numbers defined in this way, only subspecies of 'ever unfinished denumerable' species of real numbers can be composed by means of introspective construction. Such ever unfinished denumerable species all being of measure zero, classical mathematics, to create the continuum out of points, needs some logical process starting from one or more axioms. Consequently we may say that classical analysis, however appropriate it be for technique and science, has less mathematical truth than intuitionistic analysis performing the said composition of the continuum by considering the species of freely proceeding convergent infinite sequences of rational numbers, without having recourse to language or logic.

As a matter of course also the languages of the two mathematical schools diverge. And even in those mathematical theories which are covered by a neutral language, ie, by a language understandable on both sides, either school operates with mathematical entities not recognised by the other one; there are intuitionist structures which cannot be fitted into any classical logical frame, and there are classical arguments not applying to any introspective image. Likewise, in the theories mentioned, mathematical entities recognised by both parties on each side are found

satisfying theorems which for the other school are either false, or senseless, or even in a way contradictory. In particular, theorems holding in intuitionism, but not in classical mathematics, often originate from the circumstances that for mathematical entities belonging to a certain species, the possession of a certain property imposes a special character on their way of development from the basic intuition, and that from this special character of their way of development from the basic intuition, properties ensue which for classical mathematics are false. A striking example is the intuitionist theorem that a full function of the unity continuum, ie, a function assigning a real number to every non-negative real number not exceeding unity, is necessarily uniformly continuous.

I should like to terminate here. I hope I have made clear that intuitionism on the one hand subtilises logic, on the other hand denounces logic as a source of truth. Further, that intuitionistic mathematics is inner architecture, and that research in foundations of mathematics is inner inquiry with revealing and liberating consequences, also in non-mathematical domains of thought.

[1948]

[1] Excerpted by kind permission of the late Professor Brouwer [who supplied amendments to the original text] and the North-Holland Publishing Company, Amsterdam, publishers of the **10th International Congress of Philosophy, 1948, Proceedings vol. I**, pages 1235–1244 [plus the final paragraph of page 1249] are reprinted here; pages 1243–1249 are reprinted in **Philosophy of Mathematics – Selected Readings** edited and introduced by Paul Benacerraf and Hillary Putnam, Basil Blackwell, Oxford 1946.
[2] Quoted from the English version by Swami Prabhavananda and Christopher Isherwood, Phoenix House, London 1947.

Georges Vantongerloo : To perceive

The five senses at the disposal of man allow him to perceive a certain number of facts that we have qualified as objects. This very, very limited number seems comparatively non-existent among the facts, or manifestations, of creation (if indeed one can speak of a comparison).

But for man, considered independently, these five senses are sufficient for him to live his kind of life. Fish, birds, insects, and we could say even plants, behave differently having other needs for survival. But apart from these five senses, man possesses a more or less developed sensibility (as sight is more or less good); a brain allowing him to reflect; imagination (generally a little wild and fanciful); and the ability to observe and deduce. Thus he can see the invisible or, if you like, take a sounding of the incommensurable. In reality man, like all created things, is a mechanism capable of picking up waves. The difficulty lies in interpreting the sensations received. The variety and richness of these experiences go on to infinity, and can often contain simple facts which nevertheless escape our five senses. Often it is our sensibility which must draw us out of this impasse. This is what one calls having an illuminating idea.

An experience can affect us long after it has taken place, even years after, unless it escapes us. But the event has taken place, and our brain or our sensibility only becomes aware of it later. What one usually calls evolution must fall into this category. Evolution in such a case would be an accumulation of information received.

I have myself made several investigations which I will describe. I made an object in plastic material; **No.210, Six couleurs dans l'espace**, 1949. This is a curved form on which are placed six colours at a distance from one another. At first I could not measure the distances which separated the colours. In order to be able to do so with an object so shaped, it was necessary to discover a relative system of reference. I hooked the object on a wire and let it revolve. At whatever speed the object rotated, I could always see it as recognisable, and although in movement it was not changed in form. This meant that its speed synchronised with that of my vision. But if my vision was limited to a split-second, like a camera, it would no longer see the object as it previously appeared to me, and the result would no longer have any resemblance to the known object, for it would have changed its geometric forms. I possess a very characteristic photograph of this effect. I showed it at the Congress of the Golden Section in Milan in 1951.

But do not think that these results will always be identical. The universe contains innumerable phenomena which could equally well be cited. The refraction of light, for example. An object changes geometrical forms as **its** speed changes in relation to that of the observer (speed of the eye organism, mechanical device, photo). But it can also undergo physical changes. **No.210** seen through the eye of the camera, while rotating, registers multiple geometric

positions giving an astonishing image. But the work **No.214** (1950) titled **Cocon chrysalide, em-bryonnaire**, in plastic material and of circular form, retains its object-form for the naked eye while rotating. But in the photograph it will take on a physical aspect, radiographic in type. It is the refraction which dominates. I showed this to the Milan Congress in 1951.

I have also made other observations. An example is **No.228, Segment d'espace,** 1953, in plastic material on which dots of colour are painted, giving by refraction various coloured forms. One can look at this object from any side and it will always remain the same; that is to say, only the position will vary. But seen through the camera's eye it can reveal unknown aspects, and certain shots show unsuspected forms and colours. One could even say that in making this object I wanted to incorporate this indefinable quality, but doubtless man's sight does not allow him to perceive this, and he needs another instrument that can develop what is denied to the human eye. I always find my work deceptive at the moment of finishing it, but later, often a long time afterwards, I notice that I have put in what I intended without knowing it. The photograph of this work was an encouragement to me, for I had so much wanted to obtain a result that I couldn't see in the object. Yet I must have put it there since the photograph showed it to me. The incommensurable well deserves its name. It is, of course, only thus so long as it isn't under conditions which render it commensurable and even visible. Under certain conditions infinity is finite.

I have had a more or less analogous experience with **No.240, Elément indéterminé,** 1955. But there the object in itself and in the photograph is totally absent. You would imagine that I had wanted to make something indeterminate. But to speak of determining the indeterminate and subjecting that to man's limited vision, is like speaking of the energy of the atom to someone who hasn't seen the result of it. Here I think that time plays its role. Time, as an absolute value, does not exist. The fact is that when we believe we see something as existing, this thing, before being transformed into another state, corresponds to the speed of our senses. That is to say, its position at a given moment is maintained long enough to allow our senses to perceive it, or register its presence. Time therefore has a varying duration between more or less NT. [Ed: NT is the scientific indication for indefinite time.] It is like space, finite and infinite at once. Basically, we observe a segment or movement of time, a segment or measure of space. Through our senses we are unable to perceive the infinite, for our senses are themselves limited. This does not affect the existence of the infinite, and we are subject to it. Being ourselves part of creation, the infinite, we would not be able to live without the infinite. We are within it, as in the air, like fish in the water. All this is one and the same thing, but from different aspects.

Well then, **No.240** is truly indeterminate. It is in perpetual transformation. The forms and the colours are variable: they have a mobility, and that without them being

touched or agitated. They move calmly of themselves. They allow us to see, too, that the infinite is visible and hence finite, at least to man's vision. If the speed of the infinite is synchronised with the speed of vision, we see the infinite as finite. Let us imagine: an unknown, invisible factor is born, lives, endures for a time and dies. Throughout the whole duration of the time it lives, it is visible. Time is spectacular.

> Light—time—space.
> Light reveals itself by the surface on which it falls.
> The time limit is the limited and varying duration of synchronised speeds; that of the perceived object in relation to that of the senses allowing perception.
> The space limit is an extension, perceived or perceivable through the speed of our senses.
> Time, light, and speed.

Light reveals itself by the surface on which it falls, and in the same way, it reveals the surface. The speed (energy) of the illuminated object, in accordance with the speed of our vision, reveals time to us. On either side of the speed of these illuminated bodies, our vision is unable to perceive the bodies or the light. Nor can it experience the duration of time. It is the duration of this perceptible state that gives us the sensation of time. If this state changes its speed, it re-enters the infinite. For a blind person objects and space reveal themselves through the tactile sense, and duration through the sense of hearing.

By convention, man registers time by the clock, space by three dimensions. This is very practical and does not offend his senses. But man is well aware that creation is not concerned with such conventions. He is obliged to admit electricity, Hertzian waves, radar, and the atom, although he is lost in the infinitely small and great, in infinite and finite, where time escapes him and he can only recognise what his watch shows him. To accept only those things which are perceptible by our senses is to expose ourselves to a lie. Confronted with the incommensurable, man is handicapped, and has recourse to a god. But he cannot be satisfied by ignorance, and so he must interpret creation. Beautiful though they may be, fables, hymns and commemorations are only illusions.

Man's possibilities of perception are increased by optical instruments and techniques, such as radiography, detectors and a thousand others. He has realised that his five senses are limited. One must say, too, that change is perpetual, that the infinite is in action, and that the finite which our senses perceive is subject to infinitesimal transformations which escape us. We often need instruments to give us information, though happily we have our sensibility. Today we

know that the earth has existed for millions of years. It is easy to imagine that it did not always look the same as today, since everything is in process of transformation. Things are transformed physically and chemically, through action and reaction. The fluxes of nature take part. Legends and fables about it have only a literary value. Through discernment and deduction, through the subtlety of the sensibility, and through science, man is able to approach the inconceivable. The earth with its atmosphere is moving round the sun in an unknown matter, doubtless composed of gas and microbes. This matter no longer has the same characteristics as the atmosphere that surrounds the earth, yet the earth is revolving; in a vacuum? This is inconceivable! The sun's rays would then be non-existent, and simply the effect of a chemical or physical cause, electromagnetic. As the universe is infinite it must have infinite, non-identical zones: atmospheric zones of density. Light would not then be a ray of the sun but could be due to refraction: could be an effect of a cause. The state of one thing can change into that of another with different characteristics. It is therefore possible that the earth is moving in a milieu where its apparent weight, as we know it, is no longer the same, and forces the earth to describe an orbit on the ellipse from which it cannot deviate. This is as necessary to it as air to man. It is inevitable. Creation always has its reasons. The physical chemistry of the universe has its imponderables. Is it not beautiful? This really is engendered creation.

[1957]

Universal-existence?

Man has five senses, and they suit him very well. That is to say, for the type of animal he is, they are enough. Through these faculties he views life. How would man picture to himself the things in the outside world if he had even more senses: for example, antennae? We cannot imagine it for we believe ourselves perfect of our kind. It is true that for our daily needs it seems that nothing is missing to conduct us through what we call life. But how do our five senses function? Sight, for example. We see simply what our brain sets out for us: what it is capable of making us see, and what our feelings impose on it, interpreted according to our personal development. Judgments on the appearance of something by two or more people are never identical. This corresponds well to the imponderability of the universal.

To man, the earth was once flat. He saw it like that. Then it was

round, and the universe revolved round it (geocentric). Next one had to accept a planetary system (heliocentric). Then a galaxy, and later galaxies. Thus our brain allows us to see, or represent, things according to the degree of our development. But the variations of creation go on to infinity; it is so rich and really universal. The characteristics of the earth, the moon, the sun, and the planets, are really individual and non-identical. The stars and the planets are not at all similar, and they exist in varieties. All this is not contradictory. Dimensions and distances are not identical. The moon has no atmosphere and is volcanic. The earth is surrounded by an outer atmosphere, quite unlike its own, and it orbits in this outer atmosphere without falling into nothingness. The sun has its different atmospheres, its photosphere, chromosphere, its crown and its protuberances. Jupiter is only a gas. All this is orchestrated in the universe. Isn't it wonderful when all that must struggle, and what a struggle! A harmony through transformation, which is perpetual. A necessary destruction for the construction of creation. It is a marvel beyond our understanding. And here is man with his five senses who sees everything in three dimensions. And the universe which is infinite has no dimensions. It has no numbers since there are millions of stars, millions of light years away. There is no void since there are clouds of interplanetary dust (dust gas). Novae which burst, etc, etc. Man has measured distance in miles. But the distances become ever greater, one must use other units; the solar ray, the light year the parsec. [Ed: The parsec is the distance at which a star would have to be in order to have an annual parallax of one second of arc.] Now one has much more contact with the universe through radio electricity, the radio telescope, radar. This kind of subtlety, sensibility, is indicated as being more in unison with the universe. One must use the same language as creation in order to be able to synchronise with it. Sight is augmented by the telescope. But there are the dust clouds (aerolithes). Could they not be traversed by radar? Couldn't one send waves into the universe which would send back information to us on the characteristics of the stars? The asteroid Ceres is no more than 770 km in diameter. A great many are no more than 30km. Against that, Jupiter has a diameter of 137,990km. It makes a complete revolution in 9 hours 50 minutes, and the length of time for an orbit is 11 years, 315 days; 120 days longer at the Equator than at the poles. We see that the universe is not three dimensionally governed. Creation is rich and variable.

[1961]

Conception of space . I

If one takes space as a subject for consideration it can be thought of in different ways.

The objects perceived through our senses of sight or touch are always placed in an environment. Objects occupy a space or are intrinsic to it. This space is said to have three dimensions. One is able to measure points on an object, but the other part of space, the void, can't be measured. Yet this, equally, makes up part of space. Without it one would see only the object, rather as if one were deprived of seeing anything else at all. One can, of course, also see the space (the void) between two or more objects or volumes. This void, plus the object, constitutes space. It is not that space has three dimensions, but that objects are measured by three dimensions.

But measurements are sizes which themselves have relations, and are equally relations of the object. These last relations can be sensed: the observer feels them. The proportions, if the object is composed of proportions, consist of a rule of three, and they relate if the different sizes reveal a relationship between the volumes which are characteristic of the object.

This leads us to the function of lines, planes and volumes which can themselves, of course, have interrelated sizes or functions. These, while in certain cases measurable, can be in other cases without dimensions. Three dimensions do not strike our senses except through the function; direction, attraction, repulsion. Here we are confronted with another property of space.

But in creation, objects perceived through our senses are not inert; they are the energies of which the whole of space is composed. If you like, space (creation) is of variable dimensions. Space, which has three dimensions, is only that part of creation which our senses can grasp, that is to say where the speed is synchronised with our senses. Above and beyond this synchronised speed we perceive nothing. Certain animals, fish for example, must perceive other dimensions than those of man, due to their special senses and their way of using them.

One can ask oneself how this space can be represented and how it can be communicated in a work. Here the problem no longer resolves itself by means of geometry, for this space is active: one can feel it, and its variety is infinite. One can take the sensation of weight from matter: so that the colours are not only visible, but sensed. In this way matter is contained or becomes weightless. One experiences the created work like this.

But there is also refraction. The atmospheric strata which are active, make us see things otherwise than they are in reality. There is an aberration which tricks us in our judgement of space. Space can be conceived of in more than one way, and the radiation of atmospheric strata is more powerful than our five senses can perceive. The radiation of everything is invisible to us. We are subjected to it unknowingly. It transforms by its action, and the phenomena which we see are purely on the surface. Actuality is only a product. The rainbow, for example: the mirage and the

magnet, etc. A colour or an object changes when one surveys it through a polariser.

Space can also be a subject for art, just as much as religion, nature, history, etc. It is the conception of the subject that matters, not the interpretation. As for art, that must probably be a creation. This is still an imponderable. There are conventional subjects, as there are conceptual ones. It is for you to follow your nature.

Already as a child I greatly admired the firmament, the sea, the forest, the rising and the setting of the sun. Nature was beautiful and I had no need to understand it. I have always kept this admiration, and all that I learnt in school and at the Beaux Arts was not able to supplant this admiration, which haunted me. I have never been under the influence of a school, for I must say that I don't understand these conventions. I respect everyone: I leave everyone free and I let myself be guided by my impulses. Whether I expressed myself in painting, in sculpture, or by geometry, at school or in front of the Greek art at the Beaux Arts, I was always guided by my impulses. I don't understand convention, dogma, decree. Moreover, all my acts in life are controlled by a sort of antenna or radar. I cannot do otherwise. Obviously, there are degrees of capacity, and it is very difficult to express oneself, so that my ability must always be improving, and as I must always judge with my senses, which are themselves limited, I never succeed in expressing what I feel as I would like. My ideal is too high, and even if I could attain it my senses are too limited to see it in my actual work. Other instruments are better equipped to perceive the infinities. Visual sensibility and hearing are augmented by such means as photography, cinema, measuring equipment, radiography, and enable me to have access to what my senses deny me. My conception is a feeling accompanied by thought, an idea and presenting it, but the materialisation, which itself must also undergo transformation, is not an easy thing to realise. There must not be dogmas, principles or conventions. The whole must be like creation and made only to engender. This can be achieved with art, for it is the splendour of creation that I want to express. It is, then, neither scientific nor philosophic. The subject is space. I conceive it from what I am, and I am not able to do otherwise.

[1958]

Conception of space . 2

One has words to express oneself. The meaning of words is amply shown in dictionaries. Yet no one has the same image or the same impression of the meaning of a word. In the same way everyone has his own concept of space according to his individual nature. In general, man thinks of space as three dimensional, although you can speak to him of extension, of the universe. This way of speaking is often encountered among artists, and the error is seen even in the way they express themselves in their work. The confusion is inevitable. It is true that this conceptual error is current in our education. In this case it isn't space that requires another definition. The phrase 'concept of space' has no sense, not being appropriate. I would also like to say that the problem is not easy to resolve. Moreover, comprehension has nothing in common with conception. The space-universe, creation, has no solution of absolute value. Space is incommensurable. Nevertheless, through his sensibility man can have a presentiment of something which enables him to draw near to what has moved him.

Creation has always impressed me. In my childhood I was stirred by its grandeur, its beauty, its phenomena. All that happened without my trying to understand. When later I went to school I learnt geometry, and was told about space and how one could measure distances. All attention as I was, I was not able to understand, or see that nature could be submitted to measure. At the Beaux Arts my education weighed on me and hindered my intuitive feeling. But what could I do? The exhibitions, the Salons, all carried the same stamp. Yet without my knowing it, my work tended towards I don't know what; towards something that I didn't know how to express confidently. But then: His Majesty King Albert, who gave me signs of encouragement, asked me one day in 1914 for news about my work. I explained my thoughts to him: 'Objects separated in space have points of contact. It is not necessary for the objects to touch each other or be stuck to each other'. This greatly interested His Majesty but the war intervened and, after all, what I was thinking I could only express by three dimensions. I was looking always for what my education had denied me. But in 1916–17 I gave up this way of conceiving, seeing no use in it. I recalled my childhood and went to the woods, to the sea, and plunged myself once again into nature. This happened at the Hague. I thought of giving up working, but I did not refrain from writing down my thoughts and the ideas that came to me about space creation. This was not in order to describe them as a naturalist, but to reflect on the phenomena of creation. To this end I found it necessary to complete my writings by drawings. It was then that I wrote an article which appeared in **De Stijl No.9**. This article was illustrated with drawings. I also made in 1917 four compositions in the sphere, which have often been reproduced. I started from the thought of the point or sphere, as a segment of the infinitely great, which is always visible in the original work. One of the four objects, **No.3,** is a body of indeterminate form: with simply the co-ordinates recalling the point or the sphere. This work is in the Museum of Modern Art, New

York. I am not then part of any 'ism'. Van Doesburg for his propaganda stuck me in De Stijl, but to tell the truth I have nothing in common with what De Stijl pretended to want to say, nor with any other tendency: I am alone. I must also say that I was unaware that I had a conception of space: and this is natural because creation is infinite and I would never dare to say that I had found the solution to the enigma. This conception could just as well have come to me if I had never been to school or to the Beaux Arts.

There was, however, a follow-up to these investigations. This was the relations of volumes and the relations of colours when I was expressing myself on a flat surface. In order to verify the exactness of my subject I had recourse to a form in which I was able to fix a conception; whether circle, square, ellipse, or equations of varying degrees, it always remained geometric and in three dimensions. In the same way that I verified the relations of volumes, I sought to verify the space of colours. I then made a very laborious study over a long period and finally had the luck to find the exact space of each colour, following such and such accord. But then, after having thoroughly studied it, I realised that this knowledge is of no use in art. Without doubt, like geometry, it is too measurable. In science it can be used to establish the positions of infra-red and ultra-violet. This study was published in my booklet **l'Art et son Avenir** in 1924. This publication is unfortunately out of print.

Then I became occupied by the functions of lines and masses. As a result I thought that bodies were not restricted to their surface, and belonged to energy. But how to express that? Well, it is possible. Without the need of a dynamo bodies emit a radiation and this expresses itself. You may say: the moment you explain you limit, and there is no longer continuity. Yes! because today, through atavism, we think always of three dimensions. But here is what I thought and was able to verify: All is infinite but our five senses do not let us perceive it. Moreover, none of these senses allow of an absolute value. But the speed of our senses allows us to perceive a segment of the infinite every time that it is synchronised with the velocity of our senses. What happens is that we see something born, appear, undergo a transformation or change of state, then die or no longer fall within the scope of our senses. And although that can be expressed, it can be defined only with difficulty. We always take a limited view of existence because it falls within the range of our senses. One can say here that the role of time comes into play. While we are perceiving a phenomenon we believe we see it, yet we do not see its perpetual transformation. All is born, lives and dies for our senses, but not for the universe. But this segment of the infinite, this limited case, continues to belong to the infinite. It is not our senses but we ourselves who, by the fact of being limited, erroneously believe that that limitation alone exists: that of our three dimensions. In creation certain phenomena reach us.

Georges Vantongerloo

But what we believe we see does not exist. The different atmospheric strata show us a state that is not real, and make what we see appear to be of such a form or such a colour; light for example: magnetic waves, electrons or the infinity of possibilities inherent in creation. The aurora borealis, is it not magnificent? And yet we are still in our own planetary system. There are still the galaxies. And all this is creation and has nothing to do with the history of man. In this domain one can equally well express oneself through art, or through what I am engaged in. I believe it is my right to express myself in accordance with my nature.

There is also the possibility of engendering colour, a coloured effect, without using coloured material: in the same way that one can create a volume without dimensions. The latter is a non-measurable body which re-enters our sensorial zone. It is through our sensibility that we perceive these colours and volumes, and not only through our five senses. Obviously, one needs to see these works and to make contact with them in order to have a better understanding of what I have been writing.

Creation has no dimensions. It is action and reaction, which is itself action. It is a chemico-physical laboratory. Light is a radiation which can be perceived by the surface it occupies. All phenomena are radiations. One action in combination with another engenders a phenomenon. The atmospheric strata participate in the chemico-physical action. That is to say, in traversing the atmospheric strata there is a transformation, and through perception the phenomena appear to us in unreal forms. The intensity of the light varies according to the atmosphere through which it must travel. Its creation is due to a kind of electro-magnetism. But the phenomena which it makes us see are deformed, having neither real forms nor exact colours. It isn't an illusion, but a chemico-physical reaction which the spectator believes he sees. The rainbow and the aurora borealis are examples of this. The mirage too. The whole of creation presents us with surprises. It is a perpetual transformation and for this reason has no dimensions. The dawn and the sunset, the seasons, the plants and all the manifestations of creation have a sense which is not measurable but ascertainable. Take the refraction of light. Lightning, and its thunder and its brightness, are the results of a phenomenon. The spectacle that is produced is due to the phenomenon, but it must not be confused with the phenomenon itself.

My works represent my conception of creation, and have nothing in common with so-called modern art. I have never followed the movements, the isms. Frankly, my work has not been understood at all, from the very beginning, and yet they wanted to incorporate me among the army of artists. It is a similarity which interested them, and the conceptual side remains ignored. This is obviously of no importance since it is only the work which counts. But even so, it has

31

some importance since this cuts me off from the world and allows me to follow my conception. The usurpers remain for what they are. This doesn't prevent them from remaining convinced; why? because they do not discriminate. They are always looking through their distorting glasses. They believe what they see and are convinced. They believe also that the right to encroach is their due and would be quite amazed if you treated them like pretentious upstarts. So much for men.

[1960]

Georges Vantongerloo

No.240 Elément indéterminé 1955

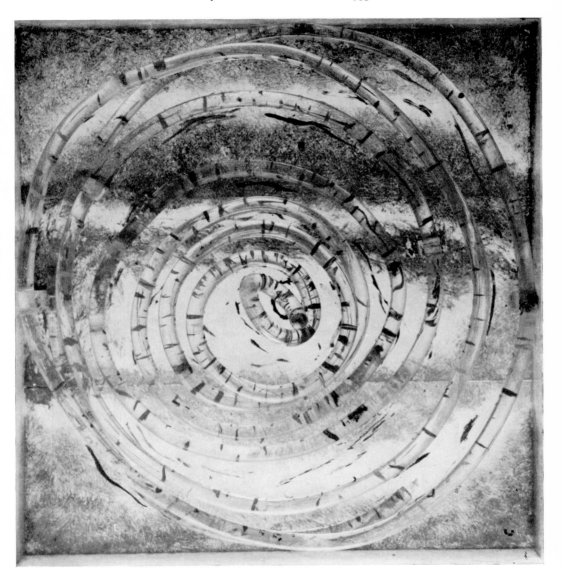

No.240 detail

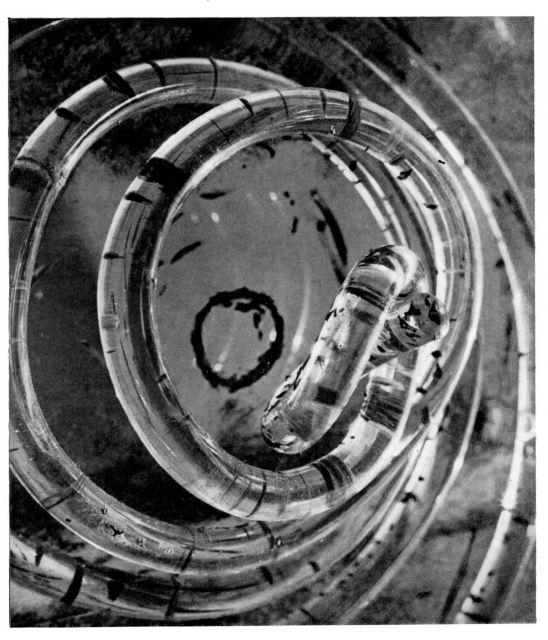

Georges Vantongerloo

No.214 Cocon, chrysalide, embryonnaire 1950

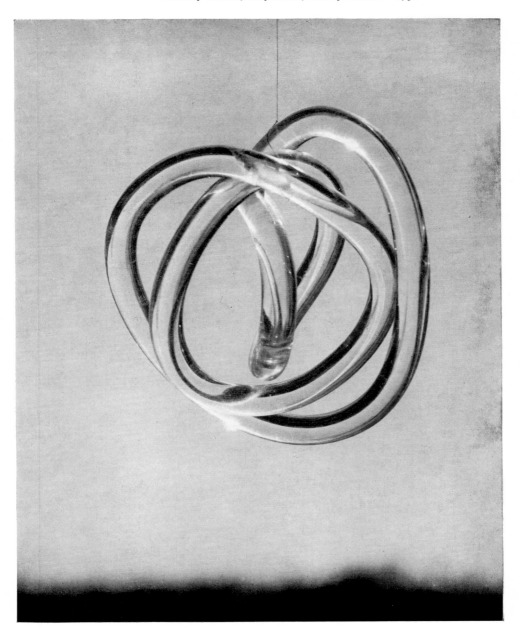

Georges Vantongerloo

No. 214 photographed while rotating

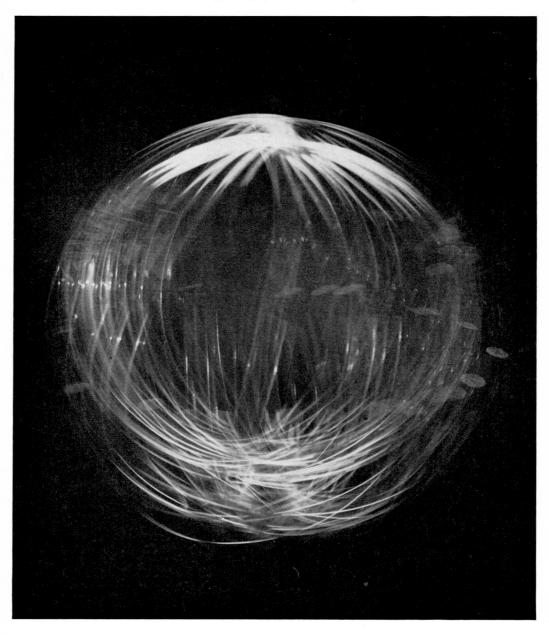

Georges Vantongerloo

No. 210 Six couleurs dans l'espace 1950

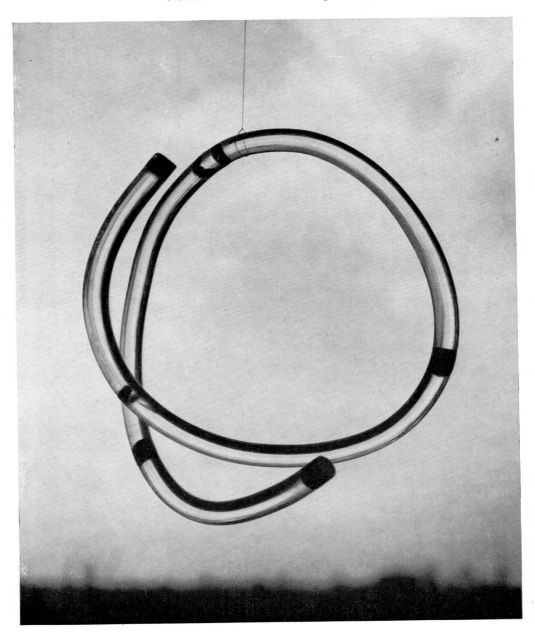

Georges Vantongerloo

No.210 photographed while rotating

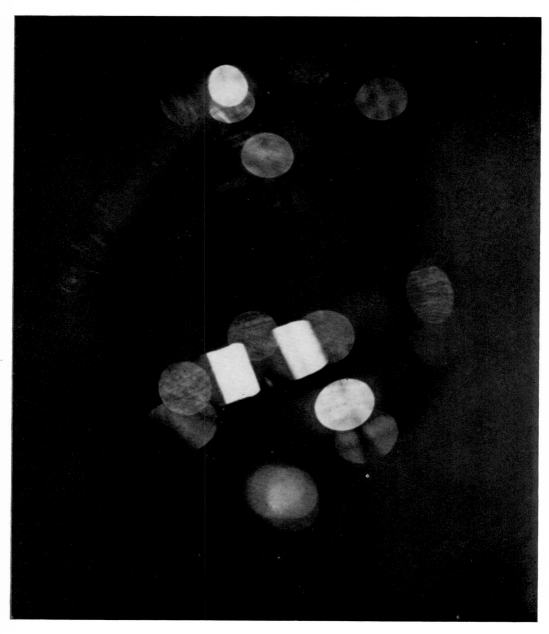

Georges Vantongerloo

No. 228 Segment d'espace 1953

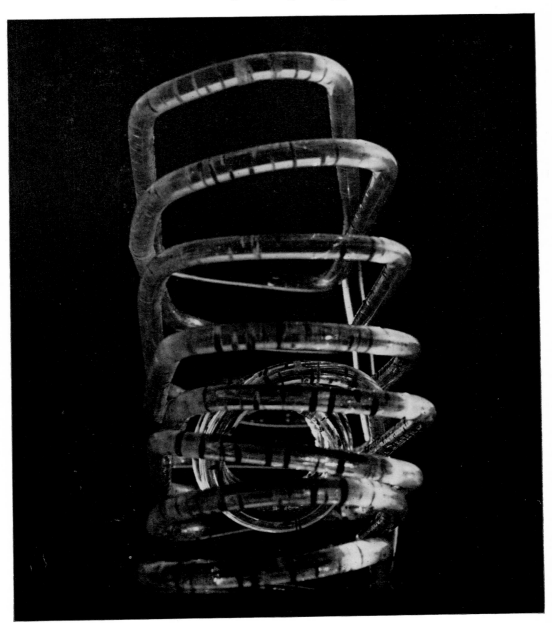

No.228 detail

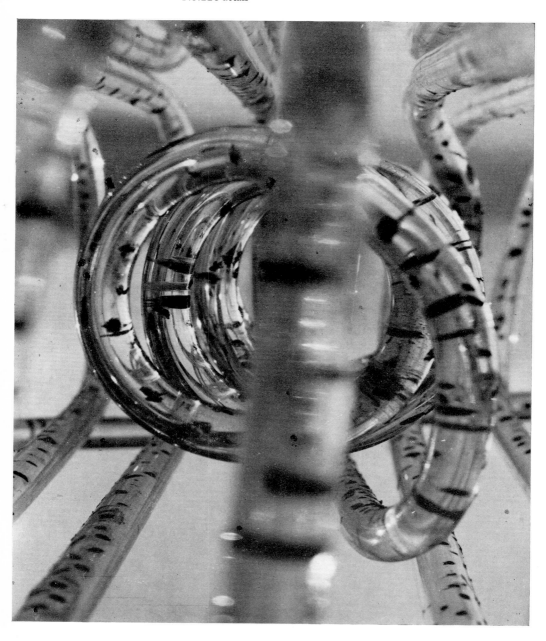

Jean Gorin : Where is pure plastic art leading ?

For some of us the means of expression in our work aims to bring out, as much as possible, permanent and universal plastic values. Our researches are striving towards the realisation of a new plastic unity in architectural space-time. We regard architecture as a homogeneous whole containing a new spatial vision of painting and sculpture; these three elements of expression are closely and inseparably related to the principle of constructive unity. Our works are no longer separated from architecture, as are easel painting and sculpture – those individualist expressions of another age.

As we know, the groundwork for the search towards a new unity of art originated in about 1917 with Theo Van Doesburg and Mondrian. The De Stijl group worked out the fundamental principles, which have fortunately influenced the international movement of modern architecture. Thus the De Stijl group gave birth to a new universal collective art, whose development still continues today, when we are facing a new phase of its evolution in harmony with modern industrial techniques.

So the work of art, as an individual aesthetic object, a picture or a piece of sculpture, no longer has the same function for us that it had in the nineteenth century. Our present aim is to prove, through work constructed with pure plastic elements, the concrete structure of a genuine synthesis of a 'total art', forming a constructive architectural whole, in all the dimensions of space-time, and which reveals to us other non-Euclidian dimensions. The result for the artist is a new spiritual and psychological human state where the individual expressive values no longer look the same, because they are canalised by universal and collective means.

These purely constructive works contain laws and principles with philosophical implications of vital importance for the progress of human culture. These works are no longer a gratuitous aesthetic game, but are a way of expressing our experimental research, a demonstration of the primordial structures of the new plastic architecture in space-time.

We are reaching a stage in human civilisation without historical precedent. Social life has been revolutionised by the machine. The rapid ways of diffusing thought have enlarged the universe and created a new vision of the world. Social life is becoming more collective and impersonal. The contribution of science, the increasingly rich and varied character of matter (elementary particles) as a result of recent discoveries, and the effect on the present form of the dialectic of nature, serve to enrich our cosmic vision from the infinitesimal to the infinitely great. Also, the discovery of laws which govern the whole of our universe, enriching our feeling and our conception of art, the fundamental principles and structure of which sometime rest on the same laws.

Tradition in art has been, and still is today, an obstacle to the understanding of its development. A great many artists still express themselves by these means and with an

outdated conception. Meanwhile, since the advent of the great industrial revolution and the scientific explosion of our time, our conception of life and thought has been overthrown by the discoveries of these last ten years.

Nor can one deny that there is in the world today a major preoccupation with the basic and predominant art, which is architecture, as in all the great epochs of history, although architecture today is no longer thought of as a sentimental or sensory creation, but as a logical and rational structure. We condemn the technical prowess of the engineers, drunk with the formalism which vast technical means have allowed them to attain, and achievements impregnated with an often ambiguous romantic or baroque feeling.

Such an architecture bears no relation at all to the demands of our age, which are for a **style** true, rational, logical and balanced; suited to the new man. Equally, we condemn the whimsical daubings of colour which have been so misused. Our technical and spiritual evolution no longer allows us to accept a few configurations, abstract or not, painted on a wall, without any relation to the architectural function of the wall, such as would be required for monumental painting which was in harmony with the spirit of our time.

A wall is of architectural value, it has no other reason for its existence than its architectural function in relation to another wall, and it is also a surface, a spatial position, a functional plastic colour. It is destroying its constructive value to paint an enlarged picture on this wall, even an abstract one. It is usual nowadays to think of the wall surface itself as a structural value of a whole, a plane of colour which together with another plane of colour forms a necessary constructive and plastic relationship, and which relates back to the overall unity of the construction.

A coloured surface in architectural space gets its *raison d'être* by being determined in relation to another surface, coloured or uncoloured. Each surface-plane must correspond to a precise function in the spatial unity of the whole, composed of positive or negative plastic values, according to the space occupied, the materials and their functions. All these relationships of architectural planes, coloured or uncoloured, are developed in space, creating a new pure plastic unity, a harmonious vision in a space-time which is the kinetics of space. Colour planes in their surface relationship with neutral planes, and different functional materials – steel, aluminium, glass – express the relationship of plastic values with the greatest intensity.

This new architectural technique of plastic space can be applied today in the great complex of modern cities: the residential areas, business, cultural, leisure, and industrial centres. All these groups must be brought into being and based on a new conception of town-planning coming from the overall unity of an organic whole.

The surroundings of tomorrow's world therefore, will be what our

Jean Gorin

joint efforts have made them. Order, harmony, rhythm, are the work of men; chaos is their condemnation. Only the creators of the new pure plastic form, and a few architects, have understood it today.

Despite all this, the human spirit in the world of today is aspiring more and more towards a rational organisation of life. Scientific revolutions, philosophies and techniques are speeding up our evolution towards a new order and balance. Man is being prepared for tomorrow's way of life, in which he will experience surroundings where aesthetic pleasure will not be merely a sensory privilege, it will be an essential collective joy, an emotional and intellectual satisfaction which will achieve lasting harmonious value through a mathematical order.

Our twentieth century must give man a culture and a style worthy of a scientific and rational age. This will be a 'total art' expressing in a new unity the balance of our individual being and its completeness, through universal plastic values.

[1964]

Jean Gorin

Composition spatiale no.6 1964
perspective section of the business city

**Construction plastique dans l'espace temps
émanant de la pyramide** 1947

Jean Gorin

Construction plastique polychromie dans l'espace temps 1953

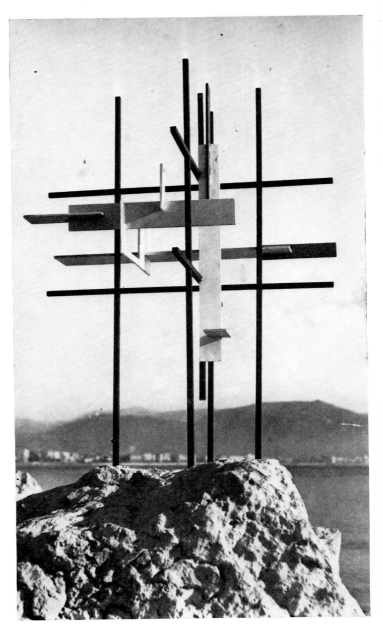

Jean Gorin

**Construction spatiale monumentale pour l'entrée
d'un stade olympique** 1953

Jean Gorin

Composition no.7 1964

Robert le Ricolais : Introduction to the notion of form

The object of this paper is to try to clarify the difficult notion of form, by taking into account some fixed point of reference. As we know, Plato was among the first to give importance to the problem of form but he was more preoccupied with **a static structure of form** than with the more extensive meaning it has today.

Part of our survey will be concerned with a more fluid concept of form, often linked with the parameter of time, and involving motion – which introduces form as we see it into living organisms, the connection between the static and the dynamic being made more comprehensible by the fairly recent introduction of wave mechanics and the understanding of vibratory motion.

At the beginning of last century, Monge (1748–1818), founder of the Ecole Polytechnique, and originator of the laws of orthographic projection, had conceived form to be the boundary of three-dimensional bodies thus limiting his attention to an exterior perception of form.

On the other hand, at about the same time, Karl Friedrich Gauss, the giant of mathematics, had a much more profound concept – he considered form as a pure mathematical entity, having what he called 'intrinsic properties'. This concept is as valid today as it will ever be, and it is accepted today that reality moulds itself, sooner or later, on pure mathematical abstractions.

It is commonly accepted that both in the fields of theoretical or applied physics, mathematics has revealed a fantastic repertoire of forms, and it is both fascinating and disquieting to witness the total abstraction made by scientists from the real nature of things, limiting their role to **a specification and comparison of certain relationships**.

Gauss was the first great architect of mathematics, introducing the art of composition between mathematical symbols: instead of limiting himself, as formerly, to the notion of numbers, he introduced the notion of **groups** and **classes** which came from the results of those compositions.

Despite their virtuosity in handling geometrical problems, the Greeks could never have reached this vision, paralysed as they were by the formalism of the rule and compass. This may be why there is so much artistic bigotry surrounding the so-called 'divine proportion' which is nothing more than a museum piece, a mere collection of dry bones.

Before discussing form, it is of some help to become familiar with Gauss's concept of space. As early as 1816 Gauss had come to the conclusion that the famous Euclidean postulate about two parallel lines meeting at infinity was impossible to demonstrate, and that the

time had come for a new geometry **in which there could be more than one parallel to a straight line passing through a point**. Here we can witness the complete destruction of the Kantian principle of spatial intuition. This discovery was a turning point in mathematical history, showing that reality and mathematics have nothing in common, confirming the saying of Renan; **'everything is fruitful save common sense'**. The extension of Gauss's principles, known as 'intrinsic geometry', was the point of departure for Riemann's theory of the topology of surfaces. What conclusion can we draw? Possibly a certain distrust between truth and the images perceived through our senses. Should we assume that without mathematics the art of architecture is liable to disaster? This I certainly do not believe, but what seems probable is that architecture will follow lines somewhat similar to mathematics, and will gain by raising some questions about the validity of some of its principles, and of the methods used.

It is a common saying that science is a well-made language. To be sure of the opposite, one has only to be confronted with scientific reports, as edited today, exuding an unnecessary pretentious jargon, where incomprehensibility is synonymous with competence.

Our civilisation of so-called specialists is wont to sink into outrageous and meaningless noises if we do not bring some order into this situation. I always ask myself why, in this age of vapid verbalism, we should not return to studying the Rhetoric of the ancients, where instead of words, the composition of words had such an importance in conveying a message in a due style. Just as in a telephone conversation we have to guess the meaning of fifty per cent of the words we use because of the distortion introduced with each word. If we scrutinise the etymology of each word in a conversation we are lost, just as someone not used to a code has to guess the meanings of abbreviations. This confirms the basic attitude of modern man who cannot afford the time involved in thinking. Universities are not immune to this kind of idiocy, which is why they are never willing to explain the meaning of 'environmental studies' and its distinction from non-environmental studies. It is as if one asked for the air temperature, and someone answered that the air is ambient.

In technical jargon also we hear some strange things. I have long wanted to know for example what 'discontinuous compression' is, and also 'tensegrity' and 'synergetics'. It is as well that Molière is not alive, but can we not remember Voltaire, who once said that what is clearly conceived is usually clearly expressed?

In the domain of form, marginal knowledge is dangerous, because we are no longer in the field of literary culture where success is brought about through seduction and charm. Deductions and statements must rest on facts and not intentions: this may be why a certain sort of ascesis should be attempted by the student, following the wise Socratic advice of 'know thyself'.

We have collected a few archetypes of perversion.

The geometrician, thinking in terms of rigid configurations acting more or less as a Procrustean bed – usually as inefficient as the iron-grid pattern of streets in San Francisco.

The pattern maker, the amateur of aesthetic geometry based on repetition in tomtom style. This sort of illness is frequent amongst Space frame makers who wrongly assume that the stresses will follow their contorted minds.

The curvaceous form lover, à la manière de Corbu . . . that sort of illness introduces aerodynamics into perambulators.

The sensationalists or lovers of so-called exciting forms, eg, a pyramid on its apex. The New York fair displayed an aggressive proliferation of these passing stupidities.

The exotic vernacular, of the Zen type, disciple of the tea ceremony in a suburban mass transit.

The organic world observer, who would like to convert caterpillars into monorails and honeycombs into cities.

Structures are nowadays invaded with the notion of shells, and referring to biological observations, we hear a lot about 'the protective action of shells'. Is the rigidity found in animal structure good or bad? It is both.

Does Nature act as a philanthropic agency? Certainly not. This turns to buffoonery when the arts come in. Animal shells are nothing more than solidified excreta formed into more sophisticated beings called vertebrates.

'In a world devoid of finality,' wrote Nietzsche, 'there is no such thing as chance.'

This need for self-analysis is I think important in order to determine with some accuracy our own coefficient of error. For instance, for some well trained ears the frequency of a vibrating string is almost as precise as that given by computation. I know an engraver who can incise a steel plate to a measured accuracy of one-hundredth of a millimetre. Besides, this self-imposed discipline has also some cathartic virtue in helping us to realise the discrepancy between what we really are, and what we think we are.

There is a very simple test, which sometimes works, to determine what I call the 'anthropomorphic coefficient of a student'. Asked to draw a circle he will nearly always mark the centre, which may be a system of construction, but which illustrates **only one** of the many

locus properties of the circle. Unconsciously, he will orientate himself at the centre.

Finalism, which means a final aim for an observed phenomenon, has plagued our scientific systems and theories for centuries. This naive anthropocentric attitude has been at the root of the so-called 'human architecture', or architecture for human beings. Respect for the individual is certainly of great value, but since most of our present problems deal with groups, I am far from convinced of the validity of this dogma. A man has a certain scale, but a man with a motor-car has a different one; they constitute two different entities.

From anthropomorphism to circulation patterns in cities

The distribution of space into four orthogonal directions known as north, south, east and west, is in some respects made in the image of man himself. It also recognises astronomical facts, such as the sun rising in the east.

The discovery of the right angle by the Egyptians certainly gave rise to a new geometrical order, with the much appreciated simplicity of passing from the unit length to the unit area. However, in spite of the practicality of this approach, one may question the validity of introducing a redundant number of points, ie, four, instead of three, to determine a plane. Such a question may yield more results than a formal doctrinaire argument.

A systematic topological analysis of various grid patterns based on the study of intersection numbers for a given area, and a segment of unit length, yields an interesting answer to the bothering problem of circulation. The most interesting theoretical pattern is a semi-regular tessellation of regular hexagons and triangles (trihex).

This configuration enjoys the property of quite considerably reducing the intersection number, compared to a grid-iron type. As an example for a ten block agglomeration, the trihex grid would yield 18.2 per cent less intersections. Among many other interesting features, the trihex grid gives a circulation along straight lines, and ease for a weaving pattern.

This semi-regular partition of urban space creates a new order of circulation and a much-needed differentiation between individual and civic activities.

Forms and structures are the consequences but are not the origin of life

Forms and structures are the consequences of the everlasting work of evolution working through a chain of secondary actions.

The French zoologist Frédéric Houssaye, of the kinetist school, gives the diagram:

Force → Motion → Forms

In this simplified but already formidably complex statement the time factor is not taken into consideration, and time is an all-important factor in the origin of species.

Here we can make an important comment on the different values of absolute and relative time. The human appreciation of time introduces an anthropomorphic error, which results in the comparison of time with distances, or distances between events. This is pure conjecture. Time indeed has no reality save in the instant – the instant suspended between two nothingnesses: the past and the future. This idea, involving the concept of discontinuity, has in recent decades become familiar to us through quantum physics. This is why we should not be surprised to hear philosophers speak of the 'granular nature of time'.

In some ways this concept helps us to understand that chance is at the root of all evolution. We can thus refute the childish idea of **progress associated with repetition**.

The uncertainty of the present age, as well as the violent behaviour of groups or individuals, is witnessed in the reaction to an idea of progress contaminated by anthropomorphism, and the dream of an everlasting life.

The most simple approach towards a definition of form is to study the influence of forces on solids of various shapes. This study covers the field of 'statics', which by itself is already a formidable enterprise, together with the strength of materials. By virtue of a paradox, the notion of matter requires a greater power of abstraction than the concept of any divine power. Under the pressure of technological problems great steps have been taken, but much remains to be

done, especially in the study of structural failures. But this aspect of forms is too specialised to be discussed here.

In the course of the last century the study of crystal patterns, expounded by Bravais, gave rise to ⌐ new discipline known as crystallography, illustrated by the geometry of space networks, and giving some powerful indications of the architecture of matter and its automorphic properties, automorphism being the strict conditions of a given geometrical repetition. We have endeavoured to show that some relatively easy topological transformations yielded the diagram of stresses, which is also automorphic, under given conditions of exterior constraint. This, of course, is the extension of graphic statics to the study of networks. Crystallography has, I think, framed a new concept of order and raised fruitful questions about the hypothetical geometry of space resulting from the so-called 'space-filling conditions'. Such knowledge is valuable for the industry of metallurgy, since we have long known that world power is invested in those with the best weapons, ie, those who know how to make the best steel.

The rigorous mathematical conditions of space-filling were admirably summed up at the end of the last century by Lord Kelvin. This was in his famous report to The Royal Society, on 'Homogeneous partition of space', leading to a semiregular polyhedron, having 14 faces, eight hexagonal, six square, 24 vertices and 36 edges since known as the tetrakaidecahedron. This momentous contribution was, I think, the greatest made to geometry since Plato's discovery of the five platonic solids the tetrahedron, the octahedron, the cube, the icosahedron and the dodadecahedron.

Furthermore, it involves the notion of pulsating functions which form the basis of the study of vibration. In the course of the seventeenth century, through the help of analytical and differential geometry, the mathematician Lagrange had speculated on the existence of 'minimal surfaces', ie, surfaces for which the algebraic sum of the two curvatures is 0 (if we define curvature as the reciprocal of the radii of curvature), giving minimal properties, or minimum volume for a given surface. Such surfaces were to be seen in the action of soap-films, as shown by Plateau's experiments in capillarity. Among many other proofs, this illustrates the predictive power of mathematics. As expressed by Poincaré: 'There is more intelligence in the behaviour of soap-films than man's imagination can conceive.' In the quest for scientific discoveries, observation should be the companion of intuition.

The introduction of the time parameter into mechanics, starting with the pendular laws, discovered by Galileo, opened in a triumphal way one of the greatest recent achievements of our civilisation; wave-mechanics. This could have been and probably was perceived

in the past by some receptive minds, such as that of Pythagora but in their time the mathematical tools necessary were not available.

I am certain that the history of science is a prerequisite to the study of forms.

To trace, as historians do, the place, the name, and the date of memorable inventions, seems to me of little value or importance. But I am convinced that in modern courses on wave-mechanics not to study the steps taken in sequence of time is a crucial error. In my own view it is a waste of time to integrate differential equations **before** seeing the vibration of a string, and giving some experimental demonstrations of the chapter of science known as acoustics, a subject more or less ignored in curricula today. The history of science is not the history of scientists, but what is of importance is the controversy between concepts and their emergent changes in the course of the evolution of knowledge. At least, such an approach would help the student to understand that as theories become superseded, only facts remain, and it is the simple collection of facts that makes the best contribution to science.

Forms and vibrations

The image of a vibration, or more precisely the amplitude in terms of time, as is well known, is given by a sine curve, the distance between two crests gives the period T, or the length of time taken by the propagation, λ being the wave length, v, the velocity of propagation. We have:

$$\lambda = .T \text{ or } v = \lambda : T = \lambda.N$$

N, being $1/T$, and named the frequency expressed in periods per second.

This frequency varies according to the form of the vibrating element, which may be a string, a rod, a membrane or a solid plate. For some problems it is important to determine this frequency, to avoid the case of resonance which may entail the collapse of the structure.

Two perpendicular kinds of vibration can take place. There are longitudinal or axial vibrations, such as we see in a coiled spring, where successive condensation and expansion occurs, and there are transversal vibrations, associated with a dynamic deflection of the spring. The velocity of propagation in the spring varies with the material, more exactly in terms of the Young, or elasticity modulus, and also of the density of the material, following the relationship:

$$v = \sqrt{Eg : w}$$

For steel, $v = 5 \cdot 400$ meters per second, approx 17,750 feet/sec. It is interesting to notice that the velocity of sound, which governs aero and thermodynamics, also concerns the transmission of sensory perception.

Another remark can also be made. If we take time as a parameter, the theory of elasticity collapses, because this theory is founded on the limited hypothesis of very small deformations, and when large deformations take place the elastic deformation is accompanied by many other phenomena. It was puzzling for the acoustician Savart to realise that the large elongations resulting from longitudinal vibrations were independent of the **section area** of the vibrating rod. It is less surprising if one considers the time taken by the rhythmic impulse. As an example, a small child can ring a bell of considerable weight, and there is no relationship between the weight of the bell and the weight of the child.

The stresses due to vibrations involving elongations much greater than the tensile stresses are witnessed in musical instruments calling for a frequent tuning up of the chord. Such phenomena are of importance in highly stressed tension structures, and clearly indicate the necessity of damping those vibrations.

As far as pure form is concerned, any corrugated sheet of metal will give an idea of what we call an automorphic shape, which reproduces itself with periodicity. The modulus of inertia expresses this periodicity by the coefficient involving periodic cycles.

The search for an optimum design for columns, which we call automorphic tubes, is an example of how the study of vibrations may lead to the creation of new forms. The scheme consisted of splitting the fundamental into its harmonics, by means of an adequate triangulation, in such a way as to avoid buckling if the same weight of metal had been used in a thin axially-loaded tube.

When a light powder such as balsa wood sawdust is spread on a vibrating membrane very interesting configurations are obtained, known as 'nodal' configurations. They clearly indicate zones of amplitude or hinges of vibrations. These nodal configurations form orthogonal networks, or sets of radial and peripheral configurations. Thus we can ascertain from the nodal position a given frequency, which can be a determinant of form.

We met this problem in an advanced design for a radar dish, consisting of an extremely thin aluminium membrane stretched on a circular frame, and for which the segment of the spherical profile was obtained by creating a vacuum.

The complexity of the physical world that surrounds us is demonstrated by some phenomena classified under the term capillarity. They exemplify very well the difference between the small and the large, and their study has considerably enriched the notion of form, since in the living world many small animals and organisms display this worm-like appearance,

especially in the class of the flagellata. As mentioned earlier, following Plateau's experiments, mathematicians developed in a systematic way and in their own characteristic style, a classification of those curves known as 'elastic curves', of which we show some examples:

The curious variations of shape of these curves result from the indeterminacy of the curvature radius sign.

Practical applications of these forms may be of interest. We can see some application in liquid tanks, calculated in accordance with this theory.

The importance of reducing to a minimum the radii of curvature and yet obtaining a given capacity for tanks working under tension, suggested to us a composition of curvature along an economic pattern. This technique still awaits practical application.

Independently of the practical side, these phenomena generate cohesive forces or mutual attractions acting with great intensity at a very short distance, but falling rapidly as the distance increases. Such action, for a given range which is very small, is still very great compared with intra-molecular distances. This action is explained as superficial energy.

It appears that in the interior of a liquid there exists a certain intrinsic pressure which is superposed above the hydrodynamic.

From the primitive canoe to the rocket, the relationship between motion and form covers admirable examples of man's ingenuity. This is too wide a field to be covered by this brief essay: and we will limit ourselves to considerations of a general character.

As we have seen, the mathematical language and its symbols have been and **will always be** an enormous reservoir of unexploited forms. It is a rule that abstract concepts devised purely for the support of thought, have later found their due place in the vocabulary of applied science by virtue of the power of abstraction and the **non-anthropomorphic** attitude of the mind before the unknown.

Probably magic and poetry in ancient time had the same power. Form is often confused with the objects we see and touch or hold in our hands. For a child the discovery of water is an unforgettable experience.

In order to control the art of flying, man had many more things to do than to fix a pair of artificial wings on his back. It is the character of air-flow that formed the shapes of aeroplanes. From the negative actions of curls and eddies a creative design was produced enabling man to leave the ground. One has to follow the laws of nature before commanding nature.

How deeply can man comprehend nature, with its multi-million scales and its interlocking combinations of actions? As has been remarked by Eddington, there is no confusion possible between natural and man-made objects. The latter are single purposed, while nature is capable of fulfilling many requirements which are not always clear to our minds.

Unmistakably life equates forms, but as we have seen the reciprocal is not true.

Together with life comes the problem of growth, and until now man has not been capable of making machines that grow. It may very well be that before solving the problem of form, man has to create life in an artificial fashion. To accomplish this, man has a long way to go yet beyond the visible and the understandable – which, of course does not mean the impossible.

[1966]

Richard P. Lohse : Elementarism . Series . Modulus

Serial and modular structures characterise the laws of design of our time. In order to give an idea of the scope and the principles of the new formal problems to be solved it is necessary to start from the first examples of tectonic and structural form.

The tectonics of planes and lines of De Stijl are particularly suitable for demonstrating the development from elementarism to serial and modular principles.

A characteristic feature of De Stijl structure is the use of straight lines, squares and rectangles of differing sizes. The pictorial elements are arranged parallel to the edges of the picture. These elements and the outside edges of the picture plane together make a structural whole. Thus the limits of the picture plane become an integral part of the formal picture. This was the first step towards a synthesis of pictorial elements, pictorial content and picture plane, and a working basis was established which formed the premise for a further step towards today's problems. This new principle must be regarded as one of the most important events in the history of art, which subsequently had far-reaching effects.

It was not the intention of the initial creators of constructivism to carry out a systematic analysis of the lapidary tectonics of the straight line, the square, the rectangle and colours, or to attempt a consistent unification of the pictorial elements and a regulated sequence of colours. The magnificent primitive expression of these pictorial tectonics essentially derives from lapidary emotional forces. Only in certain cases can a methodical intent towards the concentration and systematisation of pictorial elements be discerned. Consistent unification reveals itself only as a result of an empirical method. Measurements in these works show differentiations, discrepancies in the number and dimensions of the pictorial elements as well as of colour values; the result is an organisation aiming at pictorial equilibrium. The creative method remains in fact, intuitive.

While the content and picture plane fundamentally form a structural whole, the form vocabulary and the design method are theoretically opposed to each other. This symbolises the situation unequivocally. Geometrical and tectonic elements form the bases of the picture, but the method of design is diametrically opposed to the geometrical principle. Lines, squares, rectangles basically stand for system, measurement, standardisation, logical construction, while the method of working can be termed elementary. This analysis reveals the conflict between pictorial element and design method. Elementarism corresponds to a principle of design which in the main is determined irrationally.

The exceptions confirm the general situation: Mondrian in **Draught board** 1919, van der Leck in **Composition** 1917, Doesburg in **Composition** 1918, Vantongerloo in **Interrelation des masses** 1919. Distinctive (separate) elements and a non-systematic design method are the rule. The formal elements are the aesthetic expression of a basic philosophy: they

represent purification, rejection of the traditional attitude to form which aims at absolute harmony of absolute form. Forms are interrelated on the basis of the different values given to elements. The design evolves on the principle of domination and subordination, principal and ancillary values are selected on the basis of a pictorial principle that may be called hierarchical; in accordance with the awareness of the message to be conveyed, the formal construction has a fundamentally authoritarian character. The formal structure is reflected in the selection of the primary colours which are essentially monumental, ie, architectural colours, and aim at an absolute statement.

This manifesto of a philosophy executed on a two-dimensional level could not be confined to the picture, but necessarily urged towards realisation in the environment. The aesthetic principles are as it were symbols and lodestars of a discipline to be attained in actual life. Thus we arrive at a decisive situation with regard to De Stijl, its philosophy and its intentions. The aesthetic organisation was to have its equivalent in relation to human existence, elementarism logically had to find expression in the environment. Architecture was the immediate and logical counterpart of aesthetic tectonics, as seen in a programme of idea. The thesis 'from art to architecture' contains the commitment to a magnificent spiritual and social utopia.

This was in essence the philosophical background of the De Stijl movement in which religious and social aspects combined, legitimately comparable with the most important ancient civilisations. Every archaic method combines both grandeur and restraint.

Chronological survey of the development towards the systematisation of pictorial elements

De Stijl

In the years 1910–12 the departure from figuration begins in Mondrian's **Tree**. The construction of the picture develops analogously with cubist form-elements by means of horizontal, vertical, diagonal and semi-circular structures. In **Sea** 1913–15 all semi-circular and diagonal elements, the last traces of figuration, are gradually eliminated. It was then for the first time that pictorial elements and the limits of the picture plane became identified. Horizontal and vertical elements were arranged freely and rhythmically over the surface. Around 1917–18 two structures came to the fore: the elementary tectonics of squares and rectangles (Mondrian/ Doesburg), and the free horizontal/vertical rhythm of rectangular shapes of different dimensions (Van der Leck). In both forms of expression the pictorial elements and the limits of the picture plane are orthogonal, and the sizes of the pictorial elements are similar. The structure of square and

Richard P. Lohse

rectangular areas briefly culminates in the austere patterns of the draughtboard and lozenge pictures of around 1918–19 (Mondrian). There is a certain congruence in the pictorial concept of the works by Mondrian and Doesburg. For some time a pattern of rectangles of identical dimensions formed the basis of the vertical and horizontal structures. Tendencies towards the additive, towards measurable form-values, and towards standardisation are discernible. From this point onward, analogously with the interruption of any further development of analytical cubism, no analysis or further pursuit of this position takes place, the era of structural equilibrium of thick lines and areas begins (Mondrian).

In the context of this development, mention must be made of a significant work by van Doesburg, **Rhythm of a Russian dancer** 1918 in which the relations between the elements are remarkably equalised. Vantongerloo's achievements in the interrelations of plastic volumes are particularly important.

Suprematism

Simultaneously with Mondrian's paintings **Sea** and **Pier and ocean**, Malevich introduced the principle of additive elements into painting and sculpture in 1914–15. As for the painters of De Stijl, analytical cubism is the starting point of suprematism. Analogously with this development, the semicircular elements are gradually eliminated in order to evolve a form vocabulary of differentiated right-angled elements and lines. In contradistinction to the rectangular rhythmical and static principle of De Stijl, the diagonal is used to introduce the dynamic principle. In suprematism the pictorial elements express energy: combined into groups, they represent speed and movement: the picture plane becomes a field of forces: the elements, an expression of mutually penetrating flows of energy. Superimposition of the elements lends them spatial aspects, giving the picture plane an appearance of depth.

The result of the analysis may be summarised as follows:

In De Stijl:
1. Elimination of the semicircular and diagonal figurative elements;
2. Horizontal and vertical rhythm;
3. Identity of pictorial elements and limits of the picture plane;
4. Anonymity of pictorial elements;
5. Tendency towards the standardisation of the size of pictorial elements;
6. Tendency towards the making of groups of elements by the additive principle;

60

Richard P. Lohse

7. Wholly two-dimensional character of the picture plane.

In suprematism:
1. Elimination of semicircular figurative elements;
2. Diagonal rhythm;
3. Counterpoising of pictorial elements and the limits of the picture plane;
4. Anonymity of pictorial elements;
5. Tendency towards standardisation of the sizes of the pictorial elements;
6. Tendency towards additive group formation;
7. Tendency towards giving three-dimension quality to the picture.

The following basic similarities are found to exist between De Stijl and the suprematist compositions:
Anonymity of pictorial elements;
Tendency towards similarity of dimensions of the pictorial elements;
Tendency towards additive group formation.

Serial and modular principles of design (1943-65)

The prerequisite for a development of serial methods of design is the anonymity of the pictorial elements, and the rectangular identity of pictorial elements and picture surface. This is the basis of the systematic structures of serial and modular constructions, of synthetic groups.

The first step towards the formation of systematised groups is made by using standardised elements of identical dimension and at the same angle. Combined into free groups, the standardised elements mutually enter into opposition and become active carriers of energy.

An objective rhythm on the basis of progressive and regressive movement develops. Just as the individual pictorial element in de Stijl and suprematism still had a primary share in picture construction, so now groups of differentiated sizes assume the function of this individual element. The combination of systematised elements into groups provides a new pictorial principle. In opposition to other groups, it sets up a multiplied rhythmical force of motion.

In the course of development, groups come into being with a predetermined number of colours so fixed in a system of co-ordinates that no colour is duplicated hori-

zontally and vertically within the ordinate network. This was how the systematic series was created. The principle so evolved enables the operation of differentiated groups of different sizes, sequences and colour constellations which are in a mutually complementary and interpenetrating relationship, while all colours are present in equal quantities. Chromatic progression provides the law for formal expression. Further extension of the system is unlimited. (**Thirty systematic series of shades**.)

Connected with this is the problem of colour dispersal. Starting with primary colours, a group is developed by combinations of several colours, or by reduction.

In applying methods of colour combination, multiple colour sequences are created. These in turn are governed by group systems, which make it possible to modify the relationships between the dimensions of the units and the colour values within any group.

Problems of formal development are closely connected with the organisation of colour. To connect growing sequences of colours and forms is one of the essential tasks of serial and modular construction. (**Symmetrical groups with the same number of colours**.) Continuously developing colour groups, in a vertical series, create a diagonal movement. The whole complex of serialisation provides vast kinetic possibilities, as well as possibilities of developing systems which are combined in ever new original groups of motion, or alternatively form-closed synthetic constellations.

The problem of progressive colour groups becomes significant in the establishment of group systems. Starting from the smallest group, a progressive operation is performed. Pictorial organisation is effected by a fixed number of continuously growing groups. (**Systematically ordered colour groups**.)

A modular construction may be made on the basis of horizontal and vertical rotation of a form structure until the basic theme can be established that permits of thematic operations. The flexibility of the basic theme enables the sub-themes to be created; the introduction of intervals rhythmically articulates the theme. The problem of the basic theme, of the schematic basis, is solved by a dynamically effective principle of operation. All elements within each of the themes, similar formally and dimensionally, are given a chromatic organisation differing from all other themes, while the principle of quantitative equality of all colours is at the same time maintained.

In modular constructions the movement of asymmetrically organised and progressively developing groups within a symmetrical system has particular strength. Differentiated magnitudes form a basic group 1. Penetrating the same, further groups 1a, 1b, 1c are formed in growing progression. The same operation is performed with further progressively dimensioned colour groups until a complex and at the same time flexible order is obtained. This asymmetrical modular construction comprising eighty elements is combined with a second modulus holding sixty-

four elements. (**Sixteen progressively asymmetrical colour groups within a symmetrical system**.)

The visual change in the quantitative equality of colours is essentially a problem of the division and interrelation of the pictorial elements. Dynamic situations arise if a determined quantity of squares are subdivided into the progressive proportions 1, 2 and 3. Six horizontal bands made up of six squares are subdivided in the proportions 1, 3, 2. Each horizontal band is similar in respect of colour quantity, while the sequence of formal constellations and colours is at the same time different. The additive system changes in the course of operations into a dynamic expression; none of the horizontal bands is similar in the sequence of its colours. Each horizontal band forms a new rhythmically differentiated pictorial system. (**Six horizontal bands of six formally similar colour groups**.)

The pictorial processes described here may be taken as examples of the new constructional principles. The problems have moved, from the experimental stage to one of growing complexity and diversification. The difficulties in the development of serial and modular constructions lay in the necessity for method and product to be evolved at the same time. The complexity of the task demanded that method and result form a fundamental unit from the very outset. The difference between the lapidary and elementary working methods of early constructivism and the methods described here is evident. While the geometrising or mathematising working basis undergoes a variety of modifications in the course of the working process in early constructivism, and the pictorial result is entirely different from the starting basis, in the new construction the method and the picture are inseparable.

The essential new task in art and in architecture is the creation of flexible modular systems which are variable within a certain frame of reference, permitting diverse operations, and allowing for the expanding of the formation of structures, interacting within the framework of their system. Serial and modular structures will be the law of construction of our era, and our task will be to master these systems. Behind us is the homeland of the soundly joined tectonics of simple relationships and proportions. Before us, the field of infinite law and infinite flexibility.

[1966]

63

Richard P. Lohse

Thirty systematic series of shades 1950–55

Richard P. Lohse

Six horizontal bands of six formally similar colour groups 1950–51

Richard P. Lohse

Symmetrical groups with the same colour number 1955–61

Richard P. Lohse

16 progressive asymmetrical colour groups within a symmetrical system 1956–62–66

Kenneth Martin : Movement and expression

The kinetic nature of art is a correspondence with that of life. The word kinetic is here used to embrace the motion of making, movement as a compositional or constructing process, depicted motion and actual motion. Although the principles are always the same, each epoch has its own 'kineticism' in which, finding its own path, it exploits its own discoveries. Understanding and expression change. In the study of the history of art from a kinetic viewpoint the consideration of the relationship between event and expression would be more important than to make an attempt at an evolutionary theory, which so often results in false history: though inevitably development and evolution, related as they are to the growth and decline of awareness and experience, would play their important role. Works should be looked at with as great a freedom as possible from theory and one's own conventionalism. But the correspondences between, on the one hand, movement and change in all the circumstances of life and, on the other, the means and object of expression in art, should be sought and observed. Rotational symmetry, based on the study of and feeling for reality, is to be found throughout art as simple mechanical intuitive expression, as in primitive ornament, or as a complex symbolic construct for the passing of life, as in the **Courtyard of a Dutch house** by De Hooch in the National Gallery. Repetitive pattern, meander, the journey in the landscape painting, are all related. It is the plastic nature of these relationships, the depths of their meanings and the discoveries to be made of their prime sources, through the study of these, which are of interest. Composition is to be seen as the means of expression by kinetic equivalents for the conscious and unconscious organism of man, just as was the first drawing of a line to make an enclosed space.

Signs and symbols have an organic – kinetic origin. Born of events and growing through their cumulation, they decline in power through saturation or neglect, and are born again from the primitive source or gain fresh life through transplantation or fusion. Abstract painting, where there is an insistence on the absolute reality of the marks made and of their interrelation, has shown fresh mastery of the power of the right-angle, the diagonal, simple or complex rhythms and so forth, that belong to the primitive sources of the symbol. The nature of the power of forms and colours, directions and rhythms, what they derive from (their relation to the structure of man) and how free they ever are from associations (from the present, the past and the distant past) is a matter for consideration.

Further to my definition of kinetic with regard to the work of art, it has become customary at the present time to consider as kinetic, in the precise dynamic sense, only works which actually move, or by enlarging the scope of the definition, those which are designed to change with the movement of the spectator, both of these having an actual time factor. Also, the term has been given to still works which, by intent, affect the eyes with the sensations of actual movement However, to give to all other works the designation of static is obviously incorrect. This would reveal

an ignorance of the nature of art as a whole, as well as that of the mobile work. We can of course take the reverse attitude and say that nothing is static, but we must accept the phenomenal meaning. Static and kinetic are tied together in works of art as in ourselves, much as sound and silence are in music (and here the sound can have a static quality and the silence a kinetic one).

There are two groups of work in which I am interested here.

a. Moving construction, sculpture or picture (abstract). With change of speed, change of direction, harmony and contrast of rhythms, contrast of movement and stillness. Using the fundamental forms of movement: translation, rotation, twist, expansion and contraction. (In appearance a rotation might seem to be a shrinking and expanding and so forth.)

Arousing awareness by movement. Involving the spectator with and through movement.

b. Abstract work consciously constructed of and expressing movement. In which the fundamental kinds of motions are used, with change of movement, change of rhythms, etc, but actual movement does not take place.

Anyone who is concerned with movement is also concerned with stillness, and works with their interplay. A character of movement can be nullified by movement, as with the spinning top which appears still until its speed diminishes. Character of form can be changed through motion. It is change, our perception of change, which is the lively element.

My interest in movement, which led me to learn and work with the principles of kinetics, led me to perceive their pervading character in the world around and in thought, in the manifestations of nature, in human activity and the human spirit, and to begin to comprehend their nature in my own special subject, the work of art. In such a large field construction is invaluable. Even allowing for the slow discovery of this field, it is necessary to have a method to unite technique with thought, for in fact, as is natural, discoveries and method grow together. For me construction, which has kinetic attributes, is a series of ordered and related acts consciously executed. It is a limiting activity since each act defines all the possibilities within it and so governs choice. However, even if choice is confined to either/or, a few of the decisions necessary lead to diversity and complexity. Empiricism and intuition enter into the work in the choosing of the act, and clear understanding may follow. It is not the only or most correct way of making a work of art, but each act or series of acts may be seen to have affinity with a whole order of events outside the work, which may therefore become both personal and universal.

To begin by isolating fundamentals of motion – rotation, oscillation – and then to use them in combination, is to start not only from a beginning of forms but likewise of symbols. Also, whatever sensations are employed or achieved, rhythm plays a major role, so that the

fundamental attributes of movement and the nature of rhythms are of the first consideration.

I have worked with the primary kinds of movement and with material that enabled me to do so. This consideration has governed my choice of materials. Each element joined to the next is real and has real characteristics. As one works, all take on the power of the concept and become inseparable from it. In constructing these works movement for me is the relationship of one element to the next and to the next, a rhythmic sequence. In works formed by rotation I have been able to express all the fundamental forms of movement within severely limited bounds. It is an interest in number and in rhythm series, and in breaking and contrasting the latter, which has led me to make still, standing works. Seeking to produce the indivisible, one sees the character obtained and knows the means whereby the result came about. Reorganise the means or, through imagination and experience, bring into the structure of means another factor, and a new work can have a new sought-for character. One is working with forces in a space/time fabric although the work is still. The character of these forces is subjected to the control of a rhythmic sequence, itself a force, which despite its severity [and because of it] is capable of variety. There is harmony, or one part exerts its will over another, renders it subject, and then the situation is reversed differently. A dialogue, a conversation, discussion or argument, chance meeting or surprise; much can take place within a field of monotony.

Such kinetic building leads one to the consideration of the form produced, and to the nature of fundamental forms. The process of a kinetic construction is in essence a reversal of the methods employed by such academies as that of David, in whose compositions were fused together a selection from a stock of movements, each with its own significant meaning. Nor do its elementary forms or figures have the certainty of meaning and symbolism which their circles and pentagons had for the Renaissance perspective constructors. It starts with no meaning, only material and movement, but builds towards it through, so to speak, its own inherent discoveries.

Forms have a power over us of which we may be conscious or unconscious. They exert this through their appearance, scale, mass, usage, etc, by their relationship in space and time with us and with each other, and by their affinities. Ball, cup, box, tunnel, wall and spiral are examples of such fundamental forms that are to be observed in many different aspects. Through their universality they have their subjective counterparts. And such is the nature of the power they exert that they take on symbolic characters, just as marks through a similar process become signs. In such a kind of construction of the work of art one has movement, sign, form, or to try to give a clear example, the square (sign) comes into being through movement – there are a variety of origins and motions through which that can occur. And the movement of the square can produce a resultant box (form). Further movement can nullify or cloud character, or effect a clear metamorphosis. The movement of the observer can produce a change of sign for him and a change of appearance of form. This is primi-

tive but that is my intent. The square is not only sign but form, the box not only form but sign, and both can have the nature of symbols. Complexity exists within the simple.

To be interested in the kinetic is to be consciously interested in sensation as such, and this gives fresh power to forms and the formal, for not only is form-making a corollary of movement, but so are sensation and feeling. The combination of these as products of motion has further to be explored.

[1966]

Kenneth Martin

Screw mobile 1959

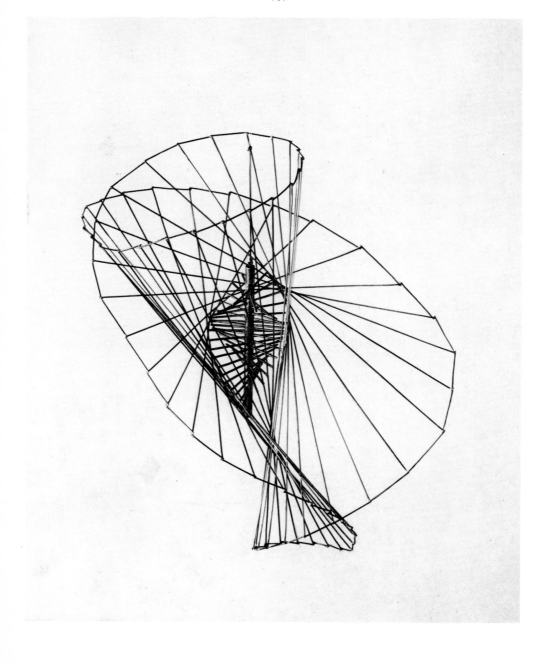

Kenneth Martin

Screw mobile (second version)　1964

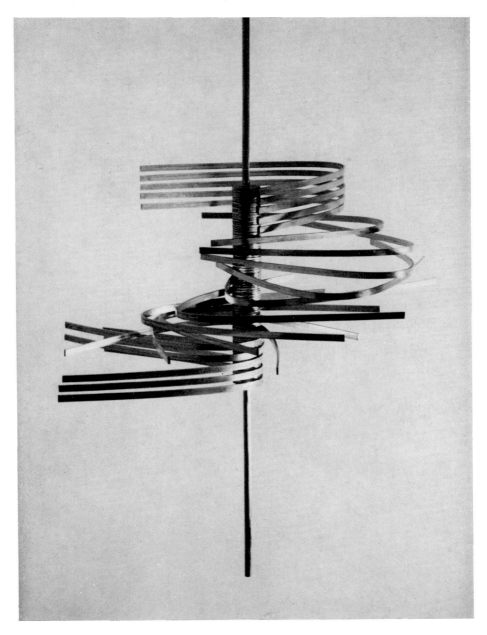

Kenneth Martin

Oscillation 1964

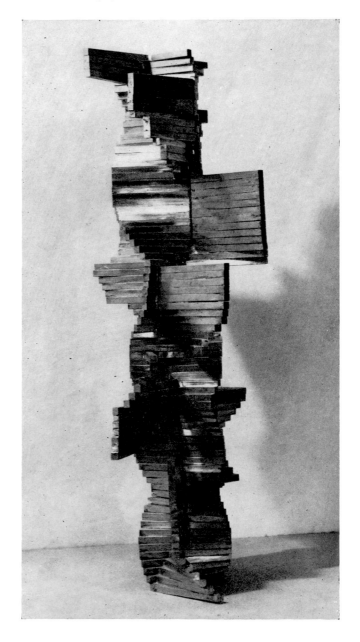

Kenneth Martin

Linear construction 1964

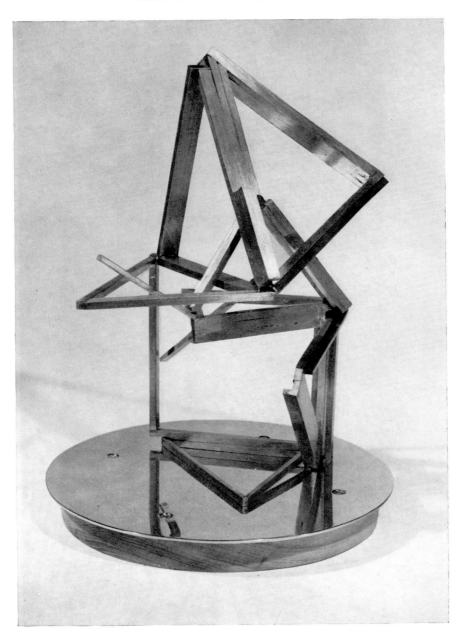

Charles Biederman : Dialogue II. Creative or conditioned vision

On the walls are seen a number of paintings from the 'realistic' period of the nineteenth century, as well as from post-realist times. There are also examples of non-mimetic, non-painting art. At this point the discussion has turned to the act of sight as this relates to the general problem of art.

'In your view, then, to see art is not an automatic function of the eyes?'

'That is impossible because our vision is not a kind of perfected machine. Numerous studies of the infant and the congenitally blind who gained sight, all clearly reveal that vision (like reasoning) is the result of an orderly learning process. We are no more born with a developed vision than with developed speech.'

'What kind of vision would you say we are born with?'

'Just as the infant is born only with the capacity to make a general sound, so it is probable that he is born only with the capacity to respond to the presence or absence of light. **The light variables of the image remain largely undifferentiated**. Only when the infant begins the process of abstraction from the various sensory sources of experience, does a structural differentiation of the **light as an image** begin. Through these abstractions the infant relates the various light differentials of the image as these correspond to experiences between himself and the outer world. Thus evolves the **building up of the image**, which continues until some kind of visual gestalt is realised.'

'Do you mean that our vision is then properly developed for its various uses?'

'For ordinary purposes, yes. For **all important** purposes, no.'

'Have we not finally learned to see in an intelligible way?'

'In a certain limited sense we have. But it is just at the very point where we begin to achieve this facility with the use of images, that we also make a false assumption. This happens to be indicated by the term "finally" which you have just used in your question. That is, we assume vision has reached its **ultimate development. Such a development will always remain unattainable**.'

'Would you be more specific?'

'As our discussion develops I hope gradually to form a reply to your question. For the moment consider this. Nothing we see is ever identical with anything else we see.

76

Nothing is even identical with itself, from one moment to the next. Change is constant in everything, **above all in ourselves who are the perceivers of change**. The universe is a ceaseless movement of creation. To be in harmony with it, our vision must also be ceaselessly creative.'

'Could you give an example of these problems as they operate in art?'

'Take that of the art student drawing the human form for the first time. He quickly realises the cursory, naive quality of his visual development. His images cease to be the dependable gestalt of the past. Vision breaks down, becomes fragmented and confused before the new image-demands of art which his vision cannot meet.'

'Why confused? Why doesn't vision simply proceed smoothly to newer developments?'

'We unconsciously assume, as already noted, that our vision reaches some "final" or "ultimate" development. It is the prolonged maintenance of this **visual attitude** that leads to confusion. Vision becomes a **habit** closed off within a limited function. The **dynamic visual development** of the early years of life, when the world and ourselves were always unfolding anew, the period of **creative vision**, has been replaced by its contrary, the **mechanical vision** of habit. Consequently, we only see largely what we have always seen : that is, a kind of visual memory is mechanically imposed upon our response to what is actually always a new, unique image. It is the conditioning which breaks down, and becomes confused, the moment this mechanical vision confronts the creative visual demands of art.'

'What do you mean by "creative demands"? Do you imply that the mimetic period of art was creative?'

'Most certainly. When the mimetic artist is truly creative he always sees deeper into **his perception of nature's reality**, which is then incorporated into the formation of his art. Take for example the difference between Giotto and Leonardo. While both artists were mimetically creative, the latter continued to a deeper creative perception of nature's actualities. As with the child, creative vision responds to the world as always new. This, in turn, permits the continued development of our creative capacities. In short, **the more deeply we perceive the reality of nature and ourselves, the more deeply we perceive the reality of creation**.'

'Is it your view that in all past times vision would reach a certain creative development and then become conditioned?'

'More or less, and art offers the most reliable evidence for understanding this problem. At first a stage of visual conditioning probably lasted for thousands of years, later only for hundreds: more recently visual changes have taken place within the life-time of an artist. Vision always reaches a higher development, however, before conditioning sets in. This play between creative and conditioned vision is relative. For the overriding conditioning, the one that remains constant and the one that concerns our discussion the most, is the **general conditioning of human vision to mimeticism**.'

'Are you suggesting that we, who live in these times of so much art innovation, remain in the crisis of mimesis?'

'That is correct. This is difficult to see because the conditioning of mimesis is no longer present in as obvious a form as in the past. First, let us note this. In the last century artists as painters reached the highest degree of realistic perception that has ever been achieved. Such an overpowering sensation of realism was experienced from these art-images, that it was supposed the ultimate in realistic development has been realised. Such beliefs, however, were by no means new. When Dante first saw Giotto's art, he exclaimed that the ultimate in realism had been secured. Today we know how very far from the truth he was. In any case, not only was the realism of the late nineteenth century remarkable, but a tremendous impetus was given to realism by still another remarkable achievement – the perfection of a mechanical instrument, the camera. Following on these events a crisis developed, deeply affecting the further maintenance of mimetic visual conditioning. On the one hand, artists were conditioned by some 50,000 years of mimetic vision and, on the other, already in the late nineteenth century, art began to undergo its first really fundamental visual change. It is the clash between these two events that needs to be deeply explored. Constant, unresolved conflict over the past fifty years, as to whether art is to be "figurative" or "non-figurative", clearly indicates the presence and character of the crisis.'

'To what fundamental change are you referring?'

'The change from the imitation of art-objects created by nature, to art-objects that are the unique creation of man. And now that the transition from the old to the new vision has long been completed, it becomes possible to construct a spectrum which will allow an orderly understanding of the principal **conditioned visions** that characterise modern art. This spectrum will have two poles, each of which is formed by an unequivocal kind of vision.'

'I take it that the two poles will serve as points of departure for understanding the diverse consequences of conditioned vision in modern art?'

'That will be one of the results. Now to establish the first pole. All of us have a notion of what is meant by art seeking literally to imitate nature, a strictly imitative response to light images reflected by objects. This effort reached its highest pitch in painting during the latter part of the last century. This was to have an unprecedented and remarkable effect upon the future course of art, in that, the very moment this extraordinary realism reached its full realisation in painting, the **creative development** of mimetic vision ceased. Let me explain.

'After a certain point, further realistic development demanded an increasingly rigorous visual **concentration upon the mechanical aspect of imitation**, so that the mechanical became the dominant concern. But in becoming increasingly limited to the mechanical, the artist himself was finally reduced to a mere visual machine. This was intolerable, for now the artist was fully subjected to the ultimate structure of conditioning: that is, when art became purely mechanical, its inevitable correlate was the suppression of the creative. The solution to this crisis in mimesis came, paradoxical as it may seem at first sight, through the camera, perfected in the same year as Courbet became a professional artist.'

'It seems to me that the camera itself is about as perfect an example as one could hope to find of a fully conditioned mechanical vision, to which you have just been objecting.'

'It has that appearance because you are restricting attention wholly to a limited view of the mechanical aspect. But there is more to the camera than that. Not only are the mechanics of the camera subject to continuous creative development, but so also is another even more important related aspect, the artist's understanding of the camera's creative potentialities. As with any machine, everything depends on how man uses it. The camera offers an entirely new method for producing and developing images of light. Since the artist here ceases to be an intervening factor between the source of the image and the image of art, one cannot say that he imitates nature. The new method is a direct response to light, in the sense that the light of the image itself structurises the image of art. As one of the inventors of photography so well expressed it, the sun had become the "pencil" of the artist.'

'In what specific sense did the camera bring a solution to the crisis in mimesis?'

Charles Biederman

'In two ways. First, the mechanical aspect of mimesis was now secured by highly developed purely mechanical means. This meant that the mechanical now became the servant of the artist, instead of the artist being a mere painting machine. Second, and surprisingly, at the moment of this mechanical advance mimesis was once more released into a creative visual development. The artist of nature's art was once more free to experience creatively the images of nature's world. In short, the mechanical means given by the camera made possible the further development of this form of art. This has not been understood because of the general failure to comprehend that the proper use of the camera's potentialities required even this kind of artist **to cease being conditioned by the old mimetic image of painting**. Not understanding this, many innovators in photography regarded the painting of modern art as both a guide and a competitor for the realisation of an art for our times. This was a tragic mistake, because this painting only offered photographic art a false direction. The revolutionary potentialities of photography exist in its opening the way for our vision again to **experience creatively the continued development of direct reality perceived in nature**. Not least in importance, the camera permits us to see what the unaided eye could never see before, both in ordinary vision and in the spaces of the universe, from the atomic to the galactic.

'But if the camera artist followed the recent course of painting, he would be compelled to sacrifice what was his unique opportunity to continue the creative development of experiencing nature's actualities. In fact, this entire domain of art is now the sole province of the camera artist.

'We can now establish one pole of the visual spectrum to which I referred a moment ago. It is formed by that realism which came to a stand-still in painting, **developmentally** speaking. It has the advantage of giving a static demarcation, thus forming a boundary for one side of our visual spectrum. This is the moment when realistic mimesis as creation ceased to develop in painting. From this pole there is no useful movement into the future, but only into the past. The last useful role of mimetic painting was in the great works of Courbet. Even in the late works of Courbet, this form of art was suffocated in the final stage of the conditioning process, the purely mechanical, the non-creative.'

'You are going too far. What of the many varieties of artist who, in recent years, have returned to the realistic image? Don't they usefully continue the creative use of mimesis?'

'To reply I will have to digress for a moment, and later indicate the specific place these artists occupy within the visual spectrum. Note that none of the neo-realists is of the same kind as Delacroix, Ingres or Courbet, in the sense that these artists in spite of their differ-

ences represent distinct responses to their perceptual experience of nature's **actuality structure**. This had been the dominating goal of art, the realistic perception of the actualities of nature. As great art, such painting ceased to be usefully possible around a hundred years ago. Now, however, the neo-realists have replaced their perception of nature's actualities as **primary to the art result**, with devices originated by the surrealists and their predecessors. These devices are imposed on nature. Therefore, we do not find a visually deeper experience of reality in this art, such as would result from a creative encounter with nature: rather, **this is surrealist art that is made to appear "realistic"**. Perception itself is deliberately transformed. However much the works of the neo-realists appear to be "realistic", the important fact is that they have turned away from the creative **and** realistic experience of perceptual nature. Transformed by surrealistically conjured experiences, both nature and art are turned inward into obscurities. It is not mere caprice that leads surrealistists to relate themselves to the activities of mental patients, those who have lost their grasp of the actualities, of reality.

'What I am calling "creation" takes place when there is a **creative interchange** between the artist and what he **directly perceives** as actuality experienced in nature. The surrealist method does the very opposite. It is not creation, or, if you prefer, creation is reduced to the role of conjuring devices to **manipulate the creative order of nature**. Instead of harmony there is conflict with nature. **Surrealism can then be defined as that which fragments, confuses, and thus destroys the reality perception of creative nature**. In this view the inner world of the artist assumes arbitrary precedence over the reality experience of the outer world.'

'You are lumping all the neo-realists together as though none of them had any alternative but to resort to surrealism.'

'Was there another alternative? The development of mimesis had reached its visually creative limits in painting, and surrealism was essentially an erroneous attempt to restore creation to the old form of art. This has been obscured because we did not pay enough attention to all the now forgotten realists who followed after Courbet. For without a deep experimental understanding of just how and why the realism of Courbet came to an end, it is difficult to understand the proper alternative to usefully continuing this form of art. It is necessary to recognise that the difficulty for the neo-realists lay in the fact that they remained conditioned by the old or mimetic vision, at a time when painting could no longer continue the pursuit of nature's actualities. For this reason these artists had no alternative but to make the actualities of nature subject to arbitrary devices, those of surrealism. In this sense these artists are really neo-surrealists. Photography, not surrealism, continues this direction of art creatively.'

'You have defined one pole, the point at which creative mimesis ceases. Perhaps you could now establish the other pole of the visual spectrum.'

'To do this we have to consider artists who recognised that the creative role of mimesis had completely ended in painting. They sought an entirely different creative solution for an art that remained nevertheless **centred** in actual nature. Monet alone made the first step. He discovered that the artist could perceive the colour of nature as a source for achieving **colour creation unique to man** as artist. He no longer wished to imitate: he created colour in his way as nature did in its way. Thus, one artist standing alone before nature began what was to become the first fundamental revision in art history. A new vision of nature was born, nature as a creative process, an **extension** of the old vision of nature. Artists had long recognised nature as creator, yet they were principally concerned with **what** nature had created. Now the artist wished to see **how** nature creates, the **mode of nature's creation, its creative process**. Perhaps with the flash of this new insight into nature the artist also recognised the human power to create an art unique to man, as the art of external nature was unique.

'However this took place, it can be said with certainty that the new direction of art became acutely conscious only with Cézanne. He extended Monet's vision of the new nature, making colour **include** and so represent the full structural character evidenced in nature. Not only colour, but colour as form and space were now opened up to the creative vision of the artist. Cézanne accomplished this with two orderly steps. He created the cubist method of geometry, not merely to create a new kind of art, but for the principal purpose of gaining a comprehension of the creative process of natural structure. This led him to the geometry of the plane, planism: to the new kind of art in which the artist took the first steps as a **creator of his own forms**. It remained for Mondrian to bring this to its full realisation in his planism of 1917. Here only flat rectangular planes are present, the peculiar creation of the artist himself. With these planes, however, **painting** came to its second conclusive termination as a creative art.'

Visual spectrum
of conditioned vision

	Art of realism	Art of re-creation	Art of pure creation	
Post 1870 Courbet	**Surrealist**	**Surrealist**	**Surrealist**	**Post 1917 Mondrian**
	Destruction of nature's realism	Destruction of nature's creations	Destruction of nature's mode of creation	

'One moment. Earlier I questioned your conclusion that the neo-realists could not continue the creative development of mimesis further. Your explanation may be true. Now, however, you seem still more unreasonable when you claim that even the new form of creation comes to a dead-end in painting. Did not Mondrian, as well as the painters who followed him, continue the new mode of creation?'

'Again, it all depends on what we mean by "creation". Let's go into this. When Mondrian realised the first correct steps for completely created forms, it was impossible to develop the rectangular plane **further within the structural limitations of the linear reality dimensions of the canvas**. With painting the artist could not develop further the new forms of art into the reality structure obvious in nature, **the only structure open for creative development**. It follows that to continue these forms further in painting, rather than retreat, would inevitably lead to opposition and so rejection of the new vision of nature already established by Cézanne. The painter would then be left with the alternative of destroying the very form by which he had established his ability to create his own forms – the rectangular plane. This is precisely what Mondrian did, while the painters who followed him simply elaborated upon the various fragments Mondrian's destructions left behind.

'Thus creation became destruction. Recall that the neo-realists, surrealising the old realism, also turned away from the reality of nature. And, the greater the degree of surrealisation, the greater the degree in which nature's perceived reality was destroyed. Therefore, our definition of surrealism also applies to the artists we are discussing here, only, unlike the neo-realists, they do not destroy the realism of nature's creations, but rather, the creative method of nature.

'So, as already noted, painting once more came to a conclusive

termination of creation. It is at the same moment, however, that mimesis completely disappears from the new direction of art, the moment when the proper transition to pure creation was completed in 1917. Those who continued further with the means of painting, as Mondrian and his neo-plastic followers did, were doing so primarily because of conditioning by this old medium whose usefulness was now completely exhausted. It is not only those artists who cannot give up the old mimetic form of art who have been unable to face the admitted difficulties of ceasing painting. In any case, we have now established the pole for the other side of our visual spectrum. And this pole also has the advantage of forming a static demarcation, since from it there is no useful movement into the future, but only into the past. As you can see in the diagram, the neo-realists form the first third of the spectrum, while the post-1917 painters who would continue the pure form of creation, form the last third.'

'There are a number of questions that arise. Perhaps some of these will be dealt with if you proceed to delineate the vision that comprises the central section of the spectrum.'

'Let it be understood that art itself can either condition or make our vision creative. The particular visual spectrum we are constructing is wholly concerned with conditioned vision. The painters you suggest that we now consider, the central group, have the intention of achieving creation with forms created by nature. But they reject literal creation as much as literal mimesis. So we are not surprised to find that they are a mixture of the other two groups of painters in the spectrum. While they imitate – for they do depict the created forms of nature – at the same time they desire to be creators. As might be expected they are the most inconsistent of all artists, oscillating between the poles of the visual spectrum. While imitating they reject imitation, because they wish to create their art, yet reject the only way to do so, pure creation. Thus they encounter some great difficulties. For the creative development of mimesis has been closed to the painter for about a hundred years, while the pure creation of forms has been closed to the painter for about fifty years.'

'Could you demonstrate your point by the structural results of their work, in the light of your view that they oscillate between two forms of creation closed to them?'

'It is possible to discern structural traits that are common to all of them, the oscillation being only a matter of degrees and not an essential difference in kind. They reject the creations of nature, while presuming to make these rejections their own creations. In order to circumvent the dead-end of creation in mimesis, the artist imposes on the form-structure of nature his inherent ability to create his own forms. The artist structurally confuses nature's creations with his

own creation. He tries to "re-create" (the original and informative expression used in the early days of Paris cubism) structures that have already been created by nature. Is this creation, any more than it would be if one artist manipulated the structure of the creations of another?

'What does the artist do when he "re-creates"? Does he not merely reshuffle the **creative order** of a structure already created by nature? Is not this more an act of conjuring than of creating? Does not this fragment distort and confuse nature's creative order, transforming it into an art-image of natural destruction? In fact, I agree with the foremost producer of this kind of art when he explicitly insists that art is a "sum of destructions" of nature. Can we destroy nature without also destroying art?

'In short, the destruction of the reality perception of nature is common to all modern art. Not only the foremost producer of the re-creation theory of mimetic art, but also the foremost producer of purely creative painting art, agree that art is the "destruction" of visible nature. Therefore, it is not only the differences but the **common differences** of modern art that are fundamental to its understanding: namely the kind of visual relation the art has to the reality perception of nature. Surrealism is, then, in its destruction of the reality of nature, the principal motivating characteristic of modern art in general. This holds whether what is destroyed is the realism of nature's creations, or the creative order of what nature has created, or the mode of nature's creative process itself.'

'How would you apply this last statement directly to the visual spectrum?'

'First we have the neo-realists. They surrealise the visual perception of nature's reality. In surrealistically sacrificing the reality of nature, with the hope of thus recapturing mimetic creation, they sacrifice the very form of art which they wish to continue. **Destroying the reality perception of nature destroys, in fact, the reality of mimetic art.**

'The painters who are found in the middle of our visual spectrum also destroy nature's reality, only they go further. They fragment and destroy the **creative order** of what nature already created. The neo-realists simply want to transfer the reality of nature into the false reality simulations of surrealism. By contrast, the fragmenters of nature wish to recreate nature's creations in their own image. **In destroying the creations of nature they destroy the creation of art.'**

'Finally those painters on the right of our spectrum. They too destroy the reality of nature, not merely the reality of its creations, nor merely the order of what has been created, but more fundamentally nature's structural mode of creation. Surprising as it may seem,

this last group is as conditioned to the mimetic vision of nature as the others. For its members are prevented from seeing the new vision of nature as pure creation, because they cannot see visible nature in other than mimetic terms. They are thus deprived of, and so deny, any perceptual vision of nature. In destroying the creative process of nature's structure, **they destroy the process of creative structure in art.**

'We can now realise what a tremendously destructive role visual conditioning has had in the general course of recent art. Over the last fifty years the majority of artists have been oscillating between the extremes indicated in our visual spectrum. This reveals the unconscious struggle for release from the paradox of confusing these two different visions of nature and art, the paradox of imitating while wishing to create.'

'How then is the creative impasse to be overcome if the new creation is also closed to painters?'

'To continue creation beyond the impasse of painting requires that the artist cease mimetic conditioning in order to develop the new vision of nature. Then the solution will be apparent. Creation can continue by evolving into the **structural dimensions of nature's reality**. This means the abandonment of painting's illusory visual structure, which then makes it possible for the new vision, both of nature and art, to become structurally free to develop creatively and not destructively. Nature comprises the full structural potentialities available to the creative act by man, and thus nature also makes evident the only structural context for development.'

'I can see that the new artist does not imitate the created order of nature. But I am not so sure that he doesn't continue to imitate nature. After all, like nature he continues to use form, space, colour.'

'Imitation requires that some correspondence take place between the **particular** forms of nature and the **particular** forms of art. When such correspondence is absent, as it is in purely creative art, then the fact that both nature and art use form, space, colour, does not of itself impose the necessity for imitation. Consider this: in the visible aspect both of nature and of purely creative art there is no such **thing** as form, space, colour, per se; there is only the **particular** visible form, space, colour, of nature and of art. The mimetic artist must imitate the particular form which nature manifests. This being the only context of imitation, it is **impossible to imitate in the context of the creative process of nature. It is only possible to be creative with nature's creative process.**'

'If one is to believe your analysis, the artist is limited to only one alternative if he is to prevent creation from becoming destruction.'

'Correction. There are two general alternatives. In the past there were two general mediums or means by which the artist expressed himself: painting and sculpture. Today there are still two but vastly different means. The modern methods and mediums of the machine, as used by photographic and purely creative arts, have now replaced the antiquated hand methods of the past. However, where the two antique hand mediums were directed to the expression of a single general kind of art, the two new mediums are for the expression of two general and different kinds of art. One continues the art of the past, except that its mechanical and creative role has been radically revised. It has really become a new form of creative visual expression, as has pure creation. The latter also continues the creative aspect of past art, but this time into an entirely different context, one in which man wholly creates his own art. So that the "limited", "one alternative", that disturbs you is really a case of a very remarkable extension of the expressive scope now possible to vision in art. For now there are two distinct general directions, where before there had been only one. All told, art has been liberated both from its mimetic and its creative impasse by the machine.'

'About the use of the machine. Isn't this making art mechanical, that mechanical vision you have yourself been deploring?'

'Remember that you already asked this question when we were discussing the mechanical structure of the camera. Recall also what was said about why each of the three major painting attempts lead to a creative dead-end. Notice that in each case a factor was referred to which your last question now puts directly at the centre of our attention. I refer to the indisputable **limited mechanical** aspect of painting. We discovered that it was structurally inadequate to support the new creative needs that had arisen out of the mimetic direction. It was the advanced mechanical machine, the camera, which liberated the creative aspect of this form of art from the now exhausted mechanical limitations of painting.

'Similarly, with the full realisation of purely created art, again it was painting's structurally **mechanical limitations** which frustrated further creative development, and led to destruction instead. Actual dimensionality was required structurally to liberate pure creation from the illusory structure of painting's limited linear surface.

'**Obviously, the mechanical aspect has always been present in art** – from the finger, sticks, stones to the brush and chisel, applied as mechanical means of ex-

pression in clay, paint, wood and stone. We miss the obvious fact that **as art advanced in its expressive qualities, so necessarily it advanced in its mechanical means of expression.** So we are having remarkable advances in the power of man to express himself creatively through art. Indeed the machine liberates the artist's creation. Therefore, one falls into a very serious error when he thinks the new arts are becoming "mechanical". '

'I still insist, however, that the machine may lead to the mechanical both for vision and for art.'

'When you qualify your statement with the term "may", then we are in complete accord. And your point is now important. When the new art machines lead to the "mechanical", it is not for any reasons **essentially different** from those occasions in the past that have always led art and vision into the "mechanical". There have always been artists who achieved great dexterity with the mechanical means of vision, brush and chisel, yet failed to give their art the **creative life of expression.** Therefore, to state without qualification tht the new machines make art mechanical, would not be to argue in good faith. The "mechanical" in art has always been with us throughout all art history, either liberating or frustrating the creative.'

'If all this is true, really obvious as you explain it, then why has there been such a failure to understand what is so obvious?'

'The obvious, as anyone knows from experience, is not always the easiest thing to see. The answer to your question rests with the problem that has been the principal subject of our discussion. **Confusion arises from the fact that we are conditioned to past mechanical methods which no longer adequately meet the new creative structural demands of art expression.** It is a tragic paradox to observe, **that it is precisely mechanical vision and thinking which prevent us from understanding the unique and necessary potentialities of the advanced machine needs of today's arts.** Not only are we conditioned to the old vision of mimesis, but equally conditioned to the old **mechanical mediums appropriate only to the expression of the old vision.** It is precisely among the conditioned artists of our visual spectrum that we find the confusion of modern mechanical means with the old antiquated hand methods of painting and sculpture. That is, they regard modern machines, methods and materials not as an advance over past mechanical means of expression, but simply as means for elaborating on the imitation of the old mechanical mediums, techniques and vision. Thus, an artist will use modern machines, tools and materials to imitate the bronze technique we see used in Rodin. And

just as this is a confusion of old and new mechanical means of expression, an error which even industry has long ago left behind, so the art result is neither creative realism nor pure creation, but the surrealised confused expression of the two.'

'Is it your conclusion that all the artists who fall within the visual spectrum are at a creative impasse?'

'Even leading practitioners of such arts seem to feel this, and not only the painters. Consider the poet who stands before an audience, silent, no poem to offer. The composer immobile before his instrument, offering silence to his audience. The dancer standing on the stage in a state of rigor mortis, no dance to give. The painter who exhibits a blank canvas. All this is a repetition of the Dada despair of some fifty years ago, when the crisis of mimesis and creation first became apparent.'

'One question disturbs me. You have concentrated upon visual conditioning as the fundamental barrier to our realisation of the revolutionary creative changes that have taken place in art. Yet, if all you say is to have any meaning, it is implied that visual conditioning can be explained away with words. Are you not inconsistent here?'

'I did not intend to give you that impression, for what you suggest about words is all too true. The difficulty is, however, that we have to use words to speak about what is neither words nor speech, but vision. Just the same, words alone cannot release us from visual conditioning, even if it were possible for me to express myself with words perfectly, and if you understood them perfectly. For we are dealing with a mechanical habit which functions automatically. Response is canalised. We identify. **Identification leads to perceiving the new always in terms of the past or memory experiences.** Consequently, when we are confronted with the new, especially the radically new, which naturally does not conform to our memory conditioning, **we either reject the new or confuse and confound it with the old.**

'Like other human habits, those formed in art will not cease merely because we gain verbal recognition of them. That can only happen when we literally realise a **visual awareness** of them. Reason, analysis, logic are all useless without visual awareness. And yet words do play an indispensable role in leading us to a proper visual awareness. Direct visual experience can confirm or deny what our words form as truth, but reason, analysis, logic can also confirm or deny that our vision forms truth. Because we cannot simply see, nor simply think, we see-think.'

Charles Biederman

'In your view then, it would be a serious mistake to disregard the verbal role in art.'

'Words play a most critical role, one which can help to point out the tragic aspect of today's art. For the words used may reveal the presence or absence of the rational or irrational base on which the art spoken of rests. It is common knowledge, among laymen and non-laymen alike, that most art rests on the expediency of irrationality sometimes disguised as rationality. It is not common knowledge, however, that this irrationality is the direct product of the various aspects of art conditioning, which have left artists confused and undecided whether they are imitating or creating. Everything depends on our understanding, in actual experience, the varied powerful forces of conditioning. Conditioned to past modes of vision, past modes of thinking, past modes of the mechanical aspect of art, we can begin to realise how formidable the problem of conditioning has become.

'By its very nature the machine is accelerating the actions and achievements of man, the destructive more than the creative, whether man builds cities or art. It is this tempo of events that now makes it impossible to continue ignoring the problems of conditioning. At the beginning I called your attention to the fact that at first conditioning extended over thousands of years, then hundreds, until finally visual change took place within the life-time of a single artist. We are now in a period when the destructive nature of conditioning must cease or the tempo of destruction will only continue to increase.'[1]

[January–July 1964]

[1] For further discussion of the views stated here, see the author's writings listed in the notes on contributors at the end of this volume.

Charles Biederman

Structurist relief no.54 1951

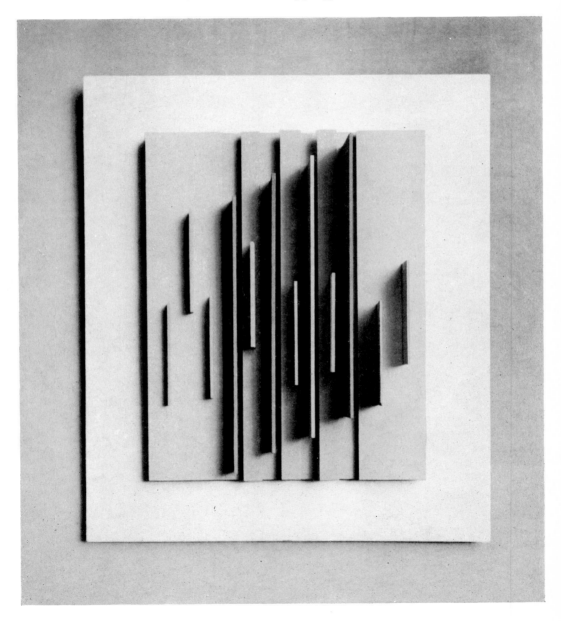

Charles Biederman

Structurist relief no.6 1957

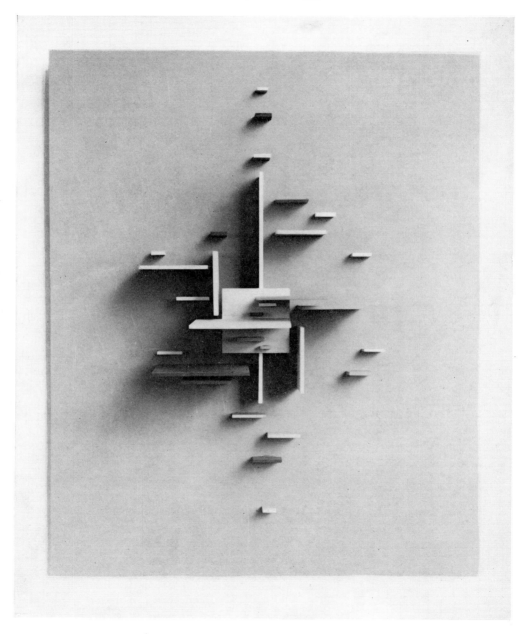

Charles Biederman

Structurist relief no.32 1954

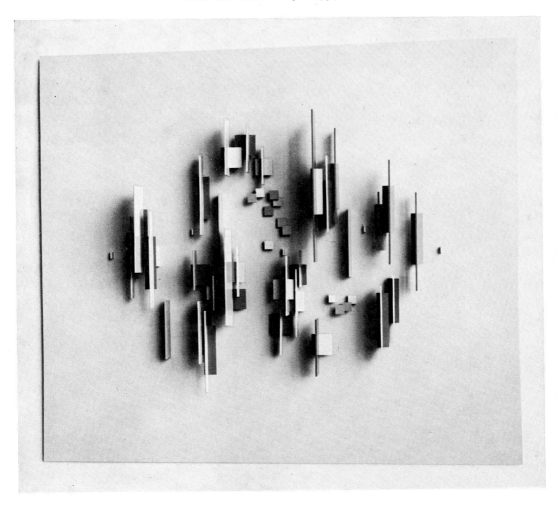

Charles Biederman

Structurist relief no.28 1961

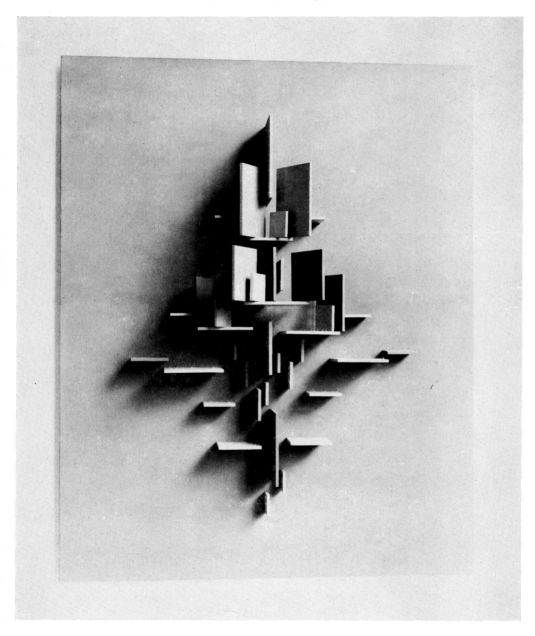

Mary Martin : Reflections

There is a world of communication which is not dependent on words. This is the world in which the artist operates, and for him words can be dangerous unless they are examined in the light of the work. The communication is in the work and words are no substitute for this. However, there is an idea that it is a duty on the part of the artist to offer up explanations of his work to the élite who are in control of its interpretation and promotion, and the necessity of such an élite being as well-informed as possible is certain.

The communication which the artist makes is slow, time consuming (both in the making and in that it takes time to reach others) and, in the first place, made for himself alone. It is a form of dialogue between artist and work in which the artist sets a logic in operation which will answer and move in a possibly unexpected direction. This is not a mystique. Once made a work should be capable of existence on many different levels.

Works of art are part of the process of human thought, or world-picture, and, while many people lead blameless lives without ever noticing art, in fact no-one lives without art. Its outward form is subject to the limitations imposed by architecture, gravity and our own scale. That is to say that it is related to wall, ceiling or floor, if we accept any resting-place dictated by gravity as floor. Its scale will influence our responses. Our own apparent symmetry and real asymmetry are bound up with the degree of relationship between symmetry and asymmetry which we seek in a work. There are many deeper sensations which may be engaged which are concerned with our physical make-up. The inner logic, or content, is limitless.

I have related works to the wall and floor. The expressive content has been concerned with movement and change, being geometrically or mathematically based. Being concerned with movement and change, it has involved rest and constancy. I have not used actual movement. With a maximum of movement of elements within the work, actual movement has seemed unnecessary and stillness essential. It may be said to be programmed in that a logic and a counter-logic are set in operation and the results are accepted. The success of such a process is wholly dependent on a right choice of symbols. This choice is based on intuition and experience.

Establishment of the surface is a primary move, since the parting from and clinging to a surface is the essence of the relief. Then that space which lies between the surface and the highest point becomes a sphere of play, or conflict, between opposites, representing the desire to break away and the inability to leave the norm. It is for this reason that the base is made important in size. In recent work, using half-cubes, the depth of the relief is dictated by the area of the base of the chosen unit. They are pure constructions in that there is no arbitrary or conventional choice made with regard to their depth. This is also true of the orthogonal constructions of 1961–2. I am concerned with a non-pictorial art of relationships. The appearance of the work should be that

95

of an object set upon the wall, if it is not a development of the wall itself. This means that the base, or surface plane, must be parallel to the wall. Provision is made for this by a device at the back which should prevent its being hung as a painting.

The movement of an element on a two-dimensional surface led to a preoccupation with transformations. In early reliefs a unit is taken through a series of similar situations in which it rarely reappears as itself. Proportional systems play a part in these, and they have not been abandoned in more recent reliefs based on number. Use of a knowledge of proportion is one of the contributions which the artist can make to social well-being as anyone who has directly experienced a building by le Corbusier will know. In recent works the unit is unchanging but the situations are permuted, again according to a system, or logic and counterlogic. To me these are twin aspects of the same reality; the relationship between the one and the many, or the constant changed by the time element. We are always the same person but the situations in which we are placed are never identical, though they may be similar. At another time the repetition of situations may become so monotonous to us that we are compelled to change our position in order to maintain our sanity, or growth. All men may be the same everywhere but each one is different, and no two places are the same. We say 'Good morning' every morning, but it is never the same morning; we are all a day older and our feelings vary. The artist, a part of nature, seeks to discover and use forming principles in order that he may in his turn manifest nature. It is as a forming principle that I see the idea of polarity, constancy and change.

[1967]

Mary Martin

White diamond 1963

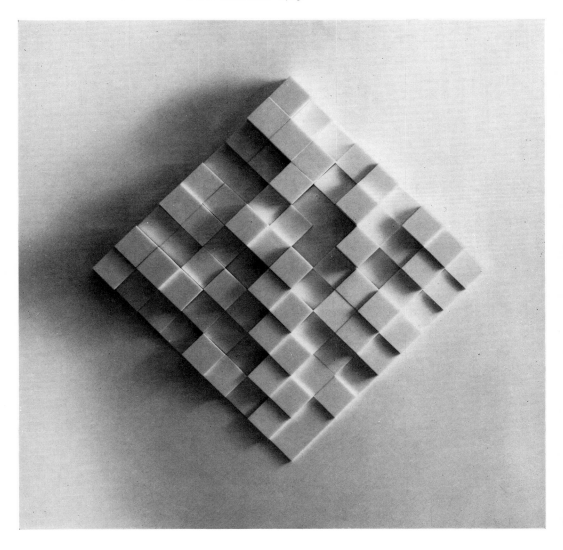

Mary Martin

Nine groups 1964

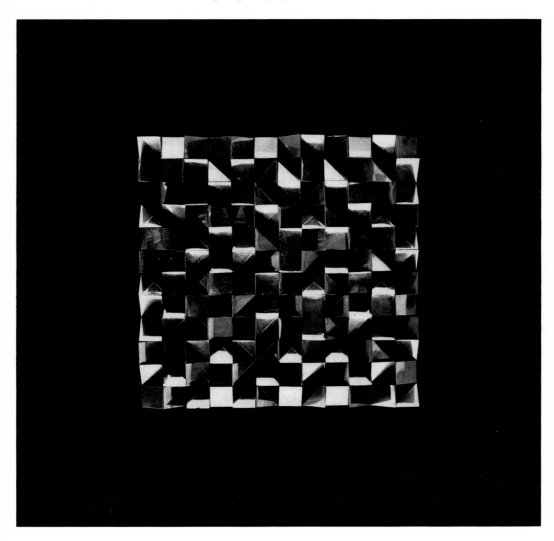

Mary Martin

Diagonal permutation 1964

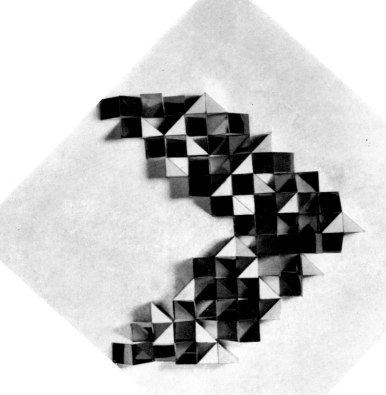

Mary Martin

Dual rhythms 1965

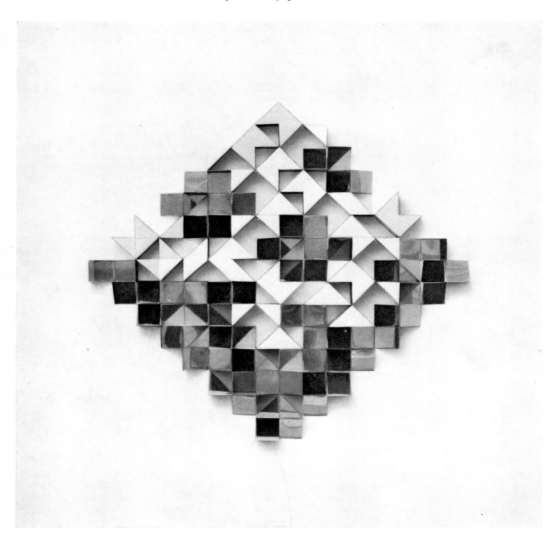

Victor Vasarely : Notes for a manifesto

These are the determining factors of the past which link us to it and which are of most interest to us: the triumph of painting over anecdote (Manet) – the first geometrisation of the external world (Cézanne) – mastery of pure colour (Matisse) – breakdown of figuration (Picasso) – the transformation of exterior vision into interior vision (Kandinsky) – one branch of painting merging into architecture, which in its turn becomes polychromatic (Mondrian) – the beginning of a great plastic synthesis (Le Corbusier) – new plastic alphabets (Arp – Taeuber – Magnelli – Herbin) – abandonment of volume for **space** (Calder). The desire for new knowledge has been affirmed in the recent past through the invention of **pure composition** and by the choice of the **unit**, of which we speak later. Parallel with the decline of the traditional techniques of painting go experiments in new materials (applied chemistry) and the adoption of new tools (the discoveries of physics). At present we are moving towards the total abandonment of the routine, towards the establishment of new functions and the basic mastery of **greater dimensions**.

From the beginning, abstraction stripped and enlarged its compositional elements. Soon form-colour invaded all two-dimensional surfaces. The picture-object lent itself to this metamorphosis, which led it by way of architecture to the spatial world of polychromatic colour. However, an extra-architectural solution has already presented itself and we break deliberately with neoplastic law. **Pure composition** is still a plastic plane with rigorous abstract elements, small in number and expressed in few colours (flatly applied, matt or glossy), possessing over the whole surface the same unified plastic quality: **positive – negative**. But through the effect of opposing perspective, these elements can create or deny alternately a 'spatial sensation', the illusion of movement and of duration. **Form and colour make one unit**. Form can only exist when it has been defined. The line (drawing, outline) is a fiction which belongs not to one, but to two form-colours at the same time. It does not engender the form-colours, it is a result of their meeting. Two necessarily contrasted colours make up a **plastic unit**, consequently a unit of creation: the eternal duality of all things, recognised at last as inseparable. It is the linking of affirmation and negation. Measurable and not measurable, the unit is at the same time physical and psychical. Through it material structure is comprehended; the mathematics of the universe, everything in its intellectual superstructure. The unit is the abstract essence of the **beautiful**, the basic form of sensibility. Conceived with art, it makes a work, a poetic equivalent of the world it signifies. The simplest example of the plastic unit is the square (or rectangle) with its complement 'contrast', or the two-dimensional plane with its complement of 'surrounding space'.

After these few brief explanations, we propose the following definition: on the straight line – horizontal and vertical – rests all creative speculation. Two parallels, forming the frame, define the plane or cut off part of space. **To frame is to create anew and to**

recreate all art of the past. In the technique of the plastic artist, from now on considerably enlarged, the plane remains the area of initial conception. The small format in pure composition marks the beginning of a recreation of multiple two-dimensional functions (large formats, frescos, tapestry, art books). But already we are finding a new orientation. **The diaspositive** will be to painting what the record is to music: easy to handle, faithful, complex; in other words a document, a working tool, a production. It will constitute a new transitory function between the fixed image and the future moving image. **The screen is flat, but in allowing movement it is also space**. Thus it has not two, but four dimensions. 'Time-movement', illusory in pure composition, in the new dimension offered by the screen, and thanks to the unit, becomes real movement. The lozenge, another expression of 'the square-plane unit', equals square+space+movement+duration. The ellipse, another expression of 'the circle-plane unit', equals circle+space+movement+duration. Innumerable other units, multiform and multicoloured, give an infinite range of formal expression. 'Depth' gives us a relative scale. 'Distance' contracts, 'nearness' expands, thus reacting on the **colour-light** quality. So we have the tool and the technique and at last the science, in order to attempt the plastic-cinetic venture. Geometry (square, circle, triangle), chemistry (cadmium, chrome, cobalt) and physics (co-ordinates, the spectrum, the measurement of colour) represent constants. We think of them as so many quantities; our standards, our sensibility, our art make qualities out of them. (This has nothing to do with Euclid or Einstein, but it is the natural geometry of the artist, who miraculously functions without exact knowledge). The animation of plasticism is developing at the moment in three distinct ways: 1. movement in an architectural synthesis, in which a spatial, monumental plastic work is conceived in such a way that a change of form can come about through the shifting of the spectator's point of vision; 2. motor-driven plastic objects which – besides possessing an intrinsic quality – are primarily used as the content during animation; lastly 3. the methodical employment of the **cinematographic domain** by means of abstract discipline. We are at the dawn of a great epoch. **The era of plastic projections on the screen, two-dimensional and in depth, in daylight or darkness, is beginning**.

The product of art has been extended from being 'the useful, agreeable object' to 'art for art's sake', from the 'pleasant' to the 'transcendent'. The set of plastic functions becomes established, therefore, in a vast panorama: decorative arts, fashion, publicity and visual propaganda, décor for industrial exhibitions, festivals, sport, theatre design, model polychromatic factories, signs and urbanism, documentary art-film, museum display, art publications, synthesis of the plastic arts, and, lastly, research by the authentic avant-garde. In all these divers disciplines, the personal accent does not necessarily imply authenticity. We are not qualified to decide in our own time, the major or minor character of these different manifestations in plastic art. Talent exists in the

old guard as much as lack of talent in the avant-garde. But neither the worthwhile work – if it is in-flexible or reactionary – nor the advanced work – if it is mediocre – will count for posterity. The effect that a work of art has on us (with differences of intensity and quality) ranges from a small thrill to the impact of **beauty**. These sensations are first registered by our emotions, and they engender a feeling of well-being or excitement. In this way the aim of art is almost fulfilled. The analysis, the understanding of a message depends on our knowledge and our degree of culture. Since only the values of the art of the past are intelligible, and since it is not possible for everyone to study modern art seriously, in place of its 'comprehension' we advocate its 'presence'. Sensibility being essentially a human faculty, our message will certainly reach the ordinary man through the normal course of his emotive receptivity. In fact, we need not leave the enjoyment of a work of art indefinitely to an élite of connoisseurs; present-day art is moving towards more generous forms, which are recreatable at will. The art of tomorrow will be a treasure common to all, or it will be nothing. Traditions will degenerate, common forms of painting will wither away into abandoned byways. Time judges and eliminates; renewals from old stock and the authentic fresh manifestations come sporadically and un-expectedly. It is sad, but essential, to abandon ancient values in order to be assured of the acquisition of new ones. Our condition has changed; our ethic, our aesthetic, must change in their turn. If the idea of the plastic work has belonged up to now more to artisan procedure and the myth of the 'unique piece', it can be found today in the possibility of **recreation**, of **multiplication** and of **expansion**. Has the wide dissemination of literature and music had a detrimental effect on their unity and quality? The noble chain of the image, fixed in two dimensions, unfolds from Lascaux to the abstracts. The future holds happiness for us in the new plastic beauty, mobile and emotive.

[1954]

Towards the democratisation of art

The beginning of the century saw the explosion of plastic figuration. Its debris has been taken up – wrongly – by the painters of our generation as the new material for composition. In this way nonfigurative and pseudo-abstract artists have produced a satiated, facile and decadent art.

True abstraction, existing in promiscuity with traditional painting,

is submerged for the moment in the enormous contemporary production. Although conscious that it cannot continue with the traditional easel, it nevertheless hesitates before the unpardonable step – a break with the old routine – because it fears losing its habitual resources. Nor is it yet able to set out its principles and rules clearly. Meanwhile, old ideas – **taboo** – remain strong and we must combat them! One of them, the 'human scale', is only relevant to the figurative object. Thus, while it may be evident that the still-life cannot be treated on a colossal scale, it is also inherently clear that abstract forms have no scale. The 'size' attributed to a canvas of small format (whether moral or spiritual) is equally a figurative survival, a survival of the anecdote, of the symbol of the time. Abstraction **must abandon the principle of inflexibility of format**, allowing only the optical scale of distance.

Geometry (square, circle, triangle), chemistry (cadmium, chrome, cobalt) and physics (co-ordinates, spectrum, colourmetrics) represent **constants**. We will handle them as **quantities**; our standard, our art, our sensibility will make **qualities** out of them. Henceforth the initial creative object will be of 'small format' made up of constants, epitomised in the **diaspositive**; an expandible medium, doubling as a sort of 'partition-scenario' which will enable the artist to recreate a canvas, a tapestry, a fresco, an **album** of prints, or a plastic cinetic synthesis, or even a filmed abstract symphony.

For while art yesterday sought to **feel** and **make**, today it can **conceive** and **bring about**. Yesterday the preservation of the work of art depended on the excellence of the materials employed, on perfection of technique and handcraft. Today we are aware of the possibility of **recreation, multiplication** and **expansion**. Thus, together with craftsmanship, the myth of the unique work of art will disappear, and the multipliable work of art will triumph at last through the benefit of the **machine**.

Let us not fear the new tools which technique has given us. We can only live authentically in our own time. Achieving large-scale distribution is necessary to answer the vast demand which comes to us from the world.

[1954]

Reflections

The development of painting makes us declare with Auguste Comte: 'Here at last is the "third state" in the plastic arts, in the clarity of a material-energetic and organic-thinking world.' The development of painting covers theme (from particular-figurative to essential-abstract), technique (mechanical and no longer manual), ideology (communal and no longer ego-centric), language (universal not personal), and belief (rational not metaphysical). It is always a question of the same 'nature' but greatly enlarged at the extremes. Until now the artist held to the middle course, transforming things to the scale of man, to his own image. Henceforward in the cosmic scale, between star and atom, only abstraction suffices. Poetry abounds in the vast landscape of physics. Intuitively, the artist already knows how to give an equivalent in art to this new knowledge; which is accessible to all, unlike the esoteric language of science, through an emotional channel, and no less through a rational one.

Two intrinsic sources of art-culture are: 1. ancient, of genetic heredity; 2. new original creation. Two extrinsic sources of art-culture are: 1. classical, absorbed through education; 2. immediate and circumstantial. Hence every individual, and more especially every creator, represents the point of a human pyramid descending into the past, with its mirror-image ascending into the future. Having a heightened consciousness the artist feels himself indebted to society: by creating something new he will be giving it a little more than he has received.

The material form of human plastic creation exists in time, and in the physical extension of the world, through its 'functions', thus becoming integrated at all levels of subjective sensibility and all degrees of objective intelligence with the psychical extension of consciousness. It is not the art-object that one should possess but its meaning, through intuition or reasoning, according to its hermetic or discursive character, in the order of preferment: individual-élite-crowd. Here is an example of a hierarchy: useful plastic functions (private and public décor, publicity and advertising, industrial design), information design (art publications, museums, collections), architectonic plastic functions (space partitioning, spatial mobility, colour schemes), urban plastic functions (the planning of a town and its suburbs, aerial landscapes), poetic plastic functions (painting, sculpture, environmental objects), cultural plastic functions (fixed projections, cinema, television, scenic syntheses) and finally, pure plastic functions (art in process).

In art a profound, constructive and tenacious current of authenticity is the necessary complement of fashion, which is superficial, freer but ephemeral.

'Cinetic' works give rise to a humanist and philosophic concept of the plastic arts which concerns at once their aesthetic, ethical, sociological and economic aspects. Proclaiming its own perpetual evolution in a progressive world, encouraging technical mutation of functions and art ideas, this concept is a synthesis of physical cineticism and spiritual inspiration.

According to our preference or our artistic aptitude, we opt for the direction of 'publication information' or re-creatable multipliable works', 'works on the optical plane' or 'cinetic works in depth' (both autonomous and architectonic), 'animated works' or 'transformable modifiable works', 'scenic art synthesis' or 'sound and plasticity', 'projectable works' or 'film', or towards 'pure research'. The orthodox practices in painting and sculpture survive and even flourish, albeit in an ossified state, and they will go on constituting for some time yet the nourishment of vast areas of society that inevitably remain reactionary.

The masterpiece no longer consists of a concentration of all qualities into **one** final object, but the creation of an **initial-prototype** which has specific properties that can be perfected in succeeding editions. Elsewhere I have defined 'plastic unity' as two contrasting constants, in a simple dialectical formula: $1=2, 2=1$. When I say black and white (and not black or white), I am opting for a view of the world where 'good and evil', 'beautiful and ugly', 'physical and psychical' are inseparable complementary contrasts: two sides of the same coin. Black and white, therefore, the more easily to transmit the message, the better to diffuse, inform, give. Black and white, yes and no. Black and white, dot and dash. This is the plastic work, recreatable from afar or multipliable by others. Black and white. This is a binary language for constituting a 'bank' of plastic images in an electronic brain. It is a vast panorama of an even statistical distribution of art, a 'common treasure'. It is the indestructibility of art-thought, and hence the perpetuation of the work in its original form.

[1958]

Homage to Alexandre Dauvillier

At whatever level we look at it, nature abounds in the 'formed-unformed' in its union of physical magnitudes. It would be vain to 'copy' them, since only the forms from art-thought can be distinguished from them and triumph over the natural milieu. The format of all abstract composition is expandible-contractable, as much in size as in the ideal distance between the eye and the work, according to the latter's particular function. Form and colour, two distinct notions in everyday language, become inseparable in plastic language: all form has a substratum of colour and all colour is the attribute of a form. But two 'colour-forms' are essential to engender a

plastic unit, the basic component of art and the basic test of sensibility. Each plastic colour-form stands for a measurable and objective physical constant, but its interpretation will be subjective from the phenomenon of the mutation of quantities into qualities. Furthermore, this interpretation will vary according to the spectator's degree of sensibility. We state the law of reversibility of the plastic unit. This unit, expressed at the outset in the binary system of positive-negative or negative-positive, black and white or white and black, is easily convertible in colour contrasts and colour harmonies. Every authentic work must be new in two senses: new in the information it conveys and new in its physical appearance in order to withstand the duration of time. Through the channels of distribution, plastic art, reproduced in fixed or mobile images, has constituted for us a 'Musée Imaginaire'. Only those works which are endowed with great informative power will successfully survive the diminutions that result from adaptation to mechanical reproduction. About the painting of the past? We will enlarge it by the functional forms of plasticity. Faced with the masterpieces of the past which are ends in themselves, we set up our initial prototypes. Without denying the principle of the unique, we opt for that of multiplicity as more generous and more human. This initial prototype is the complete work conceived not as **one** but **one hundred,** from the moment of its materialisation. Its value will lie not in the rarity of the object, but in the rarity of the quality it exhibits. One shouldn't necessarily own the original, but one of its recreated forms, which is capable of giving us an intuition or reason for its beauty, depending on whether we are naturally receptive or have the luck to be well informed. From now on the thought and methods of art can only develop parallel with the most advanced thought and technique of their time. In this way the dream of the concomitance of culture and civilisation will be realised. The less we flatter ourselves on being personal in our creations the better will a universality of spirit flourish. Such a work will be intense, durable and generous, freed by its inventor for others or for a machine to re-create. The cinetic plastic work, recreatable at will – this is the indestructibility of an art-thought. It is the endurance of an object always new in its original form. It is an immense prospect for the statistical distribution of an art that has become common treasure.

[1959]

The combinative in art

Each 'form-colour-unit' is proportionally expandible – contractable, giving us a whole gamut of sizes and so being a **mobile scale** of composition. The codification into squares of 'form-colour units' endows them with the maximum ease of handling in composition, with a basic rigorously arithmetic possibility of reference. 'The unit' has two constants; the nucleus 'form', and it complement which surrounds it. The square is 'the basic unit'. In a sense one is the thesis, the other the antithesis, and the two resolve together giving the synthesis. Apart from its **biformal** aspect it has, of course, a **bicoloured** aspect (harmonious or contrasting besides being positive-negative). With an alphabet of thirty forms and a gamut of thirty colours, at whatever unit level, we already possess several thousand possibilities through simple dual permutation: 1. depending on the number of units introduced into the composition (eg, 4, 9, 36, etc), 400 or more; 2. following more complex permutations: 3. through employing progressive sizes (combining in the same composition units that are 2, 4, 8, or 16 times as big), the number of possibilities reaches the inexpressible, practically infinite. The advent in the plastic arts of a **combination** of this extent offers a tool of universal character, while allowing for the expression of personality, as in that of ethnic individuality. One can already see the outlines of a truly **planetary folklore**, modern in its ideas and technique, unitary in its basis, highly complex at its summits, and hence displaying an objective conquest in a subjective area. The 'form-colour unit' is the basis of a new plastic language, new also in its adaptability to industrial techniques. Here the 'form-colour unit' becomes one with the materials of construction, through the preliminary moulding of the raw material into prefabricated elements. These 'squares' in all colours and all materials are eminently suitable to integrate with architecture. The vast habitation networks needed will at length emerge from their greyness into an appropriate style for our time. A technique of intrinsic decoration for the functional, opens the era of the **continually new** that is demanded by a social economy based on supply and demand. The 'eternal city' with its slums, its ruins and its fakes, will be replaced by the city that is **always young**. The 'form-colour unit', because of its constants, will enter the domain of science. Understood in genetics, statics and experimental psychology, it will become the instrument of pre-education and aesthetic conditioning for the young. The 'form-colour unit', an immense reservoir of harmonising or exalting stimuli, opens up a prospect of health and joy necessary for the equilibrium of vast human communities. Responding to binary interrogation, the 'form-colour unit' is ideal material for **electronic memories**.

[1962]

Victor Vasarely

Cybera 1952–60

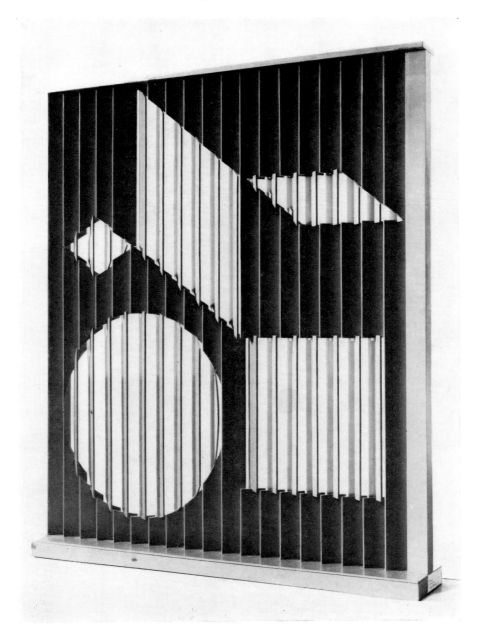

Victor Vasarely

Tlinko 1956

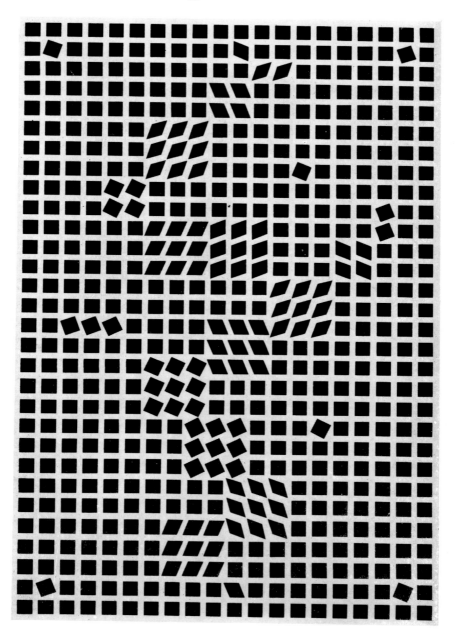

Victor Vasarely

Tlinko 1956

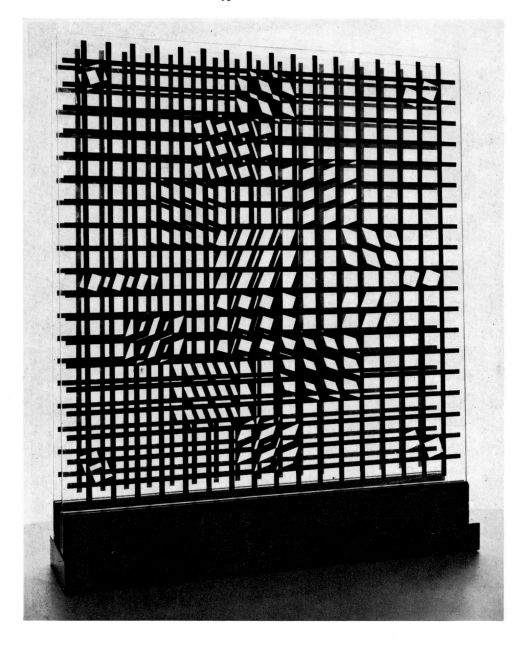

Victor Vasarely

Marsan 1963

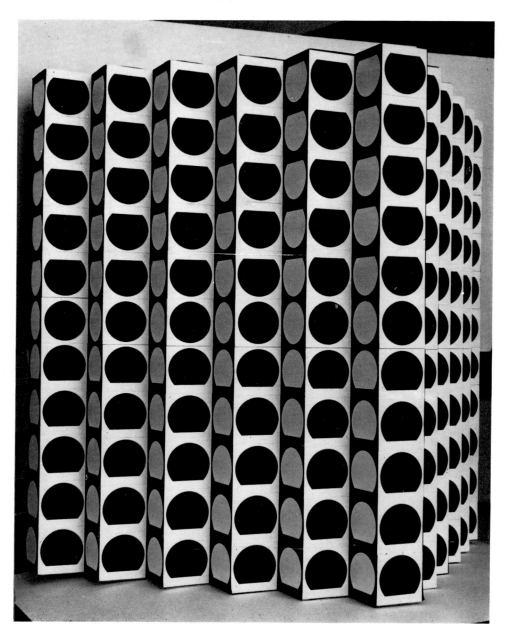

Max Bill : Art as non-changeable fact

It has always been said by avantgardists—the constructivists, the dadaists, the kinetic artists and the pop and op-artists: everything changes, everything is life, everything is in motion. Using such arguments a new state of being has been proclaimed for the fine arts. More exactly: new states of being: the changeable work. In a similar way to introducing time into the domain of physics, time has been introduced into the fine arts. So far this has been limited to literature and music, but one now hopes to realise the element of time in painting and sculpture, too. A wave has thus been started which is still sweeping on. I want to find out what in this context is mere fashion, what an error, and what might be right.

The understanding that everything moves is nothing new. The only new fact has been the proof that matter and energy are the same and different only in regard to their density and their order. The understanding that something produced artificially and moving, generates a typical form, is nothing new either. Consider clocks, carriages, airplanes. The understanding that it is possible to make new machines out of old useless ones, which have no other purpose but to move and to present familiar things to a new audience, is equally not so new. The understanding that fireworks, water displays, light and shadow projections can be created and purposefully planned, reaches back to antiquity and has not yet been replaced by something better and more impressive.

All this has been known for a long time. Why had it to be proclaimed again?

We can ask that every means which is appropriate to originate a work of art be actually used. But that does not dispense with a thorough investigation of where the meaning and the possibilities of art lie.

If we start from the principle that art is aesthetic information, we have to ask: information for whom? by whom? by means of what? information on what: on an aesthetic fact? But what is an aesthetic fact? an elementary truth? a comprehensible order? an understandable law?

Presuming that art could be described in this way one should also know what purpose this aesthetic information serves. I say: it serves as an unchangeable message from today to today and into the future.

I say that it is the scope of art to create a kind of non-changeable, elementary truth. A kind of truth which can be interpreted differently but which remains nevertheless the same. Though the environment and the onlooker are subject to change, this does not go for the aesthetic object.

This shows why essentially the subordination of fine art to the laws of change contradicts the meaning of fine art. The purpose of art is to give an aesthetic measure. If

one knows how difficult it is to give an absolute measure, as against physical nature, then one recognises that this problem in the spiritual field can only be solved by art. How difficult it is to measure exactly: time, distance, weight! And how important it is for the whole of our society that this measuring functions correctly so that our environment may be well and durably established.

However, to measure in the field of aesthetics we are quite insufficiently equipped. The spiritual life limps behind the technical development of our artificial limbs, moving toward a culminating point which at present conflicts with the unsolved problems of humanity: an adequate social order in general and an adequate spiritual order for the single human being. Elements of such a spiritual order we find in the field of basic aesthetic truth. And this can do without kinetics, without modernism, without the so-called up-to-date material. Its basis is the durability of its newness as aesthetic information.

In the end: what is the use of all those aspirations of kinetics? It should remain the serene play it has always been! The kinetic artists belong to the domain of jugglers, conjurers, the circus and the fairground. We find pleasure in their friendly and funny ways, their mischief and their tricks. But one should not see more than there really is: entertainment. This, however, has never been the idea of art and (unfortunately) will never be.

[1967]

Max Bill

Black ninth 1959–67

Max Bill

Unity from three equal volumes 1961–66

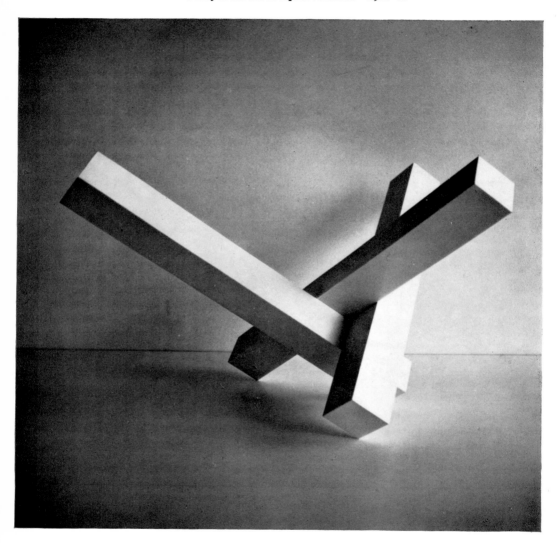

Max Bill

Construction from two rings 1965

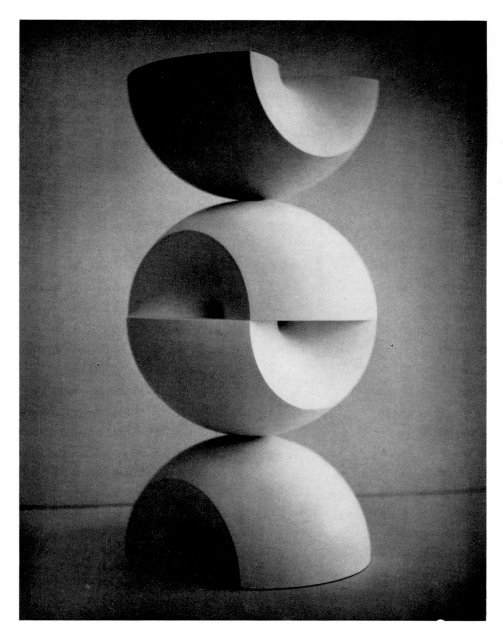

Max Bill

Half a sphere around two axes 1966

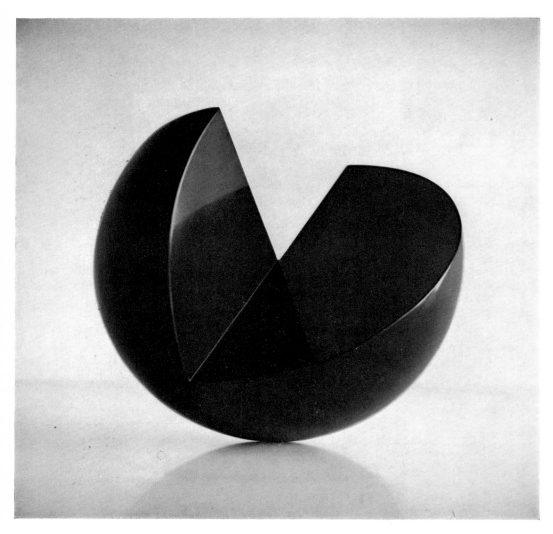

Victor Pasmore : Developing process

In the years immediately following the Second World War I found myself faced with the necessity of attempting a fresh start. An analysis and reassessment of the various manifestations of the visual arts had left me in a state of confusion. I became conscious of the fact that if modern science had opened the door of the rigid frame in which classical art had contained the artist, it had left him groping in a new environment in which object was confused with subject, figure with background and individual with general. Freedom had been achieved, but at the expense of dehumanising the image of man and denaturalising that of nature. Furthermore, as if to reinforce this situation, the conflict between reason and instinct, fact and fantasy had come out into the open to split the imagery of naturalist art. Symbol and photograph vied with each other in a scramble for priority. Inner and outer world had become divided.

It has been said that the imagery of modern art represents a revolt against the long association with science which the artist has established without a break since the Renaissance. Certainly the age of reason overstretched itself and the oracles of ancient cultures have sounded again. But, in so far as there has been a revolt against science, it has been the product not so much of an attack from the outside as of a crisis within the framework of science itself. In painting the introduction of relativity into the process of abstraction not only fragmented the visual scene, it also destroyed its connections between cause and effect. As a result, the classical relation between art and science disintegrated. But whatever the causes which have changed the face of painting and sculpture, their inner content remains the same. Man and nature are still there; it is their relationship which is different.

'Beauty is something given in nature which belongs to art when the artist discovers it.' 'Beauty is not a quality in things themselves, but exists solely in the mind that contemplates them.' If these statements of Courbet and David Hume revealed the confusion in the mind of the artist, they also unmasked what had long been inherent in European culture: namely, the clash between science and humanism. Secured by chains the dome of Michelangelo defied the demands of natural laws, while the anatomy of Leonardo bound the artist to their allegiance. Today the visual arts still circle within the orbit of these conflicting forces, but with the difference that the classical concept of their relationship has been modified. The acknowledgement of relativity in the data of physics has softened the division between man and nature, while the determinism of psychology has narrowed the range of the human will. As a result science and humanism have begun to merge. But, if modern science deflated the superman of romantic art, it revealed the diversity of natural laws. It is not, therefore, a question of denying individuality in the face of the abstract, but of re-orientating its methods of manifestation.

Today nature emerges not only as an organic and mechanical evolu-

tion, but also as a spontaneous metamorphosis. The impact of this development on the artist who is still attached to natural philosophy must give cause for reflection. For my part a further escalation of visual reconstruction or symbolic representation was out of the question. What seemed to be required was not a new mirror or a new symbol, but a new process of development. Not a new model or a new idea, but a new 'essence'. It is true that the search for essence was not new; indeed it had formed one of the principal activities in the development of modern art. But in general the tendency had been one of action on the phenomenal world from the outside, either by a process of modification on individual forms, or by the surgical operation of peeling off successive skins until the abstract structure is revealed. But if these manifestations succeeded in underlining the problem, they did not answer the full implications. What is the abstract without the individual? In other words, the problem of essence is not one of modifying or removing the particular aspects of predetermined forms, but rather of arriving at the individual from basic processes.

The search for essence involves concentrating on the nature of objects and processes as 'things in themselves' whether they be a sheet of paper, a blot of colour, the mark of a tool, the movement of the hand or the motion of a machine. By sensibility and concentration we transform them. What matters is not what they can represent, but what they are 'existentially', and what they can become.

[1967]

Victor Pasmore

**Transparent relief construction in
white, black, green and maroon** 1961

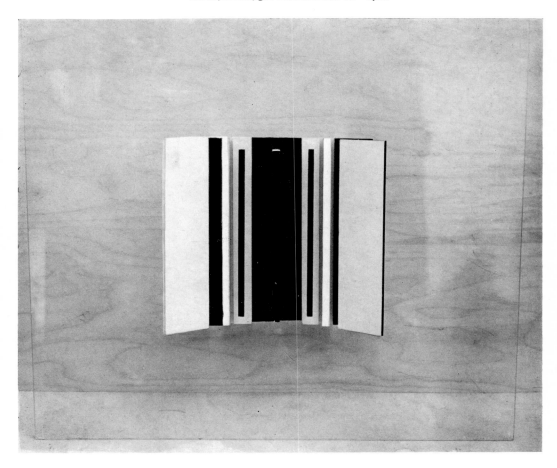

Victor Pasmore

Spatial construction (projective relief) 1965–66

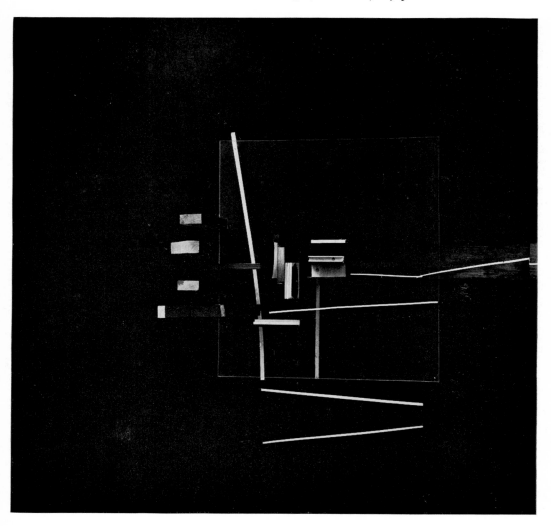

Victor Pasmore

Spatial construction (projective relief) 1965

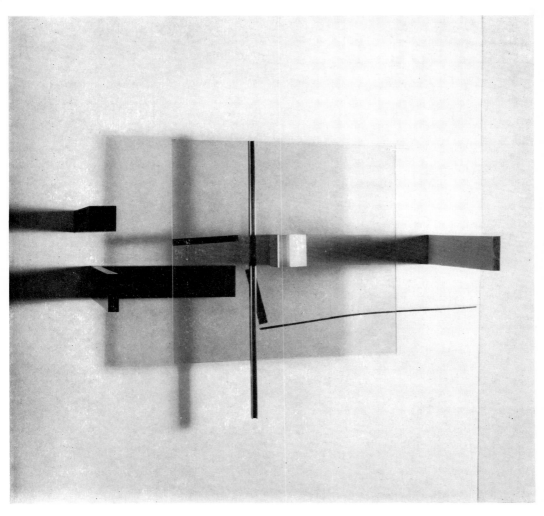

Victor Pasmore

Spatial construction (suspended) 1964–65

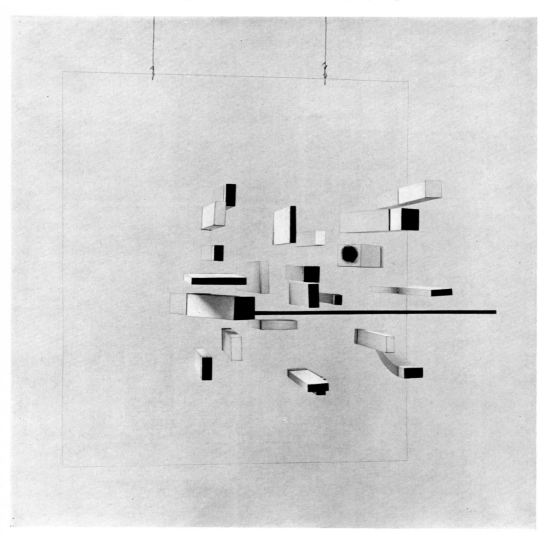

Stephen Gilbert : Notes on my work

When I first started to work in three dimensions in 1954, after having painted for many years, it seemed that a synthesis of the plastic arts with architecture would be the outcome. (Appended is a text on the subject written at that time.) After working on projects in collaboration with architects for two years, the difficulties encountered in realising these projects discouraged me from putting this theory into practice, and further work was confined to pure plastic research, which excluded the functional element.

I studied the first constructive artists, who, in the 1920s and before, used formal elements to create a system remote from naturalistic tendencies. This severe tradition, still maintained in constructive art, has produced much experimental work of great interest to me. It has been criticised as being opposed to Nature and arbitrary, but remains a discipline in which plastic expression is reduced to the essentials. However, if one aspect of society is its art, the other is expressed through its scientific attainment.

Since the first constructive artists formulated their theories, scientific thought has greatly progressed. Both in the understanding of natural forces, and in the ability to use their subtler newly-revealed elements, science has changed our viewpoint. The humanist movement in Europe has for long tended to divorce art and science. It is interesting that the constructive artists should have partially broken down this barrier, in building an art-form in formal terms closer to scientific thought than to the plastic terms of natural environment. However, in a larger field a rapprochement between art and science seems to be a new possibility. This appears to be taking place through the 'humanising' of science. The propensities of thought and intuition, developed scientifically, can, in some fields, attain more in less time, than conscious human apprehension. A society conditioned by such achievements expresses itself in art in a comparable way. The greater understanding of natural phenomena is in itself a reason for abstract and constructivist artists to develop in this direction, on the basis of a logical reconversion of their terms of expression.

A constructive plastic expression built up of curved surfaces in space could, in fact, approach the degree of perfection which science can help us to achieve. The accidental qualities of an art based on human intuition can be replaced by a logically construed art, which rejoins both natural and human environment. With such an end in view, I have myself made metal sculpture in curvilinear planes on a moderate scale, and also had larger work machined to plan by a specialised engineering firm. Although I believe colour to be essential for space-form determination, I have been unable to use applied colour effectively, and work in materials, metal, glass and plastics, in which the colour is integral or reflected.

[1965]

125

Stephen Gilbert

The plastic elements of construction

In architectural development since the beginning of the century the two principal schools have been the visual and the functional. It is the visual to which is due the reintegration of architecture in a general theory of art, and which first insisted on the use of the open structure. Even before this school had clearly formulated its ideas, Frank Lloyd Wright and Gropius had attempted to construct buildings on these lines. Mondrian in his paintings succeeded in creating a spaciality that the De Stijl architects, limited by the building materials at their disposal, only partly achieved in three dimensions. The Bauhaus subsequently absorbed much De Stijl theory, and the pure plastic development of formal space became merged with the functional, which has become the main tendency of contemporary design in architecture. But we must not lose sight of the visual side, since clear visual theory is necessary in the development of new types of function.

We are now at the beginning of a period where the new materials offered to the building trade by the manufacturers have created a number of possibilities, including reduction of wall thickness to what are practically immaterial planes, which yet retain the insulating properties and rigidity of classical construction. The fabrication of large double-glazed units, which allow the penetration of light, makes complete insulation possible with an openness of structure hitherto impracticable. The further development of surface units in colour, such as vitreous alumi-nium and plastics, enables one to consider practically the creation of architectonic space-form; the realisation of an architecture which, unified with painting and sculpture, creates a new plastic reality. The De Stijl movement envisaged this possibility. 'Painting and sculpture will not manifest them-selves as separate objects nor as mural art which destroys architecture itself, nor as applied art, but being purely constructive, will aid the creation of a surrounding not merely utilitarian or rational, but also pure and complete in its beauty.' Mondrian tried to make his pictures integrate with the two dimensions of the wall; 1. in composition, by horizontal and vertical lines, which, although terminat-ing at the edge of the canvas, give the impression of continuing invisibly on the wall; 2. by using primary colours in such a way that there is no illusion of recession. One might almost say that his use of colour was negative, in that with colour he tried to avoid the illusion of three dimensions and with black lines insisted on the existence of two dimensions, thus achieving the maximum spaciality on a flat surface.

In painting Cézanne is the first, and perhaps the last, to have used colour integrally for the expression of three dimensions on a flat surface, and to have thought no longer in terms of light and shade, but in terms of colour which makes form and is form. Poussin said, 'There is nothing visible without colour.' Cézanne understood this and used colour in a way which is as total

as that in nature. The same approach seems to be important for the realisation of spaciality in architecture.

Subsequent development through the fauve movement and the cubists has led us to the liberation of colour (as in Matisse), which is as far as possible from the method of Cézanne. In the period after Cézanne, however, it was of the greatest advantage for the painter to free colour from closed form, for only in this way could the artist cut free from external reality and produce an abstract art. This step led to a necessary simplification of the plastic elements, in which colour that did not describe particular form was used very simply for its value to maintain an abstract ratio, such as Mondrian's horizontal-vertical equilibrium, and in the case of Matisse, to counteract or complement the use of particular form. We have come to look upon the free existence of colour as one of the great discoveries of modern art. In architecture it was used as a corrective which enabled us to tolerate non-spatial form during a period when it was thought important that plastic evolution in this field should keep in touch with painting, sculpture, and scientific thought. Between 1905 and 1920 important plastic progress was made in painting. Matisse liberated colour, and Malevitch and Mondrian developed spaciality to its limits in two dimensions. Delaunay linked colour with progressive movement by realising simultaneous images of changing relationships in the same picture. By 1920 the main plastic developments had been made. The second post-war abstract movements have consolidated the positions acquired in the earlier periods.

Further development of plastic expression must be in three dimensional reality, in which formal space can be created, and which, in fact, cannot take shape without the presence of colour. By using coloured planes as surface elements we can establish the existence of formal space, and actually sculpt space: making a structure which is interpenetrated by space, visually unenclosed by its transparent glass-wall areas, and determined by the planes of colour composing it. This is an important step. The De Stijl architects and others accepted non-integrated colour because the initiative rested with the painters, who had liberated colour in two dimensions. The aesthetic imposed by the urgency of new plastic experience adjusted itself to an architecture which had not properly evolved the appropriate materials, ie, materials which should be light and thin, and possess insulating properties, and which should be made in colour which is weather resisting and durable. For this reason complete spaciality in architecture was not possible, and a compromise was arrived at with the use of liberated colour. An equilibrium was sought, in which the adjustment of forces was broken down into counterbalanced colour and form, as in the Rietveld and Schröder house at Utrecht, 1924. Now we no longer need to do this, for architectonic space-form will no longer be enclosed, but visually determined and held in tension by the integral colour components, which establish its reality, as well as its rhythm and direction. These components, which are generally thin surface planes of

colour, must be exactly related, and for this purpose sensibility to colour is required, in order to determine quality, quantity, intensity, and placing. The colour elements when in equilibrium form an integral part of the structure and cannot be disturbed, for without balanced colour there is no determined space and consequently no form.

The integration of colour with form in architecture has this in common with Cézanne's synthesis in painting: by planes of colour, painted in separate touches, he showed changes of direction on the surface of objects he wished to represent. This complete integration of form and colour which Cézanne sought in painting and for particular form, is needed to determine space-form with equal exactness. But in architectonic space-form, controlled by choice of colour, there is another factor to be considered. This is motion (which we apprehend through static movement or rhythm, as well as through the kinetic) and by it we are made aware of a series of visual impacts as a single movement in space, and can relate our visual knowledge to space-time processes. This is less possible with closed volumes, which are related to space only partially, for they block penetration movements, and allow only for external dynamic development, which is insufficient. The opening up of architectonic structure allows free communication between interior and exterior space, so that the flow of all space is continuous. We can then create a static movement in the colour-space-form equilibrium by means of a rhythm which unfolds itself and is developed by the spectator's own displacements.

Rhythm is a form of progressive motion which demands active participation, and is for the spectator a dialogue with time. Rhythm develops a movement which leads us out of the actual equilibrium of forces in which it is placed. It links up with kinetic rhythm and the scientific exploration of space, which has been developed visually in art forms (the cinema and mobile space-form sculpture).

The monumental conception of architecture, based upon our appreciation of its mass, becomes meaningless when related to progress in other fields of activity. 'If matter sheds its mass and travels with the speed of light we call it radiation or energy. And conversely, if energy congeals and becomes inert, and we can ascertain its mass, we call it matter.' In architecture we can liberate ourselves from this mass which is represented by closed volumes, not only by the sensation of movement created in the flow of space through architectonic form, and by the creation of static and kinetic colour rhythms: but also in the actual reduction of visual shape, which, by the use of certain curving surfaces, can appear to increase or decrease its area in relation to the changing point of view of the spectator.

The real problem we experience in the development of architectonic form lies in the reconciling of the factors which seem necessary to express our meaning. If we abandon

the horizontal-vertical ratio, as would seem inevitable, the adjustment of the colour components, which establish the existence of space, becomes a delicate operation in the fusion of curvilinear delimitation surfaces, where neither horizontal nor vertical are clearly defined. It is a field in which pure art and science meet to a degree which goes beyond the normal training of the architect.

[1954]

Stephen Gilbert

Projects for polychrome architecture 1955–57

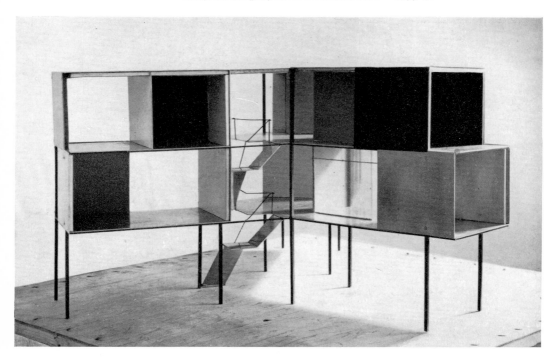

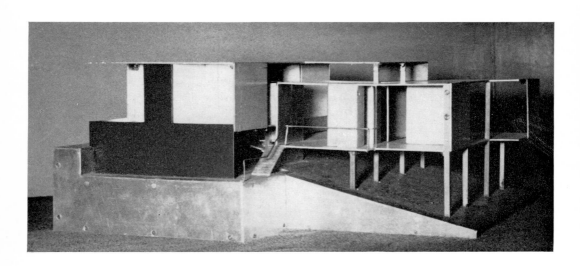

Stephen Gilbert

Spatial construction 1956

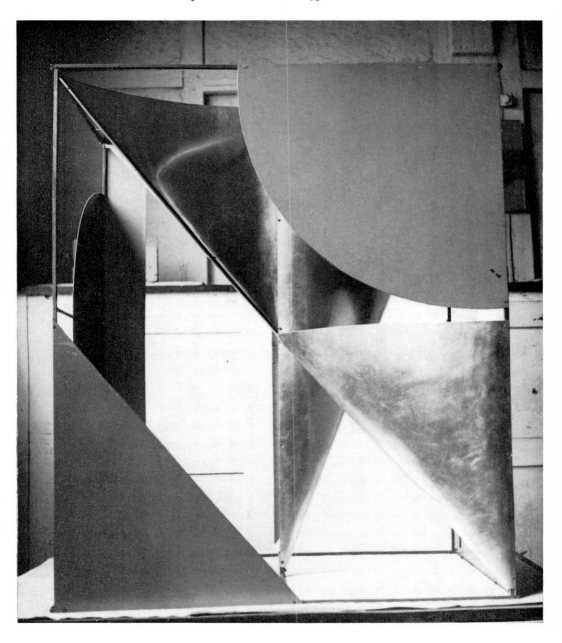

Stephen Gilbert

Spatial construction 1956

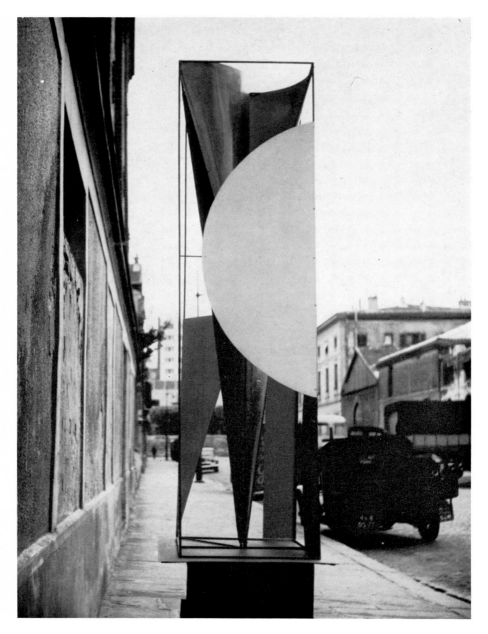

Stephen Gilbert

Structure 40a 1965

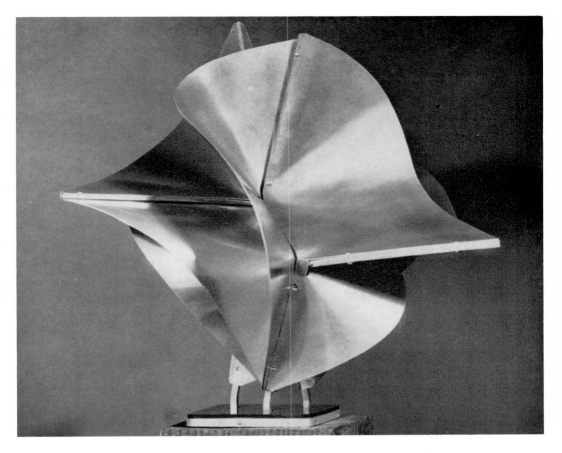

Frank J. Malina : Some reflections on the differences between science and art

I

During the recent past there has been a spate of essays and books on the lack of understanding between scientists and artists, symbolised by Lord Snow's popularisation of the idea of '**the two cultures**'. The debate between the scientist and the artist, which is frequently most intemperate, especially from the art side, will undoubtedly continue for a long time to come. The estrangement between the natural sciences and art, which became more and more acute after the Renaissance, with the growing success of modern science, began to break down at about the time the camera was invented in France by Nicéphore Niepce in 1829, to be perfected by the painter Louis Jacques Mandé Daguerre.

But my experience after a number of years of work in the engineering sciences, mainly astronautics, and in the visual arts, especially with light and movement or 'kinetic' art, leads me to believe that the misunderstandings are still far from resolved. This state of affairs is caused, not only by the confusion in the mind of artists about the objectives of science, but also by the failure of the theoreticians of art to put forward hypotheses which command the respect of the practitioners either of art or of science.[1]

When speaking of art I shall limit myself to the artifacts of the pictorial type made by individual artists for individual observers, in contradistinction to visual artifacts of the spectacle type for simultaneous viewing by a mass audience. It is important to stress that the human sense of vision is also essential in the domain of the natural sciences. Indeed, in the study of phenomena beyond the range of the human eye one has to resort to instruments that must be read, and frequently to pictorial models to facilitate comprehension.

II

The word 'science' covers the wide range of human activities stretching from the accumulation of knowledge about the myriad relationships of the physical universe and the world of man, to the application of knowledge for the satisfaction of human needs, dreams and desires. Thus we have the term 'pure or basic sciences' to cover the subjects of astronomy, physics, chemistry, geophysics, biology, psychology, etc, and the term 'applied sciences' to cover the subjects of agriculture, engineering, medicine, sociology, etc.[2]

There is now a generally accepted view that there is no clear-cut division between the basic and applied sciences, in spite of the fact that there are still some who speak of 'science for science's sake'. For example, until recently astronomers concerned with the moon and the planets of our solar systems could imagine that their work only satisfied man's

curiosity and craving for an understanding of the universe. Now they find that engineers are calling upon them for help with the practical problems of sending people to these heavenly bodies, not only to learn more about them, but to use them for human purposes.

It is comprehensible that in the past attempts have had to be made to justify the study of phenomena and problems which appear to have no relation to the immediate satisfaction of man's needs, for we live in a world where even the basic needs for biological survival of many members of the human race are far from met. Nevertheless, defence of undirected research in the basic sciences is becoming less and less necessary, for it is becoming clearer that it is not possible to predict which knowledge of the infinitude of the universe will be valuable in the applied sciences. One should also bear in mind that the portion of the world's brain power being expended in the basic sciences is very small, even though there are more scientists alive today than have lived during the whole span of man's existence.

It is perhaps worthwhile to be reminded that mathematics is not 'science' in the same way as physics or engineering. Eric Temple Bell has called it the 'Queen of the Sciences', – and why? The mathematician, unlike the scientist, is not concerned with meeting the test of physical experiment. His work is axiomatic and the results he obtains must be consistent only with the assumptions he has chosen. It is fortunate that the product of the mathematician is so helpful to the scientist in his efforts to understand the workings of the universe, and to the engineer in making useful things.

The mathematician helps the scientist to make predictions about the future. It is the prediction of the future behaviour of well-defined aspects of the universe which gives modern science its power. One might say that it is this predictive power which has caused science to be the highly respected human activity it has become.

There are those who are impatient that science is not capable of making predictions on all matters close to their hearts, leading them to cast doubt on the whole of scientific endeavour. For example, they cry that science is caught up in the 'uncertainty principle', without realising that the engineer now is able to apply this principle in quantum mechanics for the design of predictable nuclear reactors for the production of useful mechanical energy.

There are also those who would dilute the objectives of science by introducing the misconception that the emotional appeal of the elegance and beauty of an experiment or mathematical relationship is sufficient. That a scientist experiences joy from these kinds of human reactions cannot be denied. The theoretical physicist Paul Dirac once said: 'It is more important to have beauty in one's equations than to have them fit experiment. It seems that if one is working from the point of view of getting beauty in one's equations, and if one has really a sound insight, one is on a

135

sure line of progress.' P. B. Medawar, in his review of Arthur Koestler's book **The Act of Creation**,[3] points out that the key part of Dirac's remark is 'if one has really a sound insight!' If an equation in the natural sciences does not fit experimental facts, its beauty will not save it.

In aeronautics there is a saying that a good aeroplane looks 'good'. However, for an aircraft designer considerations of beauty are of secondary importance. The aircraft's safety, performance and efficiency are controlling factors. It is difficult to believe that one would call a helicopter a beautiful flying device, and it is very doubtful that anything can be done to make it less clumsy looking; nevertheless it is capable of performing uniquely many useful tasks in the field of air transportation.

Few would be inclined to call beautiful some of the arrangements of instruments and equipment used in the new field of astronautics to explore space. Lunik 1 and Ranger 7 successfully obtained photographs of the moon in spite of their bizarre appearance.

III

The chief purposes of the visual arts are, by means of artifacts, to stimulate and satisfy human emotions, to help the human mind to comprehend the knowledge and conceptions of the universe and of the world of man, and to widen and deepen emotional perception of selected portions of man's environment.[4]

The theoretical basis of art is the concern of aesthetics, but the practising artist finds this branch of philosophy about as useful as meteorology is at present for predicting the weather a month ahead. This remark is not intended to minimise the great importance of these two endeavours, which are struggling with such extremely complex fields. But it explains why anyone feels competent to criticise the works of artists. This confused state of affairs is further aggravated by artists themselves, who subconsciously resent that many of the functions of art of bygone days have been taken over by science. The basic sciences have been found more effective than magic and mysticism (to which art was closely allied) in giving an understanding of the universe, and the applied sciences in highly industrialised societies have provided means of communication and replication that have taken from the visual arts one of their most elementary and useful objectives of the past.

The fact that during the past centuries some of the useful functions of art, which persisted for millennia, have been taken over or reduced in importance by other domains of human endeavour should not cause the artist in despair to compete with those domains,

but rather to search for new ways of giving man emotional satisfaction and comprehension of the world in which he lives.

George Kubler in his most intriguing book **The Shape of Time**[5] says: '. . . Works of art are distinguished from tools and instruments by richly clustered adherent meaning. Works of art specify no immediate action or limited use. They are like gateways, where the visitor can enter the space of the painter, or the time of the poet, to experience whatever rich domain the artist has fashioned. But the visitor must come prepared: if he brings a vacant mind or a deficient sensibility, he will see nothing. Adherent meaning is, therefore, largely a matter of conventional shared experience, which it is the artist's privilege to rearrange and enrich under certain limitations.'

Science is providing the visual arts with new tools of much greater complexity and variety than coloured chemicals and static flat surfaces, which the painter has used since the days of the cave man. Furthermore, the various branches of science are causing man to experience sensations unknown before, and to be aware of phenomena in the universe previously unseen. Perhaps it is not too strong a statement to make that it is the artist's duty to help his fellow man to live in greater joy in the world of his time by making artifacts with new adherent meanings and of sufficient complexity to satisfy man's increasing sensibilities of perception.[6]

IV

J. Bronowski, in his compact and delightful book **Science and Human Values**[7] writes: 'When Coleridge tried to define beauty, he returned always to one deep thought: beauty, he said, is "unity in variety". Science is nothing else than the search to discover unity in the wild variety of nature – or more exactly – in the variety of our experience. Poetry, painting the arts are the same search, in Coleridge's phrase, for unity in variety. Each in his own way looks for likenesses under a variety of human experience.'

Much thought is being given in our day to the similarities of the 'creative process' in the arts and in the sciences.[8] As another example of an approach to this question I will quote the description of a possible model of our intellectual apparatus given by N. E. Golovin in his essay **The Creative Person in Science**.[9] 'In the first place, let us assume (as has been done, for example, by Ashby) that the central nervous system acts as a quasi-mechanical regulating system with the capability of controlling the entire body so that it continually acts to maintain itself in dynamic equilibrium within its environment. The peripheral sensory channels accept and code information characterizing the external environment. This coded information is recoded in the

process of transmission to, and receipt by, the central nervous system. There it is stored, and then processed for comparison with similarly coded and previously stored sets of standard patterns related to the minimum physical requirements for the organism's survival. These comparisons generate error signals which are transmitted throughout the body (including the brain) in the form of instruction for compensatory reactions representing the regulator's best estimate of the survival response necessary to take account of the information received. Crudely speaking, the central nervous system is a "computer with memory" whose inputs are coded data supplied by the nervous system from the environment and memory, and whose outputs are coded instructions to various organs of the body, including the computer itself.

'Such a system will be subject, of course, to the general principles of information theory. It follows, for example, that the central nervous system cannot have a capacity to process, that is, to modify or suppress the information being received by it, which exceeds its capacity to function merely as a transmission channel. Furthermore, if the flow of information from the environment grossly exceeds this channel capacity, then an efficient way available for the regulator to assure system survival in the long run is to develop, through natural selection, for example, a capacity for reducing the effective inflow of new information by finding data redundancies in the environment. Such a capacity, in principle, is identical with ability to discover the natural laws operative in the environment. Such laws allow the system's regulator to replace large quantities of inflowing data by a relatively small volume of appropriately coded stored information.

'This model suggests that the basic human intellectual propensity to study and understand the environment, and to reduce its complexity by correlations and natural laws, may be no more than the necessary physical result of the need for a biological system to regulate itself adequately in an environment so complex that the inflow of new data greatly exceeds the information channel capacity of its central nervous system. On the basis of this model, we can view the non-scientific varieties of creative activity, for example, as being biologically justified by need for play with the environment undertaken by the organism essentially involuntarily, to help maintain its regulatory and information-processing system in an optimum operating condition.'

Although one might suspect that J. Barzun would consider Golovin's model another example of **Science: The Glorious Entertainment**,[10] Golovin is, in my view, at least making a positive attempt to assist our understanding of an extremely complicated process.

My work in the fields of the engineering sciences and visual arts leads me to support the view that in both these fields the 'creative' process is basically similar, even though their objectives are so different. There are other differences, however, that seem to me to bear consideration.

V

It would be most interesting to compare the differences between the educational processes used in good modern post-secondary schools to prepare the hands and minds of scientists and of creative visual artists. I will, however, limit myself to describing the differences I have noted between the modes of work and outlook of mature artists and scientists.

References to previous work

There is a good tradition in the sciences that, before one begins work on a problem or the design of a device, one should study systematically the available technical literature, in order to minimise duplication. If the work is undertaken because it appears to have sufficient significance, then, when it is completed, a report is written for publication in which the author is expected not only to describe what he has done and how he did it, but also to cite references of other pertinent works.

In the arts a very different situation obtains. Not only are examples of other artists, especially contemporary ones, seldom studied in depth before an artist begins his work: the ethics of his profession do not demand of him that he give credit to previous related works. Partly for this reason, art is said to be non-accumulative, and replication takes on the aura of creating prime objects, since the artist places only his own signature on his product.[11]

Verbal reporting

In the sciences, which are so heavily dependent on the sense of vision, it is nevertheless expected that a written report be prepared by the one who carried out a piece of work. In the visual arts the artists are generally mute, and instead a separate class of verbalisers has arisen which not only informs the public and other artists of current artistic work, but actually writes about what a particular artist was trying to do and how he did it without, in most cases, consulting the artist himself.

The number of cases of artists writing about their own work is not very great. Some information coming directly from artists can be gleaned from personal letters, manifestos and interviews. If, when an artist exhibits his work, a catalogue is prepared, the introduction is rarely written by him. Art journals dealing with contemporary work seldom turn to the artists themselves, but instead obtain second-hand reports, which the artists look upon with whimsy.

The strange idea has taken root in the visual arts that it is immodest for an artist to write about his own work, perhaps because articles on art tend to be exhortative literary efforts rather than straightforward reports. In a scientific report, clarity and conciseness are

considered of much greater importance than literary quality; and a feeling is developing that the more a scientific paper approaches literary art the more it diverges from the truth.

Another strong tradition that has developed in the sciences is for workers with similar interests to meet together and exchange views. This is done frequently, in spite of the fact that scientists have personality traits as diverse as artists, and that much of science at this stage in the world's development is carried out under the shadow of various forms of secrecy. This tradition among artists is still in its infancy. Those of us who have been working with kinetic art go to the extent of showing examples of our artifacts in group exhibitions, but advantage is not taken on these occasions for the participating artists to meet together to discuss their work.

Team work

Nevertheless there is a danger of artists blindly imitating the modes of work of science. An example is the recent attempt to form teams of artists to make kinetic art objects. In the sciences, whether it be experimental studies in nuclear phsyics or the design and construction of a rocket vehicle to explore the space environment, the complexity of the ventures and the variety of skills required, which exceed those that any one individual can possess, have led to the formation of teams of specialists. These teams can be credited with significant achievements.

There is a justification for the use of the team approach in kinetic art when the art object to be created is sufficiently complex to require specialists of different skills. This is the case, for example, with the design of an audio-kinetic art device which requires the solution of problems of electronics, electric lighting, mechanical drives, and, of course, aesthetics. Since the objective of the device is to be an object of art, the output of the device must be conceived and executed by an artist. Since the senses of hearing and vision are involved, the artistic leader of the team needs talents similar to the composer of opera.

Teams of mature artists formed to execute conceptually simple artifacts are of doubtful value. The painter's atelier of old was not a grouping of highly creative artists, but rather an apprentice system for education and training. If, as is being attempted today, a team of artists of similar skills is brought together primarily to assemble an object containing myriads of similar pieces, then it appears to me that the team conception is being abused. The artist who conceived the object, if he cannot carry out all the labour involved himself, would do better to use the help of artisans who have no artistic ambition. Team work both in scientific and in artistic work is basically uncongenial to men with original, adventurous and nonconformist minds. Stresses and strains soon develop in such teams, for it is difficult for individuals of this type of temperament to work together toward a common objective.[12]

Experimentation

An experiment in the sciences is made to discover new phenomena, to study the behaviour of matter in its various forms, to verify the validity of hypotheses, to help in the development of new useful devices, etc. The validity of scientific and technical work is finally determined by experiment, to see that the truth of facts is not violated.

The word 'experiment' has worked its way into the field of art, with peculiar connotations. If a work of an artist is appreciably different from preceding widely accepted art objects, it is highly probable that the new work will be classified as 'experimental'. Then a miracle may take place, for without the artist modifying his work in any way, with the passage of time it is re-classified as a masterpiece. In the world of art it would perhaps be more appropriate to call the consumers of art 'experimental', since it is they who have so many times modified their view of an artist's work.

When an artist permits a work to leave his studio he feels he has accomplished a synthesis of unity in variety which satisfies him. He takes the risk that other people may not find his work aesthetically satisfying. There is small likelihood that an artist would complete a single work in his lifetime, if he considered it to be an 'experiment' after it left his studio, subject to modification on the basis of criticisms made of it.

While in the process of making a work the artist might be said to 'experiment' with his own sensibilities. When he reaches a point where he feels a work satisfies him, his 'experimentation' has ceased.

The results of experiments in psychology and physiology on the reaction of the human senses to stimuli, are certain to be used more and more by the artist, as, for example, the results of studies in gestalt psychology and optical illusion have already been utilised.

A recent impact of experimental science, of dubious character, on the visual arts consists of artists presenting demonstrations of physical phenomena as works of art. These include magnetism, polarisation of light, the breaking of light into its colour spectrum with a prism, the flow of liquids, movement of various kinds, etc. The artist provides only a frame or a base for supporting the equipment devised in a laboratory. The transfiguration of the phenomenon-producing apparatus into an art-object is accomplished by merely passing it through the door of an art gallery.

There is no doubt that these various physical phenomena, which during the last hundred years or so have become readily reproducible and controllable, will be applied in the visual arts to broaden the range of aesthetic experience. The lag in their use by artists is perhaps due only to the estrangement between the arts and the sciences, which is now slowly being overcome.

Frank J. Malina

Abstraction, invention and illusion

One of the most powerful features of the scientific method is the process of abstraction, which is as old as man. It has been found that enormous progress can be made in understanding the workings of the universe, and in devising useful things for man, when complex problems are simplified. The results obtained through the use of this process must be submitted to experimental verification to determine if the truth of facts has been adequately met to make them valuable.

In the visual arts, abstraction cannot be avoided, for the simple reason that an art object is not made of the same materials as the meaningful content represented. It is a linguistic misfortune that the word 'abstract' in the world of art has been given to a special class of artifacts. Confusion is further compounded when the word 'non-representational' is used as a synonym for 'abstract' art.

'Abstract' art appears to connote for some artists and writers an art with no relationship whatsoever to the real world of man. I cannot recall seeing an 'abstract' art-object which did not stem from something the eye had been exposed to in the visible universe, or seen through instrumental aids provided by one of the sciences. The artist, by using his powers of invention and illusion-making, can cause the relationship to be very tenuous indeed. Furthermore, ignorance or forgetfulness can easily lead one to believe that the content of an art-object came from nowhere but the artist's mind. For example, if a present-day member of a stone age culture was shown an impressionistic painting of Piccadilly Circus, he would undoubtedly be sure he was seeing a pure invention of the artist – but only until he was brought to London.

The process of abstraction has led artists to make surprising statements as, for example, Mondrian, who said in his essay **Natural Reality and Abstract Reality**[13] in 1917: 'The new plastic idea cannot, therefore, take the form of a natural or concrete representation, although the latter does always indicate the universal to a degree, or at least conceals it within. The new plastic idea will ignore the particulars of appearance, that is to say, natural form and colour. On the contrary, it should find its expression in the abstraction of form and colour, that is to say, in the straight line and the clearly defined primary colour.' Further on, he wrote: 'We find that in nature all relations are dominated by a single primordial relation, which is defined by the opposition of two extremes. Abstract plasticism represents this primordial relation in a precise manner by means of the two positions which form the right angle. This positional relation is the most balanced of all, since it expresses in perfect harmony the relation between two extremes, and contains all other relations.'

Shades of Pythagoras! Guy Métraux, secretary-general of the

142

Unesco project for the scientific and cultural history of mankind, has pointed out to me that Hogarth in his **Analysis of Beauty** tried to prove that the **curved** line was the basis of all beauty.

In science abstractions take on life only when they lead to results that give a useful approximation to the reality of nature. One wonders about the life and unity in variety of a monochrome canvas. Are artistic imitations of the geometrical abstractions used in mathematics works of art? An infinite series of static paintings or constructions can be made with two lines or rods, merely by changing their positions. It is noteworthy that artists of the Renaissance, to whom the method of achieving an illusion of three dimensions on a two-dimensional surface was a major concern, did not consider their studies of perspective geometry suitable for framing, for they could do more to satisfy their sensibilities in their paintings and frescoes.

In the arts the power of invention is in some ways much freer than in the sciences, for an art-object need obey no laws of nature. An aerodynamicist will not complain if a satisfying painting of an aircraft violates established principles of design. No-one has grounds for objection when Dali paints an image of a watch unlike one that could be made for useful purposes. It is not expected that a house will be constructed from an impressionist or cubist painting of one.

The possibility of creating illusions and multiple meanings within a work offers the artist another avenue of freedom, whereas in the sciences the greatest care is taken to minimise these subjective manifestations. One of the hardest lessons science has had to learn is the unhappy tendency of man to delude himself in spheres where delusion can lead to very grave consequences. Furthermore, the scientist attempts to give his symbols and words single-value meanings – not always an easy matter when one is probing the unknown.

VI

I wonder if the comparison I drew between the present state of aesthetics and meteorology, as regards predictive power, is fair. The natural sciences rest on the fundamental premise that nature is governed by laws; that is, there is order, regularity and unity in nature, even though some of the laws may be expressed in terms of the statistical method for dealing with complex phenomena, and situations involving uncertainty and chance. Is it possible to construct an aesthetic theory capable of predicting into the future the effect a work of art will have on people under anticipated conditions of life?

Thomas Munro, dean of American aestheticians, in his **Evolution in the Arts**[13] writes: 'Yet the task is not impossible. People and their responses are not completely different or unpredictable. Within a certain culture at least, one can sometimes predict with fair

143

success what the most common response will be in persons of a given type. Dealers, publishers, film producers and the like must do so in order to make a living. The fact that prescientific aesthetic technology now seems absurd, over-simplified and rigid does not prove that it was totally false or unworkable. It seems to have worked fairly well as long as artists and their patrons willingly thought and felt in this way, and while it coincided with the general climate of baroque culture. People had not yet acquired the romantic aversion to rules and mechanical devices. These were never sufficient in themselves to guarantee good art, but could be put to good use by a Racine or J. S. Bach as a part of his total resources. If artists and critics again look more favourably on science, these eighteenth-century attempts at an aesthetic technology can be corrected, developed, and refined.'

[1965]

¹ The estrangement between the natural sciences and art is caused, I believe, much less by scientists, for the objectives of their work are much clearer and, although many are insensitive to works of art, they are not antagonistic to those who play with human emotions.

² The term 'applied sciences' as used here refers to those activities involving the development of new devices, techniques and processes which may require knowledge beyond that accumulated by the basic sciences. These activities differ significantly from those of technology, farming, clinical medicine and practical politics which are essentially repetitive, but none the less just as important to society as the basic and applied sciences.

³ P.B. Medawar: **Koestler's theory of the creative act** in **New Statesman** 19 June 1964, p952, and 10 July 1964, p50.

⁴ The term 'visual arts' as used here refers to those activities involving the making of objects which are novel from the point of view of subject matter, of method of presentation and of accepted symbolism and convention. These activities are significantly different from those of making replications with minor variations from prototype art objects, and of adapting the prototypes for practical purposes, as in advertising.

⁵ George Kubler: **The Shape of Time** p26, Yale University Press, 1962.

⁶ C. H. Waddington: **The Scientific Attitude** pp24–35, Pelican Books, 2nd ed, London 1948.

⁷ J. Bronowski: **Science and Human Values** p27, Hutchinson, London 1961.

⁸ Mark Van Doren in **Creative America** p89, The Rich Press Inc, New York 1962, has expressed the following point of view: 'Before the creative spirit can be communicated to the young, or to those of any age who do not have it yet, it must be defined with all possible care, lest it be misunderstood at the very outset. Misunderstanding in this case can be serious: indeed, it can be fatal to the spirit in question. And the commonest form of misunderstanding consists of supposing that man ever does create anything

– that is to say, causes it to come into existence, brings into being or origi-
nates it. Man simply does not have that power, though sometimes he seems
to think so. His genius and his glory lie in an altogether different direction:
he is an imitator, not a creator.

'... The scientist and the artist are alike in that they begin with existence,
and go on from there to imitations or reconstructions of it, which by their
brilliance can blind us to the fact that nothing after all has been brought into
being. All that has happened is that being itself has become clearer and more
beautiful to us than it was before. This is a superb achievement, and it does
not belittle man to claim that he is capable of it. Rather do we then perceive
his ultimate, his incomparable distinction.'

[9] **Scientific Creativity – Its Recognition and Development** p12,
edited by C. W. Taylor and F. Barron, John Wiley & Sons Inc, New York
1963.

[10] J. Barzun: **Science: The Glorious Entertainment** Secker & War-
burg, London 1964.

[11] Cf. preface by M.A.Coler to **Essays on Creativity in the Sciences**
Ed. M. A. Coler, ppxv–xviii, New York University Press, 1963.

[12] F.W.Baughart and H.S.Spranker in a report on **Group Influence on
Creativity in Mathematics** in **The Journal of Experimental Educa-
tion Vol31 No.257** 1963, conclude that 'the contribution of the group has
been overly emphasised. In none of the five research studies completed did
the group factor make any contribution to problem solving. On the contrary,
there seems to be a consistent, if slight, advantage to solving problems alone.'

[13] Michel Seuphor: **Mondrian – Life and Work** pp142–143, Thames
and Hudson, London 1957.

[14] Thomas Munro: **Evolution in the Arts** p401, The Cleveland
Museum of Art, 1963.

K

Four stages in the construction of the Lumidyne system
kinetic painting **Ladders to the stars** 1965

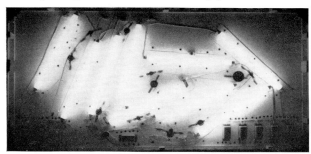

I.
Lights and
rotor drivers installed

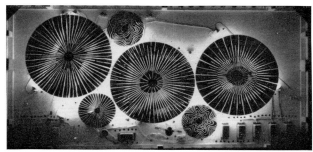

2.
Painted transparent
perspex rotors installed

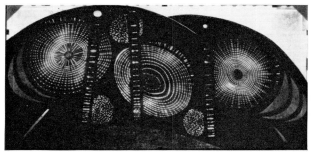

3.
Painted transparent
perspex stator installed

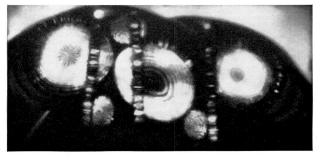

4.
Transparent perspex
diffusing screen installed

Frank J. Malina

Constellation series 1960
Ursa major (upper right) and three versions of **Cygnus**

Frank J. Malina

Audio-kinetic painting set up

The movement of the picture is controlled by the sound intensity
of a gramophone record

Frank J. Malina

Kinetic column 1961

Nicolas Schoffer : Microtime

The problem of time, whether it be physical or psychological, is of particular interest now. It is one aspect of the question that specially preoccupies us, that of time looked at as a malleable substance that can be formed and deformed at will.

If we study time as a substance in flux, the process of visual perception will greatly help us in identifying its minute fragments, which I call 'microtime'.

It is known that a succession of delays accumulate along the whole path of an image, running from the retina to the brain through the optic nerve, causing a break between the moment when this image strikes the eye and the moment it is perceived consciously as such. Let us consider this instant (of the order of one 30,000th of a second): it is of prime importance for, in fact, it is within this microtemporal fragment that an event is really constituted. Besides, this fragment of time enables the brain, whose transmission rate of visual information is limited (sixteen images per second), to make a choice from among this information. One can imagine then the enormous range of energy in this minute delay, which can be intensified or diversified, and is consequently malleable.

Indeed, what happens here but an intensification, a diversification of microtime if an ever-greater number of images per second is conveyed to the retina, forcing the brain to make a choice from within an ever-widening range? Besides this, so that the choice doesn't tend towards the periodic, and so that the visual transmissions have some aesthetic significance, it needs the creative artist to mediate, armed with new techniques and in particular those making use of light.

Cinema or television, which tend to give a specific structuration to successive fragments of time, would appear suitable mediums. But their technical make-up, as well as their pressure of commercialisation, considerably limit their possibilities of expansion on the artistic level.

If a pencil of light is emitted for an extremely short time, say, a millionth of a second, and by using reflectors revolving at high speeds a microtemporal ray obtained, this can be given a specific orientation, through systems of static and mobile reflections, having well-defined inter-relationships in space and time. A variety of programmes can be introduced: in the colours of the light beams, their intensity, their sequence and order, as well as the rotation speed of the mobile reflectors. Likewise, the amount of light emitted can be increased, and the course planned made more complex. In this way we obtain an extremely wide register, ensuring an infinite variety in the proportioning of visual information, from which, according to their range, conscious perceptions make their choice.

We should consider the intention which controls the working out of all the structures: the possible paths of the microtemporal rays and programmes, colour, luminous

intensity, intermittence, speed, etc. If this intention is guided by essentially aesthetic preoccupations: that is to say, if structures and programmes are conceived in their entirety as a work of art, then we may speak of a real control over time.

It is important to add that this use of microtime on the aesthetic plane can emerge in very different fields, such as psychology, psychosociology, neurophysiology, and probably biology and genetics as well. But this is only an illustration of the enormous possibilities of microtime. For, as we shall see, this microtime which I call 'perceptual', is only one microtime among others, seemingly less malleable it's true, in the present state of our knowledge, but quite as rich in promise.

Conceptual, virtual and perceptual

Still on the plane of perception, let's now try to analyse the internal structure of an action, of an event.

It is clear that in the ordering of the flow of events, only the past is truly perceptible, while the present is virtual and the immediate future merely potential. This brings us to distinguish three stages in an action; future, where it is to be conceived; present, where it takes place; and past, where it is seen as an event. Now we know that this last stage corresponds to a **perceptual microtime**. In the same way, we can say that the action is projected forward into a **potential conceptual microtime in advance**, which later becomes concrete in a **virtual microtime nucleus**.

More precisely, we have in microtime-in-advance a kind of directional placing of the physical event, and at the same time a preliminary branching out of perception in this direction in order to receive a message which is as yet only potential. Or, if you like, it produces a fairly powerful projection of energy, bringing about a condensation of it in a particular direction. When this condensation reaches saturation point, the liberated energy operates in the chosen direction, carrying with it a whole chain of events which unfold and become concrete in virtual microtime. Lastly, in the third phase, which I call 'post-action' or 'retro-action', the retro-active mechanism of perception is an internal function of perceptual microtime.

The fundamental problem of time is thus posed once more.

What are the factors which incite these vacillating movements from the conceptual to the virtual, and from the visual to the perceptual? What are the relationships between the three micro-units of time? Do they retain their quality during this alternating process; is this quality improved or degraded? What are the possibilities of manoeuvre with each one of them, or between two, or between all three at once? Can one interfere with their sequence or their energy ratios?

A whole field of research is thus opened up to us, a field whose exploration would allow, for example, the conversion of retro-emitted energy into a new advance action, or into virtual action. As an absurd illustration of this possibility, we could imagine a powerful station picking up solar energy which it would condense and restore to its circuit, even into the original conditions of transmission. By going further, in sending the sun's rays back to their source, one could provoke a terrifying 'Larsen effect' causing, if not an explosion of the sun, at least serious disturbances in the solar system itself.

To escape from the temporal scale

This theory of microtime, better than any other means of probing the infinitely small, makes us aware of the bias and inadequacy of our Einsteinian conceptions of space and time. It is very probable that our ideas of duration, beginning, end, limit or threshold should be revised. It is very probable that the universe, as man imagines it, is only part of a much vaster group of macro-systems and micro-systems, with different temporal and even non-temporal structures, animated by a kind of respiratory motion conforming to an infinitely varied rhythm, being mutually sustained and certainly having neither beginning nor end. In short, there may be an entirety the complexity of which goes far beyond us, prisoners that we are within our narrow spatio-temporal scale. Our only chance is our intelligence, our ability to transcend. Microtime can be the sole basis of approximate reference in a tentative measuring of these hitherto incommensurable systems which envelope us. It can also be a way, however narrow, by which man, casting aside his scale, penetrates other structures, temporal or non-temporal.

It is here that we come back **to art,** the sole human action that goes beyond us and guides us at the same time, **and which alone gives man, through the intermediary of man, a substance superior to him**.

In the infinity of the universal aesthetic evaluation

Artistic creation is distinguished from all other action by its impression of permanence, since the work of art from its conception veers towards a non-temporal order. The reasons for this veering, which is an essential condition of aesthetic success, we should also like to believe are connected with a certain manipulation of microtime, bringing about an enrichment of it. Let us return to our triptych of advance-action, virtual action, and retro-action.

It seems that in the case of an 'action' of artistic creation, the advance-action is always influenced by a retro-action, with a view to its reconversion. Between conceptual microtime and virtual microtime 'reconverted microtime' should be inserted therefore. This is a

Nicolas Schoffer

fragment of time, reflected in accordance with an order approaching the ideal in our temporal and spatio-temporal systems, seized from the infinite of universal aesthetic evaluation. This should be imagined as a mass, radiating in all directions, spatial and temporal, constantly retro-active in relation to our systems, with inexhaustible reserves always available, which sustains with its substance life as we know it. In short, this aesthetic, non-temporal universe would be an image of a kind of deity.

Art, Science, Religion

In this perspective the character of primitive art, always religious and sacred, is evidence of the first sign of an awareness of this divine essence of the aesthetic universe, an awareness which only today has taken on the clarity of a revelation; today, in a world where scientific and technical preoccupations dominate . . .

But already, by recognising in art the quality of transcendence and the power to make it explicit, we can free ourselves from mystical confusion. And the time is not far distant when one will see the artist and the scholar reconciled in a common exploration of temporal structures. At this stage of evolution, then, an infinite evaluation will be increasingly and abundantly opened up to man. Art will seem like the real nucleus of the energic-temporal mass of all the known and unknown universes, even as the breath of universal life. And this notion of a kind of God will appear clearly as a non-temporal and permanent phenomenon, active and retro-active, receiving and transmitting, omnidirectional and random, but above all omnipresent and limitless. It will appear thus even to those who, having caught on to this idea (or who are picking it up) are compelled to follow in a logical way its penetrating but endless path, never wholly achieving contact.

[1966]

Nicolas Schöffer

Spatial microtime

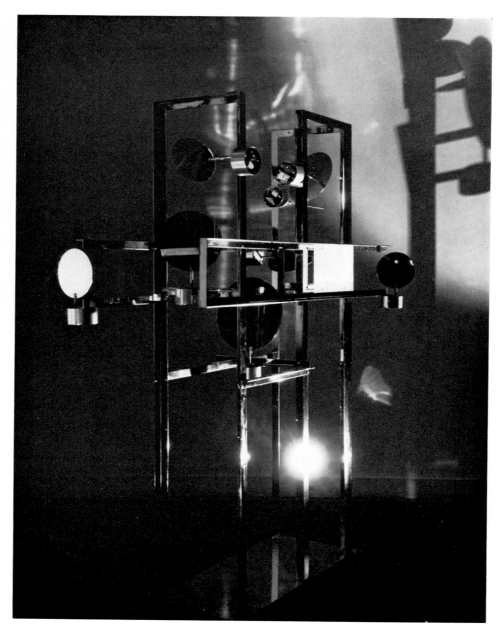

Nicolas Schoffer

Microtime 13

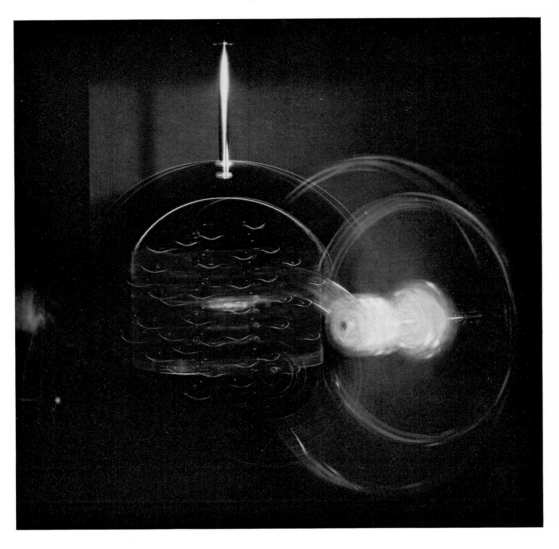

Nicolas Schoffer

Microtime 23

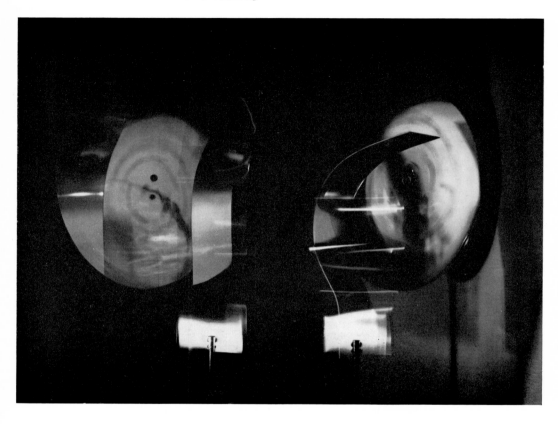

Nicolas Schoffer

Microtime 15

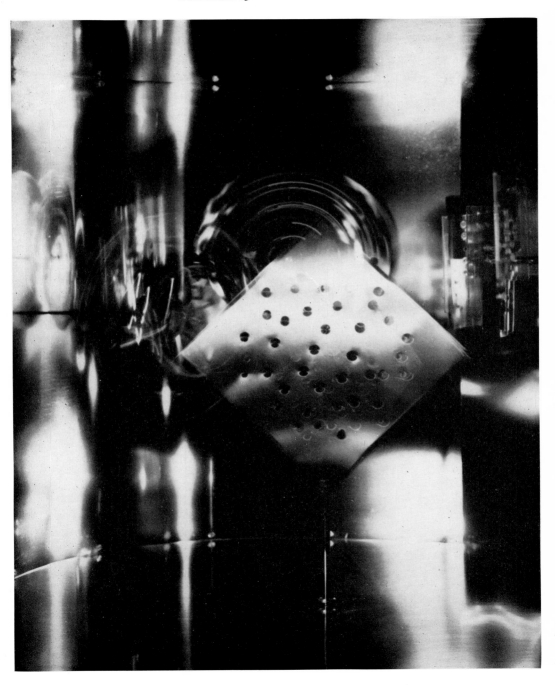

Luis Tomasello : Atmosphere, movement and colour

In the development of concrete art the main event has been, and still is, that of fixing a colour upon a real plane. We know that our perception of colours for physical reasons causes them to appear to detach themselves from the picture plane and to move in opposite directions: in depth within the limits of the picture surface and from this surface towards the spectator.

No doubt the structural black rules in the painting of Mondrian when his work was predominantly in static equilibrium, were used to balance the values and fix the position of the colours on the surface of the picture.

It is understood therefore that painting on a plane surface is invariably based upon illusive effects. I have decided that the illusory separation shall become a reality, and consequently have chosen to work in three dimensions.

I attempt to make the jump not only for the reasons I give above but also because I am convinced that the possibility for new developments in the picture plane has been used up, and it is my belief that the geometry of painting now comes into play in problems of movement and in kinetic art.

The forms I use are therefore spatial, but they are subordinated to the plane upon which they are located and from which they operate in the direction of the spectator (anti-perspective). The repetition of forms or other elements which I use, whether they be cubes, solids, voids, cylinders and so forth, disposed in series, add up to **the spatial surface**.

Before working in three dimensions I executed in 1957 some works which were in two dimensions and kinetic, and in which I used the square as the usual element in the composition. Now this square within the space has become a cube. The harmonic properties of the cube lead me into composition of a purely mathematical nature. They lead also towards an understanding of the problem of light which I am investigating. Joined to a surface by one edge, six sides of the cube are free. According to the incidence of light, one face of the cube reflects it with a greater intensity than three others which have varying reduced values, and the colour is placed on the two faces directed towards the plane. The colour on the internal face of the cube, attached to the plane, creates reflections on its surface and radiates an atmosphere of chromatic luminosity. **Colour is projected by form and vision becomes sensation.**

After the first objects in white and black with external facets of colour, I arrived at an extensive simplification in which I used white upon white. These objects without any black or colour which is directly visible, operate in a climate of spirituality generated by the colour which is reflected.

The impressionists captured an atmosphere by transposing it on to

the canvas. In the objects with which I work an equivalent effect is produced in concrete terms.

The function of light is resolved into a fundamental aspect of the work and this makes it an ever-changing object. According to the time of day, the incidence of light and the spectator's changing viewpoint, the objects are transformed. The sun, or a natural light, gives the ideal illumination to appreciate the endless variations of these dimensional objects. The shadows projected by the elements appear to have colour, translucence and movement. **Movement** originates not only in the changing viewpoint of the spectator but more particularly in the intensity and movement of light itself. My investigations are carried out within the field of concrete art. My point of departure is to be found within the work of Mondrian in particular, a master whom I admire and who towards the end of his life opened up new directions.

When he replaced the black rules on his canvases with lines of colour, later broken into parts and loosened, as in the Boogie-Woogie series, did not this also imply a kinetic use of the picture plane?

My **objects** unite within a single **plastic** expression both sculpture and painting, and leave open their eventual integration with the architectural environment.

[1965]

Luis Tomasello

Réflexion 1960

Luis Tomasello

Réflexion no.50 1960

Luis Tomasello

Atmosphère chromoplastique no.110 1963

Luis Tomasello

Atmosphère chromoplastique no.117 (detail) 1964

David Bohm : On the relationships of science and art

In order properly to understand the relationship between science and art it is necessary to go into certain deeper questions, which have to do with what underlies both these forms of human activity. The best point of departure for studying these questions is perhaps a consideration of the fact that man has a fundamental need to **assimilate** all his experience, both of the external environment and of his internal psychological process. Failing to do so is like not properly digesting food, thus leading to the ingestion directly into the blood of foreign proteins (such as viruses), with destructive effects, resulting from their failure to work together with the body-proteins to form a harmonious over-all structural process. Similarly, psychological experiences that are not properly 'digested' can work in the mind as viruses do in the body, to produce a 'snow-balling' state of ever-growing disharmony and conflict, which tends to destroy the mind as effectively as unassimilated proteins can destroy the body.

Whether one is discussing food, man's natural and social environment, or ideas and feelings, the question of assimilation is always one of establishing a harmoniously ordered totality of **structural relationships**. Ever since the earliest days, man seems to have been in **some ways** aware of the need to do this. In primitive times, science, art and religion, interwoven to form an inseparable whole, seem to have been the major means by which this assimilation process worked.

Science was concerned not only with practical problems of assimilating nature to man's physical needs, but also with the psychological need to **understand** the universe, ie, to assimilate it mentally so that man could feel 'at home' in it. Early creation myths, which were as much scientific in their aims as religious, certainly had this function.

As for art, it evidently helped man to assimilate the immediately perceptual aspects of experience into a total structure of harmony and beauty. It is clear that **the way** a human being perceives with his senses helps, in large measure, to make him what he is, psychologically speaking. The artist not only had to observe nature with a certain kind of objectivity that could be called the germ of a 'scientific' attitude (eg, in order to get the kind of images and ornamental patterns that he wanted), but he also very probably had an unusual sensitivity to the beauty in nature's forms and structures. By expressing this perception in the form of artistically created objects, he also helped other people to see in a more sensitive way. In addition, his work ultimately led to architecture, as well as to decorative art, which helped man to create around him a physical environment that he could assimilate, into a relatively harmonious structure of perception and feeling.

Although our main interest here is the relationship between art and science, I do not think that it is possible to understand this properly without paying at least **some** attention to religion. Religion has been concerned centrally with the question of experiencing **all** life,

all relationships, as one unbroken totality, not fragmented, but whole and undivided. As an excellent illustration of this fundamental aspect of religion, I am reminded of an ancient Hebrew prayer that I learned as a child, which ended with the injunction to 'love God with all your heart, all your spirit, and all your might'. I took this to indicate that this was really the way one is meant to **live**. One sees in this example (as in many others that will come to the mind of the reader) that a key function of religion was to teach a kind of self-knowledge, aimed at helping man to be whole and harmonious in every phase of life. To this end it was necessary, of course, to cease to be concerned excessively with narrow interests, of self, family, tribe, nation, etc, which latter tend to break the psyche of man into conflicting fragments, making a whole-hearted **total** approach to life impossible.

Of course, man's efforts at harmonious assimilation were misunderstood by many and became confused, thus leading to destructive results. Science for example, extended the possibilities of war, plunder, and enslavement, with its attendant miseries far beyond what primitive man could do. Religion became a means of supporting the established order of society against the natural tendency for such an order to change with time. Such support was founded on speculations concerning a supposedly eternal supernatural order, which also came to give comfort and reassurance to people on the basis of illusory notions. But these functions are destructive, because **any** idea held solely in order to give pleasant feelings or to assure the stability of a particular custom or organisation, must ultimately lead people to think in terms of comforting and apparently satisfying illusions, rather than in terms of what is true. In this connection, art was often interwoven with religion, with the purpose of backing up the illusory aspects of religion, by giving these aspects a false air of reality and concreteness, in the form of beautifully and skilfully made images and symbols of gods and supernatural forces. Similarly, scientific ideas were restricted and distorted, so as not to disturb the prevailing religious mythology.

In view of the destructive effect of illusions, of the kind described above, it may be said that the most significant implication of science is less in its many positive achievements than that it teaches us to look at facts in an unbiased way, **whether we like it or not**, and that it is meaningless to do otherwise. Indeed, one of the main points that I wish to make in this article is that such a **scientific spirit** is necessary, not only in what is commonly called 'scientific research', but also in art and in every phase of life, and that without this spirit, human actions are continually in danger of deteriorating into a mere response to illusion, leading to conflict and destruction.

In modern times the functions of science, art, and religion have become fragmented and confused. Science developed at an unparalleled pace in technical directions, but it seems to have parted almost completely from its role of aiding man to assimilate the universe

David Bohm

psychologically, so that he could feel at home in a world that he understands and to the beauty of which he can respond inwardly and whole-heartedly. On the other hand, it seems that artists are not generally very seriously concerned with the scientific interest in seeing the fact, **whether one likes it or not**. Indeed, it seems that many artists (though, of course, not all) have rather widely tended to accept the current view, which regards human relationships, expressed in culture (including art, literature, music, drama, etc) as a field that can be manipulated at will, in order to give pleasure, excitement, entertainment, and satisfaction, quite apart from questions of fact, logic, coherence, etc, that are of central importance to the scientist.

As for religion, its function has grown even more confused still. Science has made it impossible for most people to accept the religious mythology literally. What is left is a vague and confused notion of some kind of God, along with various fragments of self-knowledge in the form of moral precepts.

Science and art have tried to take up some of the functions of religion, but so far in a rather confused way. Thus, the science of psychology aims at a kind of self-knowledge, leading a person to try to make a 'useful' and a 'profitable' adjustment to society. But man's essential illness today is his feeling of fragmentation of existence, leading to a sense of being 'alien' to a society that he has himself created, but does not understand. Thus, he cannot assimilate his whole field of experience into a totality felt to be beautiful, harmonious and meaningful, with the result that a mere 'adjustment' to the current state of affairs is not felt by most people to be really adequate.

Art has also entered the field of self-knowledge. Many artists have tried in their work to **express** the present state of confusion, uncertainty and conflict, probably hoping that if these are given a visible shape and form, then somehow one can obtain mastery over them. This is a resurgence of a primitive 'magical' way of thinking, a way that may have been the best that primitive man could do, but that is surely inadequate today, even if it was perhaps somewhat useful in earlier times. The fact is that no conflict is ever resolved **merely** by expressing it in visible or audible form. One may perhaps feel better for a while in doing this, but actually the conflict generally goes on as before, the better feeling being largely based on illusion. As was clear in the best teachings of ancient religions, the proper way to deal with conflict is to look at it directly by being aware of the full meaning of what one is doing and thinking.

Science can now help us to understand ourselves in this way by giving factual information about brain structure and function, and how the mind works. Then there is an **art** of self-knowledge, that each person has to develop for himself. This art must lead one to be sensitive to how his basically false approach to life is always tending to generate conflict and confusion. The role of art here is therefore not to provide a symbolism, but rather, to teach the **artistic spirit** of

166

sensitive perception of the individual and particular phenomena of one's own psyche. This spirit is needed if one is to understand the relevance of general scientific knowledge to his own special problems, as well as to give effect to the scientific spirit of seeing the fact about oneself as it is, **whether one likes it or not,** and thus helping to end conflict.

Such an approach is not possible, however, unless one also has the spirit that meets life wholly and totally. We still need this **religious spirit**, but today we no longer need the religious mythology, which is now introducing an irrelevant and confusing element into the whole question.

It would seem, then, that in some way the modern man must manage to create a total approach to life, which accomplishes what was done in earlier days by science, art and religion, but in a new way that is appropriate to modern conditions of life. An important part of such an action is to see what the relationship between science and art **now actually is,** and to understand the directions in which this relationship might develop.

One of the basic reasons for the present tendency of science and art to remain separate and apparently not closely related is the current scientific view of the universe. In earlier times man believed that he had a central role in the universe, which helped give meaning to his life. With the Copernican revolution, the earth came to be regarded as a grain of dust in an immense, meaningless mechanical universe, while man was seen as less than a microbe on this grain of dust. Surely, this view has had a very great psychological impact on mankind, quite generally. But is it true that science **necessarily** implies a completely meaningless and mechanical character to the universe?

Some light is thrown on this question by considering the fact that most scientists (and especially the most creative ones such as Einstein, Poincaré, Dirac, and others like them) feel very strongly that the laws of the universe, as disclosed thus far by science, have a very striking and significant kind of **beauty**, which suggests that deeply they do not really look at the universe as a mere mechanism. Here, then, is a possible link between science and art, which latter is centrally oriented towards beauty.

Now, there is a common notion that beauty is nothing more than a subjective response of man, based on **pleasure** that he takes in seeing what appeals to his fancy. Nevertheless, there is much evidence that beauty is not an arbitrary response that happens to 'tickle' us in a pleasing way. In science, for example, one sees and feels the beauty of a theory, only if the latter is ordered, coherent, harmonious with all parts generated naturally from simple principles, and with these parts working together to form a unified total structure. But these properties are necessary not only for the beauty of a theory, but also, for its truth. Of course, in a narrow sense, no theory is

true unless it corresponds to the facts. But as we consider broader and broader kinds of theories, approaching those of cosmology, this notion becomes inadequate. Indeed, as has recently been pointed out in a television programme by Professor Bondi, who is an authority in the field, we now have two rival cosmological theories, one due to Einstein, and the other to Hoyle. The unique new situation prevailing at present is that, for the foreseeable future, it will not be possible to make experimental tests that could discriminate between these theories on a factual basis. We shall then have to decide between them firstly on the basis of **beauty**, and secondly on the basis of which one of them helps us better to understand the general facts of science, ie, to **assimilate** such scientific experience into a coherent totality.

To throw light on this newly developing kind of situation in science, one may note that the word 'true' has a spectrum of meanings, lying between two limiting cases. First, as has already been indicated, a 'true' idea corresponds to the facts. But then, 'true' also means 'true to self', as when we talk about a 'true line' or a 'true man'. In the broad sense with which cosmology is concerned, the universe as a whole is to be understood as 'true to itself', ie, a unified totality developing coherently in accordance with its basic principles. And as man appreciates this, he senses that his own response with feelings of harmony, beauty, and totality is parallel to what he discovers in the universe. So, in a very important way, the universe is seen to be less alien to man than earlier excessively mechanistic points of view seemed to indicate.

Here, it seems, is a key link between art and science. For to the scientist, both the universe and his theory of it are beautiful, in much the same sense that a work of art can be regarded as beautiful – ie, in that it is a coherent totality, in the way described above. Of course, the scientist and the artist **differ** in a very important respect. For the scientist works mainly at the level of very abstract ideas, while his perceptual contact with the world is largely mediated by instruments. On the other hand, the artist works mainly on creating concrete objects, that are directly perceptible without instruments. Yet, as one approaches the broadest possible field of science, one discovers closely related criteria of 'truth' and 'beauty'. For what the artist creates must be 'true to itself', just as the broad scientific theory must be 'true to itself'. Thus, neither scientist nor artist are really satisfied to regard beauty as that which 'tickles one's fancy'. Rather, in both fields structures are somehow evaluated, consciously or unconsciously, by whether they are 'true to themselves', and are accepted or rejected on this basis, **whether one likes it or not**. So the artist really needs a **scientific attitude** to his work, as the scientist must have an **artistic attitude** to his.

It seems to me that in the question of truth and beauty, one finds what is really the deepest root of the relationship between science and art. On the basis of this understanding we can now study the relationship of science and art more broadly.

David Bohm

In early days both science and art tended to work largely in terms of images, representations, symbols, etc. Thus in science it was commonly thought that theories and instrumental observations were simple reflections of the world as it is. Later, it became evident that such a simple reflection process cannot give the whole story. Each theory and each instrument selects certain aspects of a world that is infinite, both qualitatively and quantitatively, in its totality. According to modern physics (especially the quantum theory) when one comes down to the atomic and subatomic level of size, the observing instrument is even **in principle** inseparable from what is to be observed, so that this instrument cannot do other than 'disturb' the observed system in an irreducible way: and indeed it even helps to create and to give form to what is observed. One may compare this situation to a psychological observation, which can likewise 'disturb' the people being studied, and thus take part in the process that one wants to learn about, as well as 'create' and shape some of the very phenomena that can be observed.

There has been in physics a gradually increasing awareness that scientific theories cannot be mere reflections of nature. Rather, as has recently been suggested by Kuhn,[1] they are more like 'paradigms', ie, simplified but typical examples, the study of which illuminates nature as a whole for us, by revealing the essential relationships that are significant for observation and experiment. In a similar way, the physicist's instruments enter into a 'paradigm relationship' with natural processes at the atomic levels, in which these processes reveal their essential order and structure in a simplified but 'typical' way. Once we understand the paradigm relationships we can look afresh at nature in all its complexity, and see it in a new light, in a wide range of more particular and limited kinds of questions.

Now it should be evident that artists also make what may be called 'paradigm' structures. No good picture is exactly or even mainly a **mere** reflection of its subject matter. Thus, a painting by Rembrandt is not just an image or symbol of the person who appears in it, but rather, by heightening certain features and simplifying others, the artist brings out a 'typical' aspect of character, having a broad or even universal human relevance. So science and art have **always** been deeply related, in this way, because both have **really** been concerned mainly with the creation of paradigms, rather than with a **mere** reflection or description of subject matter.

The move away from imitative representation of nature in science, and toward the creation of what may be called a 'pure paradigm', was anticipated by a corresponding movement in mathematics. Thus, mathematical expressions were originally regarded as **symbolising** the properties of real things. But with the development of what is called the 'axiomatic approach', mathematical expressions ceased to be regarded as **basically** symbolic of something else. Rather, they were **initially** given no meanings in themselves, all their meanings being in their relationships

to other terms in a theory, these relationships having to be expressed as purely abstract **mathematical operations**. In this way they became elements of **structures of ideas**. Just as a brick in itself does not represent or symbolise anything else, but has all its 'meaning' in the structures that can be made of bricks, so a mathematical term gets all its meaning by participating in mathematical structures, created and developed by mathematicians and scientists.

Parallel with this new approach to mathematics, the notion of scientific theories as 'paradigms' rather than as symbols, representations, or simple reflections of nature, fits quite naturally. Such theories are creations of the scientist, evaluated partly on the basis of their beauty – ie, harmony, order, 'elegance', unified totality, etc, and partly by their ability to help us understand broad ranges of scientific fact – ie, to assimilate them into a yet broader coherent structure. Such understanding includes the ability to suggest new relationships that are worthy of further investigation, both theoretical and experimental. Thus, the theory plays a dynamic and creative role, not restricted to a mere passive understanding of what is already known, but also going on to 'keep ahead' of knowledge in certain ways, anticipating what may come later, as well as suggesting new 'paradigm relationships' with nature, to be established in experiment, and to serve as a basis for further theory creation on a yet higher level.

It seems very interesting that the development away from representation and symbolism and toward what may be called 'pure structure' that took place in mathematics and in science, was paralleled by a related development in art. Beginning with Monet and Cézanne and going on to the Cubists and to Mondrian, there is a clearly detectable growth of the realisation that art need not represent or symbolise anything else at all, but rather that it may involve the creation of something new – 'a harmony parallel to that of nature' – as Cézanne put it. It is surely significant that this direction of evolution has been continued in a now very active school of art, which has included those who are called by various related names, such as 'constructionists' and 'structurists'. Although these artists are by no means in complete agreement as to their aims and beliefs, one can see in their work and in what they write the implication that ultimately the artist must start from certain basic (and generally three-dimensional) structural elements, which have in **themselves** no meaning, but which participate in forming a structure created by the artist, and which in this way take on all their meaning. As happens with scientific theories, such artistic creations can be beautiful in themselves, and also serve as simplified paradigm cases of structure, throwing light on the general nature of structure, as perceived directly at the level of the senses (rather than as mediated by scientific instruments). In this way, art too can play a dynamic role, corresponding to that of science, because it is able to lead to new ways of perceiving man's environment, and these in turn can become the basis for further artistic creation on a yet higher level.

It seems remarkable that science, art, and mathematics have thus been moving in related directions, towards the development of what is, in effect, a mode of experiencing, perceiving and thinking in terms of **pure structure**, and away from the **comparative, associative, symbolic** method of responding mainly in terms of something similar that was already known earlier in the past. Such an approach is as yet in its infancy, so that there would be little reason, especially in a brief article of this kind, to attempt to evaluate the works of specific artists, scientists, or mathematicians with regard to this trend towards taking structure to be the essence of all experience. It seems sufficient at this point to call attention to the very widespread evolution in related directions in several different fields of human endeavour.

To me, the principal significance of this direction of evolution is that it has the potentiality for indicating a new kind of response to all types of experience. That is to say, one has seen in mathematics, science and art a set of paradigm cases in which one can respond directly to perceived structures and not merely in terms of a comparative, associative, symbolic evocation of habitual patterns of ideas, feelings and actions that were laid down in the past. Such a possibility, presenting itself most simply in these fields, may then be realised more broadly, ultimately perhaps spreading to the whole of life. In this way, it is possible that an important contribution could be made to solving modern man's problem of creating a more harmonious and whole-hearted approach to life. For a great deal of the fragmentation of existence has always derived from attachment to habitual modes of thinking, perceiving, and action, which are no longer appropriate, and which tend to come into conflict with the structure of the fact as it is. Anything which can teach man what it means to see this fact afresh, creatively, even in some restricted set of fields, such as the sciences, art, and mathematics, could also help in changing man's general approach to life in a corresponding way.

In view of the deep relationships between art and science that have been indicated here, what is the proper kind of connection between scientific and artistic work? It is first of all clear that there is no reason for scientist and artist simply to imitate each other, or mechanically to apply the other's results in his own field. For example, it would evidently be of little use for the scientist to begin with a particular work of art and try to translate or adapt its structure, so that it would become the basis of a scientific theory, expressing the laws and regularities of nature. For the scientist must think in terms of **abstract axiomatic concepts** and **instrumental data**, which are extremely different from the basic **perceptual structure** of space, light, colour, and form within which the artist works. To be sure, science and art have had a common origin in the distant past. But meanwhile, these two in reality complementary ways of coming into contact with the world have diverged and become very different. Their real unity is therefore to be apprehended only in a rather subtle way.

What the scientists can learn from art is first of all to appreciate the artistic spirit in which beauty and ugliness are, in effect, taken as sensitive emotional indicators of truth and falsity. Here, one must run counter to the popular image of the scientist as a cold, unemotional sort of fish, interested only in 'hard headed' practical extensions of man's mastery over nature. If one talks with typical scientists one soon discovers that, in fact, few of them have more than a secondary and incidental interest in practical applications of their ideas. Such a discussion soon reveals that what really interests scientists most deeply is the development of an understanding, leading to the assimilation of nature. Thus, many physicists are tremendously excited by the notion that **all** matter, from the most distant galaxies to the earth, including human beings, is constituted of similar atoms. In this way, they feel that somehow they are mentally assimilating the whole universe in which we live .And some of the most creative scientists (such as Einstein and Poincaré) have indicated that in their work they are often moved profoundly, in a way that the general public tends to believe happens only to artists and other people engaged in what are regarded as 'humanistic' pursuits. Long before the scientist is aware of the details of a new idea, he may 'feel' it stirring in him, in ways that are difficult or impossible to verbalise. These feelings are like very deep and sensitive probes, reaching into the unknown, while the intellect ultimately makes possible a more detailed perception of what these probes have come into contact with. Here, then, is a very fundamental relationship between science and art, which latter evidently must work in a similar way, except that the whole process culminates in a sensually perceptible work of art, rather than in an abstract theoretical insight into nature's structural process.

What can the artist learn from science? Here, it appears reasonable to me to suppose that as no particular work of art can be simply adapted or translated into a scientific or mathematical theory, so no particular theory of this kind can simply be translated or adapted to determine the structure of a work of art. Instead, I should think that what the artist could appropriately hope to learn from science is something far more subtle than this. First of all, it must seem that he could appreciate the scientific spirit of an unbiased objective approach to structure, which demands that it be internally coherent, and coherent with relevant facts, **whether one likes it or not**. Understanding that this requirement is just as relevant in art as in science, one may thus perhaps be helped to see why art is not properly to be considered as an arbitrary action, intended mainly to give pleasure, satisfaction, or emotional release. Rather, just as scientific truth is found to be inseparable from artistic beauty, so artistic beauty may be seen to be inseparable from truth in the scientific sense, when the latter is given its broadest possible meaning.

To be sure, the scientist must test his truths with the aid of instrumental observations and mathematical equations, while the artist must do so with direct perception,

in a more subtle way, that is much harder to explain verbally. In spite of this difference, however, it seems to me that art has, and always has had, a certain factual aspect, in the sense that a good work of art must be coherent in itself, as well as with the basic natural laws of space, colour, form, light, and of how they must be perceived. It does not seem to be really possible for the artist to manipulate these in a completely arbitrary way, directing his work **merely** by the criterion of producing something that is pleasing to himself and to other people (although it must be said that many artists and art critics write as if this actually was the case).

Finally, there are more specific ways in which the scientist and the artist can learn from each other about **structure**, which is really of central interest in both fields. The fact is that the deepest and most general scientific ideas about space, time, and the organisation of matter have their roots largely in abstraction from perceptual experience, mainly visual and tactile. The new evolution of art can help open the viewer's eyes to seeing structure in new ways. As has already been indicated, the value of this to the scientist is not basically in the particular idea that a work of art or a statement by an artist suggests. Rather, it is in a new general understanding of structure at the perceptual level, which is relevant to every field of experiencing. From this, the scientist can form new abstract ideas of space, time, and the organisation of matter.

I have personally discovered that through talking with artists and correspondence with them, as well as through seeing their work. I have been greatly helped in my own scientific research. The main effect of these contacts was to lead me to look with a fresh view at structure as I perceived it directly with the senses. As a result, it became clear to me that current scientific and mathematical notions of structure may have only limited domains of validity. For if one looks again at the kind of perceptual contact with the world from which existing scientific and mathematical concepts have ultimately been abstracted, one sees that a great many as yet unexplored directions of abstraction have, in reality, been open all the time. In this way, the mind is freed to consider new ideas of structure, rather than to go on with comparative, associative symbolic thinking in terms of habitual patterns laid down in the past.

What has been described above may well indicate an important potential direction for the evolution of a further relationship between science and art. Vice versa, new scientific notions of structure may be significant to the artist, not so much because they suggest particular ideas to be translated into artistic form, but rather, because if they are understood at a deep level they will change one's way of thinking about **everything**, including art.

In this connection, I have discovered in my scientific work that in the long run it is less important to learn of a particular new way of conceiving structure abstractly, than it is to understand how the consideration of such new ideas can liberate one's thought from a

vast network of preconceptions absorbed largely unconsciously with education and training and from the general background. It seems to me that with regard to this question of preconceptions, the situation should be basically similar in every field of creative work, whether this be scientific, artistic, or of any other nature. For by becoming aware of preconceptions that have been conditioning us unconsciously, we are able to **perceive** and to **understand** the world in a fresh way. One can then 'feel out' and explore what is unknown, rather than go on, as has generally been one's habit, with mere variations on old 'themes', leading to modifications, extensions, or other developments within the framework of what has already been known, either in one's own field or in a closely related form in some other field. Thus, one's work can begin to be really creative, not only in the sense that it will contain genuinely original features, but also in that these will cohere with what is being continued from the past to form one harmonious, living, evolving totality.

More generally, it seems clear that everyone, whatever his field of work, could benefit from the kind of creative liberation of perception as a whole that is implied by a deep understanding of the relationship between science and art. For this would help free both the abstract intelligence and immediate sense perception from conditioning due to preconceptions and habitual responses at various levels. An understanding of this kind would, however, require a much more thorough exploration of the question of the proper relationship between science and art than has been carried out in this article.

What is most relevant in such an exploration is to discern the basic and essential **differences** between the scientific and the artistic ways of observing and understanding structure. The harmony of these different but complementary modes in which a human being can respond to the world will surely constitute a much deeper and more significant relationship than would a mere similarity of certain concepts of structure in the two fields. And this harmony must evidently depend on questions that are more fundamental than those that can be properly treated in terms of either field alone, questions such as those involved in understanding what is really to be meant by beauty, truth, order, structure, creation, etc. By giving deeper insights into these, a study of the relationship of science and art can enrich both fields, as well as many other aspects of human life, which also arise from these deep roots. For these roots are at the basis of man's process of assimilating all experience into one dynamic and creative totality, a process on which depends his physical and mental health, his joy in life, and ultimately perhaps, the continuation of human life on this planet.

[1] T. Kuhn: **The Nature of Scientific Revolution** University of Chicago Press 1963.

Constant Nieuwenhuys : About the meaning of construction

The word 'construction', used in relation to art, evokes the image of an activity that is essentially opposite to the common concept of painting as a means of personal expression. In the slang of Parisian art critics, the term 'abstraction froide' – cold abstraction – was used during the fifties, to accentuate the 'cool' climate of any non-individualist conception of art. The counter-term 'abstraction chaude', or warm abstraction, was never used and would have sounded ridiculous. This can only be explained if we consider the negative and disapproving meaning of the term 'abstraction froide'.

The constructivist movement in art arose in the first period of mechanisation, the tendency of constructivism being typical for industrialising countries. Constructivist artists are very much aware of the presence and the influence of machines, and many of them feel solidarity with the workers in industry – they are inclined to want to be workers themselves. There is a romantic side to this worshipping of machines and mechanical craftsmanship. But if we consider the historical fact that artists have always been dependent on the non-working upper classes in society, we can understand that constructivism could only derive from a social revolution that put labour forward as the source of richness and culture. Hence it was the most logical form of art in Russia during the years that followed the revolution of 1917. And in the other countries of Europe where industrialisation began to have its impact on daily life, constructivist ideals arose that were always connected with interest in the life of the working classes; sometimes with feelings of solidarity with the proletariat and with ideals of a new socialist society. We may therefore consider the 'arts and crafts' movement in England in the nineteenth century as a forerunner of constructivism, although the 'arts and crafts' movement was distinctly against machinework. We should not forget however that the role machines play in constructivist art is rather superficial.

The works of constructivist artists are handmade, and if they use products of industry as their material the same thing can be said of the arts and crafts people who used such products as machine-woventhreads, plywood and chemical colours. In spite of the machine cult that characterised some earlier constructivists, especially in the Soviet Union, their relationship to mechanisation should be seen against the background of social changes that affect the social position of artists as well. The constructivists more than any other artists are aware of the decline of individualism, and they strongly feel the need of an objective style that allows them to get hold of social problems that are connected with the new position of the artist in industrial society. The extreme consequence of the constructivist tendency was the functionalist doctrine that consciously reduced creativity to a function of labour, and thus gave up art itself as the adventurous, the ludic activity it really is. Functionalism has proved to be a very resistant theory that still subsists in architecture, and certainly in town planning, as the dominating conception. I think, however, that the

meaning of constructivism in our day is essentially other than that of the constructivist movement in the beginning of this century. The process of mechanisation in the higher developed countries has gone so far now that human labour will no longer be the principal force of production. Automation, especially, allows an increase of free time that makes the idealisation of labour senseless. The main problem of our time is not the organisation of industrial work but the recreation of the unemployed 'worker'. But a worker who is unemployed continuously ceases to be a worker. Not the labourer but the player, not 'homo faber' but 'homo ludens' is the type of man to whom the future belongs.

This entirely new situation incites us to a new interpretation of construction that goes in an opposite direction to the way that once led to functionalism. The ideology of constructivism – parallel to that of socialism – is no longer bound to the idealisation of labour, but on the contrary will lead to the ideal of the liberation of the former labourer from the need of production, the liberation of the labouring masses whose creative forces until our time have been wasted in activities that were simply necessary to keep mankind alive. The task of the artists – at least in the highly developed industrial countries, but sooner or later all over the world – is the preparation of a culture that will activate the total creative force of all humanity.

If we think of the establishment of such a culture, we are no longer speaking of spare time for the labourers, in relation to the creation of a culture, for the simple reason that the distinction between 'labourers' and 'cultured' upper class is an old-fashioned one that will be abolished. Labour can be done by the machines, and the machines can be controlled by cybernetic units. Creation is the specific faculty of man, a capacity that will employ the total energy of everybody.

The construction of a new type of culture, that in the real and positive sense will be a mass-culture, is the only purpose of a further development of constructivism. Constructivism has nothing to do with a demonstration of individual fantasy, as is the case with the American 'happening'. It will go beyond the present conception of material construction and beyond the conception of a sociological and psychological construction. The artists of today have abandoned the art of painting – and of sculpture and architecture as well – because they don't believe any longer in the 'expression' of their personality, without an integration of this personality in a more complex system that will enable any individual to reach a higher level of creative power. This higher level will be the collective culture of a future society in which there will no longer be labourers and creators, but in which labour and creation will be synonymous. I have called this future society New Babylon and I have tried to trace its most characteristic features in the maps and the models of urban mass-culture I have made during the past ten years.

[1966]

Spatial construction (detail) 1958

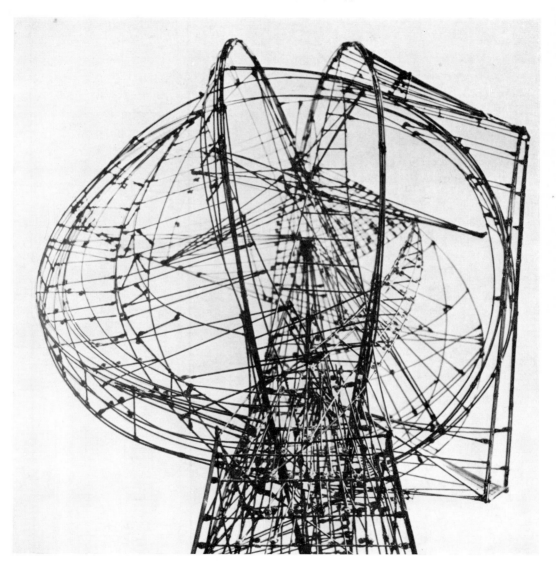

New Babylon (model) 1958–61

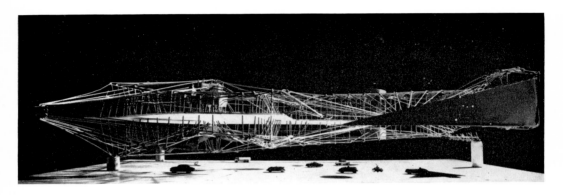

New Babylon: Concert hall for electronic music (model) 1958–61

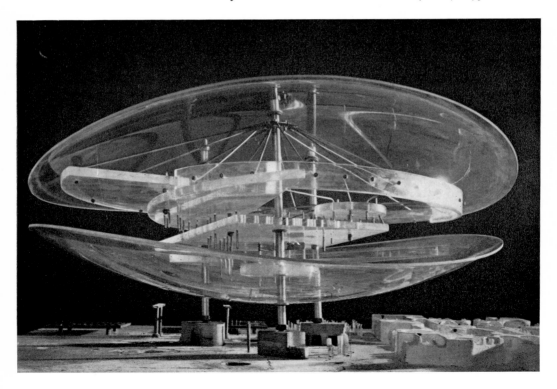

New Babylon: yellow sector, exterior (model) 1958–61

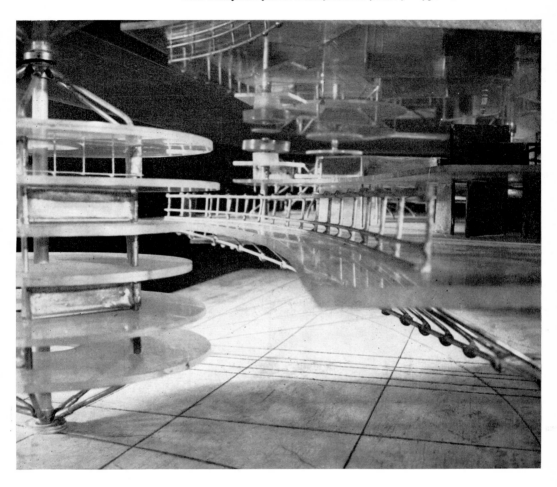

Abraham Moles : The three cities

Cette espèce pourtant se plaint, donc elle existe. [Valéry]

We live in a society of changing values. Until now it has always been thought that man's aspirations were superior to his accomplishments and he was eternally dissatisfied, his situation in society always giving him too little scope for what he would like to be able to achieve. The whole of our social structure and philosophy is based on this imperfect balance. The individual wants to acquire, that is to say to incorporate into his personal world, objects or acts belonging to the world of other people, of nature or society. He intends to expand his personal sphere, which he calls 'vital space', incorporating in it the greatest number of outside elements. In exchange for this he must offer something of himself; his past or present work or creation accumulated as his potential wealth. It is this vector of action or acquisition which defines the 'homo faber' of the philosophers – he who makes through incorporating a part of nature into his personal world – that 'homo oeconomicus' of the nineteenth century who sought to get the most he possibly could from his fellow creatures while giving the least possible of himself. This vector of action defines the extreme-Western civilisation itself which tries to devour the natural and social world and overflow into the cosmos.

It is the idea of this conquest, be it that of the individual in his social milieu, or that of a group, despite the constraints of nature which is an optimalisation of the ratio gain/loss. This can be materialised in a 'balance', exemplified functionally from a statistical angle by Zipf's famous 'law of least effort', shown in a particular instance by the economists in the notion of 'fair price'. 'One gets nothing for nothing' is perhaps one of the fundamental axioms of our social life, so deeply rooted in our mores, so completely inherited from centuries of scarcity that it has become part of our religion in the form of the idea of the guilt of happiness so aptly illustrated in the myth of Polycrates' ring. King Polycrates was happy. Feeling so happy that he could wish for nothing more, he thought his fate was too exceptional to conform to worldly laws and that his happiness could only be destroyed if he did not cajole the fates by inflicting a penance on himself. Among his riches he had a beautiful ring which he particularly treasured. He decided to sacrifice it in the sea. But the gods refused his offering: a fish swallowed the ring which a fisherman then recognised as belonging to the king and returned it to him. Polycrates, seeing this incongruous restitution as a sign from the heavens, tried in vain to rid himself of the fetish without success and finally lost both wealth and tranquillity in this desperate enterprise.

This complete reversal of all values is perhaps what Nietzsche prophesied, but it has materialised in a way he doesn't seem to have foreseen. Economists suggest the idea of an affluent society living in an abundance of wealth, dissolving economic values where the ratio of surplus goods to demand implies a social mechanism based on consumption not production. The problem is, a competition for consumption. This society loudly proclaims its right to happiness,

a term which it regards as synonymous with affluence. One could call twentieth century man 'beatus possessor'. There is the instant satisfaction of desires, and the installation of machines in order to satisfy and maintain them. Dichter calls this the 'strategy of desire'.

The needs of modern man lie on another plane; the 'right to beauty'. This is where the work of art comes in.

The Work of Art is out of place in contemporary society. These emotive capital letters refer to the values of a vanished society preserved by romanticism in the culture frigidaire. No work of art is eternal any longer, despite the fact that the artistic **function** is inherent in the human condition. We live in a society of consumption: the word 'consumption' must apply equally to washing machines and gothic cathedrals. The new thing in the mass society is that it **consumes** the work of art, and the monuments of the past centuries are gnawed away by the tourists, each of them carrying off a morsel in the little box they carry and which has made the name of Kodak famous.

In fact, we live in a society based on the equality of the right to happiness. Everyone knows that beauty is a part of happiness, thus we are all entitled to Beauty; it belongs to everyone, that is to say, no-one. So the cathedrals and bridges will be divided into as many pieces as there are kodak cameras. Each one of us carries off his postcard, his fragment of an art work. If, in other times, masterpieces seemed to be eternal, it was simply that they were **big**; but it takes only a few billion happy insects to exhaust the reserves of originality.

Only twenty years ago, the ministers of Culture – or those who represented them – were complaining because lovers came to kiss in front of the **Birth of Venus**, not understanding that the real crime of these Sunday lovers lay elsewhere. They forgot that Botticelli had created his Venus for exactly this purpose and that all sensuality, the fundamental principle of artistic intelligence, gives a right of entry into the Temple of Art, with precedence over respect. They complained of lack of respect as if it were lack of understanding, as if to be understood the work of art had to be respected before being loved.

Today, the real cause of the death of Art is clear. Its decline isn't from the lack of respect shown to it, but on the contrary from too much comprehension of its nature by too many people. General education, tourist guides, the publicity given to values and the raised standard of living have simply done their job too well. Art culture is so well disseminated that nobody now would dare to admit to being bored by the **Mona Lisa**, because it has been too thoroughly set up as an idol for universal admiration. This galloping democratisation of the 'Unique' would be unimportant if the work of art was inexhaustible. If the Renaissance artists thought it unalterable this was because

doubtless in their time the number of people available to exhaust it was not big enough. From the moment that universal education lays down a universal table of values, Beauty within the reach of all purses (turn to the right and take the picturesque route number 276), the social body as a group intensifies its consumption of Culture. It is at exactly this moment that the word 'culture' becomes part of the religion of the welfare state. In the collective memory of this society, signs and their arrangements formalise and become banal: little by little they lose their originality and substance in proportion to the number of people who know them and can discuss them: the inexhaustible combinations become exhausted; **the work of art wears out by being looked at**. In this way the unique, rare and isolated pleasure of the individual in front of the gushing fountain of a beauty that submerges him, is replaced by the no less authentic pleasure of too great a number coming to drink at this fountain; if there are too many, sooner or later it will dry up. It is a quantitative problem! Global society in banalising works of art consumes them.

A new phenomenon has happened; the work of art fulfils its function too well. It is not destroyed by lack of understanding, but by its complete and honest understanding by everyone. Society is no longer split by the degree of comprehension and culture; everyone understands, and for those that have the misfortune not to, there are excellent manuals it is their duty to buy, thoroughly explaining all there is to understand.

Whether they like it or not the creators are also immersed in the global society; they do not practise any asceticism with regard to the television, cultural travels, or the great virtuoso's concert. Except in some pathological cases, they live in society receiving their ration of varied beauty, accepted and recognised: they take part in the great consumer movement. As human beings, they are playing their part in vulgarising the 'Unique'. But at the same time they feel, at least in their specialised field, the progressive exhaustion of all aesthetic values which results from the immoderate consumption by a society of which they are accomplices, willing or not.

They are therefore compelled to search for the new, inside their own field. Innovation is no longer necessarily allied to genius, it is bound to the function of the artistic creator. They see the artistic wealth of previous centuries slipping through their fingers, and the vulgarisation of every beauty in an inevitable process, bound up with the socio-cultural mechanism. If they don't want to betray their proper function, after having observed the exhaustion of all the arts, they can only renounce their actual existence or try to **renew the arts themselves,** that is to say, **to look for other arts**. The creative function has shifted from the idea of 'making new works' to 'creating new arts'.

If the artistic message includes a **semantic** element, explicable and translatable, and an **aesthetic** element linked to immediate sensuality; moreover, if as the aesthe-

ticians teach us, we know the degree of complexity acceptable to the consumer and if creative mastery is in any case limited by intelligence – for the consumer 'average' (by definition), for the genius (creator) 'superior' (by definition) – then there is a maximum tolerable complexity in a work of art. There are, consequently, universal rules, even if they are only of a statistical character. The frontier of all specific art **as a message** or as creation is fixed by this maximum beyond which lies the absolutely unintelligible, synonymous with disorder. The passage from the level of the creator to that of the consumer will be even more assured by artistic vulgarisation and by the collection of pocket art books. Where then, are the **new** arts to be found, if not in **sensory combinations**, the first stage in an operational research into the artistic function?

What does our society look like, then, and how does it grade its hierarchies, since that is the essence of social differentiation: the segregation into antagonistic classes, conscious of themselves and of their dissatisfaction, disappearing into a **meritocracy** where each is given a large enough slice of the economic cake to mitigate his obligations towards the others, but also small enough not to compromise distribution according to merit? Merit here is a token; according to Michael Young's definition, the composite product of the intellectual quotient through personal effort.

The social group is at present in the chrysalis stage. The old class structures of the socio-economic pyramid, based on access to wealth, are progressively dissolving in the Welfare State. Conversely, other structures emerge, resting on criteria of differentiation quite alien to economic status.

In the past, society could be seen as a pyramid of layers between those who had and those who had not, as illustrated in Hemingway's **To Have and Have Not**. Those who had not, wished to have, and those who had wanted to have more. Power was a hidden thing: social mobility was possible through the possession of wealth, power served wealth, which was a real end in itself. If there was ambition for pure power, it was only a pathological case. From now on society no longer is a pyramid, as Veblen, apropos American society, clearly expressed: possession no longer signify effective power; the capitalist millionaire passing his life on his Florida yacht would hardly be welcome interfering in the business of hiring or sacking X, Y, or Z in the firm he owns.

A new species, suggested by Burnham, is coming up. The technocrat, the administrator, the engineer, the director, the priest of the computer who alone is capable of interpreting its oracles: all these roles acquire a steadily increasing power based on efficiency, on competence, on work, on the burden of responsibility; in short on such a quantity of virtues that it appears very difficult to deny them this power. They are those who 'control the machines' and the

strike power of the technocrats, of which there have been very few known instances, has every chance of being as effective as their work.

The technocrat can provide the world with what it needs, administer wealth according to the optimality principle, appease conflicts in the name of common sense and reason, open and solve discussions, smooth over difficulties, and if he doesn't always succeed in this it is only due to the ill-will of the participants. The relations of the technocrat to political power are ambiguous: often they are those of the young turks towards the old pachas. His relations with the social mass are clear: he gives them what it asks for in optimum conditions and starts a public relations office to explain to those who may feel frustrated because they want everything at once, that one can't have one's cake and eat it. In fact he accedes to real power and from this point very little time is needed to eliminate nominal power by re-absorbing and assimilating it into the technocratic way of life.

What becomes of the intellectual in this situation? He has had a sorry fate in the bourgeois era. Coming from the bourgeois class he has been thrown out and branded because he wore his hair too long and refused to be married to the factory prepared for him, in order to err in the way of useless work, into creation without recognition, into asylums for misunderstood geniuses. He took risks but took them wrongly since what he was doing often opposed what was asked of him, and in any case was often of little use; everyone knows that new works don't bring in money and that new inventions never work. In the nineteenth century at least, they constituted an infallible way to lose money.

In the new society which is being constructed, the position of the intellectual changes with his social status. For one thing, he has put on a tie (often), his hair is a little less long and sometimes, the height of daring, crew-cut. On the other hand, the society of Enlightenment is soaked in culture, a thirst which it lacked somewhat in the nineteenth century. Our century has discovered that it cannot count on 'serious' people to make culture, for seriousness induces conformity, conformity induces loss of aggressiveness and thus of originality, creative culture being accurately defined as a **permanent secretion of originality**. Thus a place must be found in the establishment for the intellectuals. Of course this place will be carefully limited, like a swamp where ideas are created, the generation of ideas always being disturbing, and, what is more dangerous, sometimes disquieting. This is what Jean Duvignaud has called the **intellectual ghetto**. But since its recognition as such, running water and a standard of living have been introduced into it.

Moreover, the intellectuals have begun to organise themselves into a social hierarchy, based on their relative **degree of prostitution**. At the bottom of the ladder one

finds those who have completely prostituted themselves, that is to say, those who wholly accept society as it is, discovering within it a certain number of functions which exact a minimum of creative originality (but not too much) and who intend to fulfil one of these functions. They are assessed and paid according to talent; the size of their bathroom is tied to the relationship between their talent and the needs of society. Journalists of bravo-culture or of the thirty-sixth programme on the commercial channel, producers of extra-territorial competitive channels, middlemen in 45 rpm records, etc. If they are not at the top of the wealth élite they are in any case at the bottom of the intellectual pyramid. Nevertheless, they are certainly part of the intellectual city **de jure**: no syndicate of intellectuals could refuse them admission.

Then, as one climbs the pyramid by degree of prostitution one meets all those who have sold themselves for honours and to Public Service, not such a compromising sale as the others. If it involves external conformity and a tie, perhaps a red one, it does not necessarily imply the Legion of Honour. Backed by their security nothing stops them, except premature imbecility, from creating new ideas and practising as an intellectual officialdom.

Right at the top of the pyramid of Respect are found the really pure, those who have kept their long hair and their genius, without being unduly worried about the salary they are given, and by the same token, without feeling **alienated** by this salary. Consequently, they are still likely to have a valid conversation with the beatniks of Greenwich Village and the ascetics of the intellect who, while living polygamously in a hotel room with cold running water, are constructing the True Music of Tomorrow or the Theory of the Decline of the West. For this sort of thing still happens due to the inability of society to make appropriate provision for genius. Although our society has made great progress, it can only recognise genius when it is here and accepted; it remains quite incapable of searching it out.

We are at the point where the ghetto of the intellectuals has won a victory in that its existence is no longer threatened. Better still, it is not only tolerated but accepted as having a valuable function in the social world.

We see taking shape the next stage in this investigation of the values the technocrat points out as necessary for the harmonious functioning of a society: 'the right man in the right place'. After having defined the best place for the intellectuals, ie, in the ghetto, the next consideration is that if, after all, their ideas are unusable, perhaps the reason is that they aren't yet understood. One must not overstrain human ability, which was the error in the demands of the nineteenth century: expecting of an idea not only that it should be **good** but also that it should be all **ready for use**. There was perhaps a **contradiction** of terms, a fact the psychologists discovered

some time ago: it was not far-sighted and made for inefficiency to ask of an idea not only that it should be good, but also that it should be usable.

This is the discovery which is being made at the moment: the need for **packaging** and **conditioning** ideas which are ingenious but often unsound, transforming them into 'true' ideas by work that could very well be done by specialists, logicians and other erudite people.

In the name of efficiency the technocrats are discovering the usefulness of **specialisation** in the world of thought which they administer, through the channels of subsidies, foundations, prizes and officialdom. They are discovering the need for what Lazarsfeld calls the 'Third Man' in the field of mass communications, the one called upon to **interpret** the unintelligible ideas of the untouchable genius in order to render them useful. By this means they justify their function as officials whose job it is to make ideas work without having to create them themselves. There is also the function of an 'arranger' who transforms the profound genius of Alban Berg into the excellent musical scenario to be consumed by an appropriate audience (dressing up and conditioning of cultural products).

In short, it appears that a movement is taking shape among the patrons of modern society – business groups, money groups, efficiency groups – to retrieve the ideas of talented creators, whose evolution is itself the dynamism of society, fully accepting that their basic originality must be paid for by a lack of practical sense and awareness of consequences, and understanding the need to relate these applications by exploiting their originality and determining their soundness.

At all events, the intellectual is no longer a 'surplus man', as Turgenev portrayed him in nineteenth century society, but has a 'social function': the establishment offers him a means of livelihood by comfortably installing him in a well-heated monastery, a good way from the city, such as Marie Curie demanded in 1905.

Even so, would the intellectual who had taken stock of himself stay in his ghetto to fulfil there the function asked of him, without having any illusions about his capacities and without wanting to handle the levers of power, whose theory he knows so well? His instinct for play, essential to his creativity, would lead him to surrealist disorder, with disastrous consequences. It is essential that the intellectual shouldn't want to escape from his monastery and go from **The Bead Game** (Hesse) to the action at which he is so manifestly inept.

At the end of the nineteenth century the intellectual and the student were able to produce nihilism, something at which they excelled, and to invent the theory of permanent revolution. Unfortunately they couldn't render it really operational, although it has been care-

fully pragmatised by the bureaucrats of the Stalin régime, ancestors of the technocracy to come.

The image of the society of tomorrow will differ profoundly from the social pyramid dear to Pareto, which is demolished by affluence. It will restore everyone to neighbouring levels of abundance and prosperity, with certain differences; the worker will be in an Austin and the director in a Rolls, but this difference will not be large enough to carry with it any kind of social dynamism.

Society appears as a group of three cities: the first, which is immense, is that of the **administrated** whose table of values starts with **happiness**, and who have voluntarily relinquished all pretensions to self-government, since they are so comfortably organised by others, who themselves accept the burden of this responsibility and power.

The latter constitute the **second city**, that of the **technocrats**, who have absorbed the politicians in the name of 'specialists in political science'. This city is in size no more than one per cent of the preceding one, and lies on its border, from where it sends emissaries into the whole social body. Its scale of values rests on **efficiency, optimalisation, smooth functioning**, the **absence of conflict**. The citizens of the technocratic city are trying, like Creon, to make the world a little less absurd, to subject it to reason. By their very nature they are full of virtues and their only fault, perhaps, is presumption, shown in their unshakable certainty of being the sole positive expression of the Beautiful, the Just and the True. They accept their responsibility to make the world function, and find in efficiency the springs of a passion to devote their lives to, giving themselves up to examining the dossier on city drains at 11 o'clock at night to be ready for the Programming Commission the following morning.

The third and last city is surrounded by walls. It is that of the **intellectuals** who, besides coming from the same schools and universities and having the same intellectual quotient as the technocrats, represent all those who have given proof in some way of **active anarchy**, who are more interested in innovation than routine, in revolution than administration, in the idea than its realisation, in creation than in execution. Among them, too, is an important middle-class who live in the suburbs of the administered city. These are the **entertainers**, those in the lime-light of television, cinema or the press, who are talked about because of their talent, whether the breasts of the national heroine of female beauty or the artistic sensibility of the **Daily Magic** layout man. These last are directly subsidised by the technocrats, for they provide an excellent shield for the difficulties inherent in power.

The group can be broken down into two categories: those who have **talent** – see above – and those who have **genius**; conforming to the well-known distinction proposed by Edgar Morin. The talented in our own society are already paid directly in cash. Those who have

genius no longer starve, but they still feel themselves **dependent**, faced with the power of money, which without threatening their livelihood, assured by a secondary job, questions their success; the fruition of their works, those unrealistic 'ideas' that society is not yet wholly prepared to investigate and use.

But this is only a transient state and as we have indicated above the technocrats are realising little by little the need to establish an ambiguous but solid alliance between the technocrats' city, which needs a continual influx of new ideas for adaptation, and the intellectuals' city, which needs money and esteem. This is how the new social contract between the intellectual and the city will be drawn up, based on a **tacit**, mutual and permanent incomprehension; the intellectuals appearing to believe that the technocrats give them money to tear at the fabric of ideas and to give themselves up to delightful games of mental ingenuity, like **The Bead Game**, for the honour of the human spirit (De Broglie); the technocrats believing that the intellectuals are trying to improve man's lot by creating new values. The value fundamental to the intellectual society is **subversion**: in order to create, one must be 'against'; subversion carefully maintained by the amount of adrenalin in the blood, through indignation. The intellectual is inheriting the Platonic idea, the Hegelian synthesis, and Jewish dissatisfaction conveyed by Tucholsky's celebrated phrase; 'es is nicht so, es ist ganz anders' (it is not so, it is quite otherwise).

In this way the function of the intellectual city is harmoniously integrated with all its peculiarities into the social body: the intellectual is no longer outside 'the Egg', he is inside. The technocrat engages his services and pays him, is attentive to his ideas and knows how to reinterpret them when they are too abstruse for his own use (or for that of the administered towards whom he has the duty of clarity). Eventually he will turn to other (second class) intellectuals for this adaptation.

We are living, then, in a society where classes are disappearing and with them class antagonism, to be replaced by a system of three cities. The first is the **City of the Administered**, committed to **happiness**, with the vast majority inert and apolitical, comfortable consumers, in the process of putting the residue of power that it has retained from past revolutions into the hands of the public opinion institutes, the cultural specialists and those who willingly take on the overwhelming weight of responsibility. It is not a question of the administered opting out, but of a bargain which is based on an extensive interpretation of the division of labour.

The **City of the Administrators** or technocrats is on the fringe of the former one. It accepts responsibilities and worries. Its value lies in its efficiency, its pleasure is power. It consists of the humble technocrats with their braided caps: bus conductors, post office

Abraham Moles

employees, undisputed owners of a small amount of power, painstakingly delimited by Max Weber: related parts in an harmonious pyramid. They are protected by their basic education against the follies of religion and things vague, they are hostile to overseers. Their respect for precision and efficiency is strengthened by their awareness of possessing power themselves.

Lastly, if not in the desert at least on the outskirts of the big City, is the **City of Intellectuals**, creative and revolutionary in essence, attentively run by the technocrats who let a controlled disorder prevail, reconciling an orthodox distribution of water with sexual surrealism and a moderate crime rate. But goods made in the automated factories, the joys of the pleasure industries, mass entertainment, holiday camps are not excluded from the intellectual's city. Like other people, the intellectual has a right to the material things of civilisation to which his work contributes, even if negatively. If his ethics are those of self-mastery, this should not deprive him of tinned lobster or the delights of the supermarket.

However, among all that the intellectual can create is a theory of how to make use of the world, that is, how to exploit affluence for his own ends. We have seen above how in a mass society affluence brings with it alienation, aimlessness and resignation. The boss is the slave of his slaves, the housewife of her refrigerator, the family man of his television or car. If, for the intellectual, **the problem of alienation is posed in the same terms, it is not necessarily resolved in the same way**. At least one other element intervenes on his mental horizon: the fear of stupidity, fostered by his aggressiveness.

In other words, the existence of Cinerama is not absolutely synonymous with the crassness of the cinema, and if television is a powerful statistical tool in the 'cultural mosaic', that doesn't prevent it being used as a tool of serious culture. This needs discipline and effort, but these are precisely the qualities most inherent in the intellectuals. It is the problem in reverse: how to make use in the intellectual city, of affluence and the powerful resources surrounding it but which are foreign to its nature. How can the intellectual city retrieve for technical civilisation its proper aims, subject them to real values, to culture and spiritual power, to the discord essential to creation, to the dialectic of the simple and the complex, to the necessary erethism and joy. There must be an intelligent way of using collective vulgarisation, even if we don't fully understand it. If Guinness distributes thousands of copies of a fine print by Hogarth on the intellectual's underground line, thus saving him the need to visit the Wallace Collection, this latter does not **necessarily** become a victim of drink propaganda. It is possible to exploit cleverly the riches which the affluent society provides, without being compelled to take its counterpart, the alienation which they convey but do not contain.

The supermarket, the triumph of modern society, can have two

189

functions; that of forcing the consumer, drunk with advertising, to buy snail forks he doesn't need, through suggestion; and that of providing a wonderful glitter of light and colour, creating a new landscape, expressing a new beauty, composite and unintentional.

The artist who goes into the supermarket armed with a camera and a surrealist spirit finds an intoxication of lights, sounds and colours, in the perspective of tins reflected in the anti-shoplifting mirror fixed to the ceiling, the kaleidoscope of shelves, and captures all this in his surrealist camera, making from it a pure image of modernity, essentially revolutionary and quite detached from the consumption of snail forks. Intoxicated by the residue of romanticism, too many artists still go off to do Turners in the countryside but shun the stations, production lines and oil refineries, seeing in them only elements of the alienation they are fighting, and overlooking the discovery of images 'there for the taking', to be detached from the manufacturing context which instigated them.

Here the multiple function of the spectacle and form to be found in modern society is defined, for outside the aesthetic theme taken up by the surrealist camera running along the supermarket shelves there is another for the intellectual artist to use for his own ends, instead of being made use of as a consumer unit.

What are the ethics of the technocrat at the saucepan counter (administrator of the supermarket, employer of the saucepan designer or psychologist responsible for consumer research)? If they were to propose a doctrine, a set of rules based on illusion, they might say that in the hardware department you are offered the salesgirl's smile, the sensuality of her blouse, the play of glittering reflections on aluminium, the inexhaustible commercial obligingness, and, into the bargain, you can buy the saucepan. Perhaps it is possible, while conforming to the rules of the game, to accept the smile, the light reflections and the sensuality but to refuse the saucepan. It is precisely this kind of behaviour that the technocrat wants to avoid, but he has been unlucky enough to make it a rule of the game. If the technocrat, as a producer of **The Bible** in Cinemascope, can spend millions in hiring the breasts of female entertainers and succeed in selling stupidity to the consumer of **The Bible**, he can't stop the operator of a Greenwich Village cinema club from borrowing, free of charge for publicity purposes, a fragment of the seventh reel and running it upside down during a show of cinematic art. Deprived of the significance of its Hollywood story, it takes on a beauty from its vast perspectives and the Technicolor which no member of the film club could afford, while immunising the audience against the canyons of Colorado and its mass-produced Indians through its deliberate incoherence.

The ethics – that is to say, not the moral but the behavioural conditions – of the intellectual who lives apart from, and yet in the midst of the vast consumer society, be he

mathematician, poet or cinéast, are a consequence of the form taken by liberty in this new society. Not so long ago this liberty was restricted by blockades, walls erected by the law to denote forbidden zones where no-one could go. In the punch-card society the restricting walls of the law take on a more and more important extension, tending to become closer together. This could be expressed by the practica more important extension, tending to become closer together. This could be expressed by the practical rule, likely soon to replace the Declaration of the Rights of Man, that 'all that is not forbidden is compulsory', a notion taken from totalitarianism and capable of being imposed through happiness. The field of liberty would then be reduced to nil: man being totally integrated into the social system which brings him Happiness.

The philosophers have already anticipated all this. In fact it isn't easy – even for the technocrats – to join up the blockades of the law; in all systems there are **interstices** between these walls, but these interstices become so narrow and complex that the average person is incapable of discerning a perspective through the maze. An exceptional IQ and dedication are needed; it is so much simpler not to bother. But it is precisely the intellectual, driven by a subtle and aggressive spirit of antagonism, who is as capable as the technocrat trying to fill up the interstices for him, of searching them out in the walls of the law and finding in the maze a route to **liberty**.

To do this, creativity is needed, a way of everyday life, a revolutionary strength. The intellectual draws them from the basic values of his city: absolute opposition, surrealist ferment, despite his relatively modest means compared with the consumer. He will accept the evidence, long denied for idealist reasons, that the supermarket salesgirl is, and can only be, an **object**, there to be used. He will appease his conscience with the thought that utilisation is not destruction. He will avail himself of the salesgirl in the same way as he does the reflections on the saucepan that he is spared from buying. When coming out of his Theleme Monastery without rules, in order to penetrate the world of interstitial liberty, he will be equipped with a small shopping list, thus defying the market research specialist.

The technical world is vast and beautiful if we know how to put its meaning into parenthesis. Why not make use of it?

Eli Bornstein : Notes on structurist process

In this essay I shall attempt to present some notes on the creative process in which both the artist and the work are involved. I must stress the word 'notes' since I am not setting forth any definitive polemic on method, technique or philosophy of art creation. I attempt rather to illuminate structurist process through my own experience in a manner closely akin to the character and operation of the process itself. One encounters a major difficulty at the outset. Words in writing, reading or speaking form a continual unilinear chain moving in time and space, link by link, whereas the creative process is multilinear or, more correctly, a mosaic of interwoven and overlapping processes sometimes occurring simultaneously and sometimes at widely separated intervals of time. Since the creative process is in a continual state of growth and change, it cannot be fixed in time. Consequently in these 'notes' I have tried to avoid some of the distortions inherent in the verbal medium, by suggesting the mosaic of multiple components characteristic of the creative process. Furthermore, many aspects of this process operate on an unconscious or non-verbal level. I have encountered unexpected, and indeed surprising, values and meanings in attempting to explore and communicate something of structurist process in words. My hope is that it may prove of some interest to others.

The process of creating art is a complex one, just as man himself is complex. ('Truth is never pure, and rarely simple.') However one may approach it, it will never be complete since as process it is endless. Particular movements or directions in art, individual artists' life spans, and specific art works are mistakenly viewed as beginning or endings of the process. If as Whitehead said, 'the process itself is the reality', all attempts to isolate single elements of the process cannot help but be unreal or distortions of reality.

My attempt here will not be to give a detailed account of my own procedures in creating a structurist relief, but rather to present what are for me pertinent underlying experiences that may reveal something of the character of the process, its goal and results. I shall avoid attention to the technique of construction or use of materials since I regard these as incidental means, as tools utilised by the process to realise or achieve its end, even though they do relate to the final character of the work. 'How to do it' presentations in art are usually quite pointless for reasons of mistaken identity – 'how' being mistaken for 'what' and 'why'.

As in nature, the creative process in art feeds on and is nourished by many things including its own creations. My points of departure in these notes will be a consideration of the multiple sources of my art, and something of the interaction among these sources. I shall try to answer the questions : Where does the work of art originate? On what is it based?

I have written elsewhere about the primary sources of art creation;[1] origins of structurist art;[2,3,4] evolution and other conflicting concepts.[1] The notes that follow will

Eli Bornstein

fall under the over-simplified headings of **nature, history**, and the **artist**. The order in which they are presented is incidental for they are interactive, overlapping, and do not operate in any isolated order but function together as a whole. These headings will be repeated in capital letters wherever pertinent to emphasise their interrelationships. I shall attempt to move from general observation to the more particular, and conclude with some specific comments about the process of creating a structurist relief.

 Nature in its widest sense is the primary source of art creation. As a source it is infinite, and all art through time can be seen as man's changing and evolving orientation to and awareness of nature. The visually perceptible growth process of nature at all levels and its ever-changing character are a continual source of wonder and delight to the artist. I see the love of such living wonder as the underlying raison d'être for the creation of art. Denial of this source leads to a devitalised and abortive art without potential for further development or growth. There is always a conscious return to this underlying source, however long the fallow intervals. History demonstrates this repeatedly.

 History in its widest sense refers to the process of man's development and change. It includes all his accumulated knowledge in all fields of endeavour. Each generation forms a minute part of the great span of an historical process. All that we are and accomplish arises from the past. I see history not as a grab-bag for revivals of novelty, but as a vital source for securing consciousness of one's origins and potentialities. I see history as the source from which the artist can find answers to the questions: 'Who am I (as artist)?' 'Where am I (as artist) going?' 'What am I (as artist) doing?' Just as the artist as a human being answers these questions of identity through his own personal history (ie, the human archaeology of psychoanalysis), so he can only answer the questions of his functioning as artist by following the history of art from the earliest dawning of civilisation. I see history as revealing direction for further growth and realisation of new potential. Although there were many periods in the past where a consciousness of history hardly existed, mythology of one kind or another filled this need. Today, however, as part of a literate culture that began with the birth of writing and printing we consciously pursue, accumulate, and disseminate every kind of knowledge. Consequently it is no longer possible to function meaningfully outside of historical context. To ignore history, to distort or falsify history in order to satisfy particular wishes, is always done at great peril. Today we witness many superficial interests in history within the world of art, where self-consciously fashionable creations of art are processed as instant-history. We see critics and writers madly straining to graft history on to fashionable creations in an attempt to give sustenance to what has not emerged through this source to begin with. The problem of seeing history is of course complex and difficult and for this very reason distortions and perversions occur

easily. Only history itself as process confirms, denies, or modifies all human perspectives.

I see the **artist** functioning in society as a creator of visual beauty, joy, delight and wonder. I see the artist as creating, communicating and expressing cognition and awareness of unique levels of reality through his art. As Henry David Thoreau put it: 'All that a man has to say or do that can possibly concern mankind is in some shape or other to tell the story of his love – to sing.' Like Orpheus the artist's role is to enchant, as nature itself enchants, and to do so by forever extending and liberating man's consciousness and vision.[5] Today the artist popularly assumes every conceivable role: the artist as sociologist (pop art); as psychologist (abstract expressionism, action painting, surrealism); as scientist and optical researcher (op art); as mystic and philosopher (non-art); and a multitude of other roles. Rarely do we see him function as artist. The social alienation of the artist that we hear of so often; the inconsequential nature of his activities as related to the most vital generative aspects of our society, such as science, technology, etc; are in no small part due to the submission by artists of their most vital role. Mass communication disseminated with electric speed popularises every kind of art more widely and quickly than ever before. The sheer quantity of art and the number of artists invoke Gresham's law – that a flood of bad money soon drives good money out of circulation. Never before has the artist been bombarded with so many seeming choices of undifferentiated alternatives, temptations and distractions. With all the turbulent volume of information increasingly confronting him, the artist is more likely than ever to pass through his own era as its victim, without consciousness of its unique content and potential. The choices each artist makes, and even more important the underlying criteria he uses consciously or unconsciously to make these choices – in other words his motivations for making the kind of art he chooses to make – determine ultimately the kind of values his art will have.

The only meaningful footing the artist has, as I see it, is in the primary sources of **nature, history**, and himself as **artist**, functioning interactively within this trinary context. All other sources – however temporarily sustaining, successful, or rewarding – are desultory and in the end misleading.

The word 'process' that I have used repeatedly implies the element of time through which the process unfolds. Time is an extremely important element in the process of creating art. It is equally important in the unfolding appreciation and awareness of what has been created. It is as if the winding-up of energy and sources necessary to the creation of a work of art requires an equal or more lengthy period of unwinding for absorption of what it is. (We are still in the process of absorbing and assessing the impact of the Renaissance, impressionism, photography, Cézanne, Mondrian and all that they led to. The consequences of all of these revolutions have by no means been fully absorbed.) This element of time is usually overlooked by critics and taste-makers.

194

Eli Bornstein

History often demonstrates that the slow evolution of true comprehension and judgment reveals the impatient critics of each period as they usually were – hopelessly bewildered and blind when they should have been most alert. They are literally blinded by their own impatience and the impatience of their profession, as if art were merely something to keep voraciously gobbling up and spewing out. (The critic who said 'I really don't know' wouldn't last long as critic. Sensationalism and invective are his stock in trade.) The artist himself soon realises how vital the element of time is in comprehending and assessing his own creations. He is continually fraught with disappointment for not 'realising' (as Cézanne put it) what he seeks to create. He soon recognises that this time-lag is characteristic of the creative process and painfully learns to live with it. He learns the importance of ideas which flow back from his own creations. The failure to accept this condition, or the attempt to circumvent it, only leads away from art itself. Time, then, is a vital ingredient, both in the creation and in the recognition of art.

Man's preoccupation with space is a fascinating subject whose history has yet to be fully documented. Science is presently reaching out to the interplanetary space of the vast universe, and to that of the minutest structure of matter. Psychological investigation since Freud continues to explore the inner 'space' of the mind, and the process of cognition itself. Media of communication which function as extensions of man's sensory or nervous system[6] have shattered all pre-existing boundaries by explosions and implosions of technology into space. In acoustic space the sequence has run from speech to writing, printing, telegraph, telephone, radio, electronic computer; in visual space from drawing and painting to photography, cinema, TV; and in optics to electron-microscopes and radio-telescopes. In art the preoccupation with plastic space, both two and three-dimensional, has concerned man from his earliest perceptions of his environment. From the time he discovered the walls of his caves and started to create images and organise surfaces, through his creation of sculpture, temples and churches, man has continued to explore visual and tactile space. The Renaissance rediscovered the illusion of space through perspective. Impressionism discovered the illusion of light in space through colour. Cézanne discovered the realisation of space unique to painting, through juxtapositions of colour planes. The early attempts of cubism, and subsequently those of Mondrian, carried this discovery beyond the illusionary, mimetic and representational relationship to subject matter already liberated by photography. In sculpture a similar exploration of tactile space occurred from the Renaissance through impressionism and cubism to constructivism, moving through volume and gradually opening out into space through planes. Both in painting and in sculpture, abstract or non-mimetic art evolved. Visual painting and tactile sculpture moved in an exploration of space from mimesis to abstraction to invention and creation. Structurism now explores the visual-tactile organisation of real colour and form in space

and light, parallel to nature's creations. Structurist art has reinstated the tangible and tactile as a visual-tactile art. I do not mean that the perception of a structurist relief is achieved through the hands or sense of touch, but rather that the relief is kinaesthetically tactile, as is real colour-form in space and light. It is thus multi-dimensional and affords multiple points of view and multiple aspects through changing light, as **nature** itself, and architecture, do. As in **nature** and architecture, the sensory response goes beyond the illusionary and visual where the space is 'felt'; the structure is 'felt' by being within and around it.[7] Here is an art of spacial creation utilising elements of past media of painting and sculpture, and emerging as a unique medium that is neither painting nor sculpture in the traditional sense. As a spacial visual-tactile art structurism can contribute to the future transformation, understanding and creation of our environment.

Structurist art is further unique as an attempt to infuse new levels of vision, meaning and content into abstract art, and to carry it beyond its present impasse. The confrontation of the problem of abstraction by Mondrian and Kandinsky in painting, and constructivism in sculpture, has characterised the crisis of art in our time. The appearance of abstract art raised the problem of how to carry it beyond the decorative, ornamental or barren vaccuum which seemed to many its ultimate destiny. Countless retreats have been made from this crucial problem, as can be seen by the many directions that art has taken since the problem first arose. Cut off from the sources of **nature** and **history**, many artists have turned to mysticism, psychology, sociology and science, or retreated to elaborations and futile repetitions of past forms of art.

All of the above may seem to have strayed far beyond the more specific process of creating a structurist relief, yet I see these 'notes' as the foundation upon which structurist process operates, and without which the process is meaningless. In another place I have discussed the problems of development and growth that confront the structurist artist.[4] For the **artist**, then, the process unfolds through the evolved vision of **history** and **nature** and **art** itself. The new structurist medium has for its elements: form (volume through plane); colour; light; and space (limited three-dimensionality through full three-dimensionality). The organisational principle underlying the inter-relationship of all these elements is: Structure. This medium continually reveals itself, through cognition and recognition, and through the actual experience of working with these elements. The process is further fed by cognition of **nature**'s structure and growth process. New possibilities unique to this stage of development in the art are thereby suggested. The attachment to **nature** is to its visual manifestations of colour-form-structure in space and light as building process, and not to the specific imitation of appearances of given forms. Whereas the elementary 'building blocks' of the structurist **artist** are as yet extremely limited by knowledge, experience and materials, the 'building blocks' of **nature** are infinitely varied, luxuriant and intricately lavish, yet

sublimely simple. When we look at a tree, or flower, or blade of grass, for example, ideas relevant to the art are suggested. **Nature** here can suggest structural potential in terms of utilisation of form, space, colour and light relationships. These are translated into terms relevant to the stage of development of the art. The process in realising a specific work, as far as I am concerned, does not feed on mathematics, science or technology, even though such relationships may be observed afterwards. Technology may be utilised in the form of tools or machines as means of fabrication, but mathematics, science and technology as such are not initial sources from which the work springs. No equations, no theorems, no formulae. The work springs from visual cognition of primary growing **nature** – its spacial, tactile, and tangible colour-structure in light – as suggestive of further growth within the limitations of the art. The art then suggests new ways of looking at **nature**, which in turn opens up further expansion of the existing limits of knowledge in the art. The whole interactive process is a continual pressing towards further expansion of awareness and creative expression. **Nature** and **art** can be looked upon here as parallel creations which use similar processes, although the **artist** is barely beginning to utilise the immense and endless potential of **nature**. Here the **artist** is creating art in **nature** as **nature** itself creates.

An 'idea' for a work occurs, based upon vision of past work and **nature**. This idea is worked out through drawings. The drawings themselves are a very limited projection of ideas and are, at best, far removed from the tangible three-dimensional character of the work. Yet drawing serves here as a limited notation and visualising device whereby the artist's experience 'fills in' as much as possible of what cannot really be indicated in the drawings. The development of any idea suggests almost infinite possibilities of further development and variation. The choosing of a single idea for development, from among many, is based upon which idea seems expressive of most potential. The next stage is to create an actual model of the idea utilising all the elements of structurist art. During the realisation of the model and its construction more development and change may occur through this first tangible seeing of relationships. Thus the finished model may demand many alterations of the original working drawings, and when completed may suggest even further necessary changes. The full-scale enlarged work, then, evolves through this process and may again require further changes over the model, and consequently the drawings. The 'feed-back' from the work to the working drawings is necessary only in that the drawings are required as reference, record, and notation.

Because of the constructive character of structurist art, ideas go through many stages of alteration, change, development and realisation. At each stage of development, and with each work, an almost endless range of variations and permutations is possible. The temptation to remain indefinitely at any one stage by expanding, elaborating and consolidating one's

new awareness and control, is offset by an even stronger pull towards further realisation and discovery, continually suggested by each work and one's extended vison of **nature**. The emergence of idea and of choices for possible development is based on a slowly developed sense of 'rightness', 'feeling', 'awareness', etc, interactively growing out of the primary sources already discussed and the consciousness of, and sensitivity to, the constructive possibilities of the elements being used.

Within this working process, the **artist** is involved in the pendulum process of growth. He continually moves between over-simplicity on the one hand and over-complexity on the other; between too little and too much; going too far and not far enough. The integration of the elements he is working with only grows between the perils of over-concern for one at the expense of the others, leading now back toward painting, now back toward sculpture, the media from which this art originally evolved. For example, too much diversity of colour, without related development of the other elements, destroys structural unity. Too much similarity of colour strengthens structural unity but moves towards structure as sculpture, where the function of colour is minimal. This kind of pendulum process could be demonstrated with regard to the use of each element, and the inter-relationships of elements, at all stages of development. Yet it is through this process that awareness gradually occurs, only to become inadequate as one extends one's experience further into the unknown.

The four works reproduced here represent a selection covering a period of five years. It is unfortunate that the works completed before and between each of the four cannot also be seen. It is also regrettable that these four works cannot be seen in colour. Nevertheless, I hope that some aspects of the structurist process may be apparent from this limited sample.

These notes, then, briefly suggest the underlying criteria that characterise the structurist process as I see it. The process, as well as the medium itself, is only a beginning and its horizons stretch far beyond any present vision. Through fortuitous time and the efforts of countless generative artists, **man**, **history** and **nature** can grow towards further communion and higher levels of consciousness. And art can realise its role in this endlessly unfolding fulfilment of our creative potential.

[1964]

Eli Bornstein

[1] Eli Bornstein: **Conflicting concepts in art** in **The Structurist No.3** pp73–78, University of Saskatchewan 1963

[2] Eli Bornstein: **Structurist art – its origins** in **The Structurist No.1** pp2–12, University of Saskatchewan 1960–61

[3] Eli Bornstein: **The window on the wall** in **The Structurist No.1** pp52–64, University of Saskatchewan 1960–61

[4] Eli Bornstein: **Transition toward the new art** in **Structure 1/1** pp30–35, University of Saskatchewan 1958

[5] Eli Bornstein: **Sight and sound – analogies in art and music** in **The Structurist No.4** pp12–20, University of Saskatchewan 1964

[6] Marshall McLuhan: **Understanding Media** McGraw Hill 1964

[7] Eli Bornstein: **The Crystal in the rock** in **The Structurist No.2** pp5–18, University of Saskatchewan 1961–2

Eli Bornstein

Structurist relief no.17 1958

Eli Bornstein

Structurist relief no.23 1960

Eli Bornstein

Structurist relief no.2 1964

Eli Bornstein

Structurist relief no.3 1964

Francois Molnar : Towards science in art

K. E. Gilbert and H. Kuhn, drawing a lesson from the history of aesthetics, have written that 'This lesson is not and cannot be univocal and clear'. Neither speculative aesthetics nor its history can give us a clear indication about these facts. But an artist confronted with making a work, or in front of someone else's, needs some facts. Aesthetics should become a practical normative science, something that traditional aesthetics has always refused to be. Those artists who felt themselves cut off from it started to invent theories into which they automatically introduced norms. But they failed to achieve a sufficiently scientific degree of objectivity: the norm always remains their subjective norm. As early as 1912, Kandinsky was trying to find the fundamental theories of abstract art. Later Malevich, then Mondrian and Van Doesburg, to mention only the most important, devoted much of their activities to theoretic work. Today there are as many theories as abstract artists. But in the end, this extraordinary flowering of theories can be schematically reduced to three principal tendencies.

1. The first idea that occurs to an artist who has lost a praiseworthy confidence in nature is that music can dispense with nature. It is only the juxtaposition of sounds in time. In the same way could not forms and colours be juxtaposed in space? It is quite natural that in wanting to find a semantics of plastic art Kandinsky should have been inspired by music. The conjunction of two forms make a 'Zweiklang', he said. It is easy to see that 'something' exists between two forms, but the terminology is wrong. Starting from the 'Zweiklang' one begins to talk about counterpoint, the fugue, the symphony, and other vague terms in painting. For not only is music an art of time, and painting of space, but there is, moreover, a big difference between our sensory organs, according to whether they are being used to pick up sound or light. If this second objection loses some of its point in the light of modern neuro-physiological research (apparently the separation of the senses at the cortex is not as sharp as in the peripheral organs), then the first objection becomes even more important. In fact, in order to be able to apply information theory to research into the signals of the plastic arts, one must first linearise these signals; that is to say, give them a temporal dimension. The theory of information has experienced some difficulty in linearising these spatial signals in a really satisfactory way. It is the Markovian method, essentially temporal, that has been responsible for the spectacular results in music and literature.

2. The second group of theories tries to establish a doctrine of abstract art on a mathematical-geometrical basis. It is an old idea; from Pythagoras to Ghyka, through Villard de Honnecourt and Durer, many artists and theoreticians have used geometry in their attempts to explain the nature of beauty. No doubt one could find in a great number of old master works a kind of linear scheme. But here again there is a confusion. Geometry is a science that has its own beauty: one can feel it with one's eyes closed; while painting must have a perceptible beauty.

The pentagon can have many possible rational or irrational mathematical elements, but it is no more beautiful as a result. If it is beautiful, then one must look for its beauty elsewhere. Forms based on the golden number are not beautiful because they show an irrational mathematical relationship; this relationship is not obvious, and can only be understood after a certain consideration. This does not mean that one has to give up the idea of using mathematics in art theory. On the contrary, we are very much concerned in finding laws that can be expressed by mathematical formulae. The power of the exact sciences is precisely that they are able to equate the laws of nature.

3. Lastly, another group of artists want to establish plastic art on a poetical or lyrical basis. They are not thinking either of music or of geometry. According to their theory, there should be no theory. 'The donkey says to the canary: How do you sing? I open my beak and go tweet, tweet, tweet.' Neither is this idea a new one. One can find forerunners of it far back in history. But without going too far back, it is obvious that this attitude is deeply rooted in romanticism. Ever since the romantics, people have tried first to subordinate then to replace reason by the dark forces of the unconscious. This process has led us to a total abandonment to intuition. But what matters here is that it again speaks to us in a language foreign to plastic art. Paradoxically, and contrary to their ideas (according to which there should be no theory), those in favour of this doctrine have literary ideas, and speak a literary language. While the history of art shows us that, at least in Western civilization, painting has always tended progressively to eliminate literature in order to establish itself in an increasingly pure form, modern lyricists try to infiltrate literature into plastic art through a hidden door. They are concerned with literature, even whose who expressly deny it.

Obviously, an act of faith cannot be regarded as a plastic work, whether it be the exhibition of a blank canvas or a bin of rubbish, or the building of a fairground maze. These acts can be significant, the objects exhibited significant, but we still find ourselves in the realm of literature.

Of course there are slight differences, for the groups only rarely show themselves in a pure form. One sometimes finds theories that are a mixture of antagonistic ideas. Thus a theory at present in vogue, presented in a pseudo-scientific language, is only a hybrid mixture of two contrary tendencies: a naive geometry and a cynical lyricism. But mixed or pure, expressed with the help of a poetic or scientific vocabulary, most of these theories never go beyond verbalism: in any case they do not reach the level of objective facts.

Let us say it again: modern art needs facts. In order for aesthetics to be of some use in the immediate future and become operational, it must first be fact finding. Now we have just seen that a number of theoreticians – the erudite – refuse, through hypocritical modesty, to concern themselves with facts, while the other side – that of the artists – has no scientific objectivity.

The one science which could usefully occupy itself with aesthetics and which is capable of laying solid foundations for a science of art is psychology, since its object is human behaviour; and unlike philosophy it is a science dependent on facts, on the 'matter of facts' in the sense of Hume. The introduction of psychology into the science of art will not be an isolated phenomenon. One of the most remarkable aspects of the recent evolution of the sciences is the insertion of psychology, even into physics – so we are told. The difficulty is that a work of art has too often been defined as a sort of vague coin of the absolute. But it is very difficult to make experiments with the absolute.

The first concern of a 'fact-finding' aesthetic, therefore should be to define the work of art, not as an absolute but as something which belongs to the spatio-temporal world. In order to do this one must exclude a whole sequence of ideas which are found in the definition of the work of art. A science of art should use Husserl's system of parenthesis, but the other way round, as it were. Provisionally it must put all our metaphysical concerns into parenthesis, so that we can give the facts our undivided attention.

If we succeed in defining a painting outside all philosophical considerations, we find ourselves faced with a physical object. The picture is an extensive secondary light source, capable of realising in the spectator a sympathetic response (aesthetic). With this definition it is possible to study the picture on three levels:

1. As a physical object; a source of radiating energy, measurable by a variety of physical procedures.

2. As an object perceived by a specific recipient: man.

3. As an object appreciated aesthetically by the same human receiver embedded in a socio-cultural environment.

This separation into three zones is inspired by the plan of C. W. Morris's theory of signs. In fact, these three zones are interrelated: the physical object has no meaning without the receiver, and the emotive appreciation of the receiver influences perception.

Physical object
Perception of physical object
Aesthetic effect

Nevertheless, for the purposes of analysis, we are able to a certain extent to study these artifically separated zones.

Let us begin with the physical object, and take as an example a black and white reproduction of a picture. This reproduction is made up of a multitude of black dots of varying sizes. It is therefore an extended, secondary and selective light source. One could move some kind of receiving instrument over the surface (an exposure meter or a thermometer, for example) and measure the amount of light or heat sent back. Without any doubt, this radiating source of energy constitutes the physical basis of all visual perception, and hence of all concrete aesthetic in the plastic work.

Now let us consider the case where the receiver is the human eye. Seen from a certain distance the dots of the reproduction fall below the threshold of spatial discrimination, but objectively they still exist on the retina. Even if the reproduction was almost continuous, its appearance would break down on the retina according to the number of relevant nerve ends involved. One would be able to establish a connection between any of the dots, and see anything; for example, instead of a hand, a whitish mark. However one reasons, the image persists: one sees a hand.

We have just asked a fundamental question. As Koffka says, why do we see things and not non-things? The experiments of the associationists help us to see things as forms, but they do not explain everything. There is, of course, a perceptual training. But it has also been shown that there are some forms which we see as forms, even if we have not seen them before. There are, after all, in abstract paintings some forms that are not things seen or known, where experience cannot intervene as an organising force. However, one must recognise that such a force exists. J. P. Sartre said: 'One must find a very powerful incentive for the eye so that it can undertake, without looking for a likeness, the unification of this scattering of colour which is the abstract painting'.

We have now reached the form, which, according to Colin Cherry, provides the bridge between science and art. Form can be defined as a group of different chance elements (Moles). It calls for a certain repetition and superfluity, the assessment of which can be mathematically defined in relation to the receiver. There is a difficulty, in that our eye is not just any optical receiver with constant sensitivity, regulated once and for all, but is strongly influenced by our whole personality, with its memory, its preoccupations, its sensitivity and its motivations. Consequently the perception of form also depends to a large extent on social factors.

The following diagram explains this situation.

In approaching a complex phenomeonon it is legitimate to pick out several elements and study them separately, provided that one never forgets that they are part of a greater whole.

In simply studying the picture-eye situation, one already finds several constants which are of the greatest interest to scientific aesthetics. On a physiological level our eyes are subject to limitations, be it only the eye's ability to distinguish, which determines our visual threshold, or even the inability of the eye to accomplish any given movement at any given time. The eye with no limitations could in theory accommodate itself at an instant, T_1, to any given point in the visual field, independently of the location of the retinal image at this point, and independently of the location it had been adjusted to in the preceding instant T_1. All points in the visual field would thus become, against short odds, equally probable fixed points of concentration, and the behaviour of our eyes, chaotic. In fact, this is not the case. The position of our eyes is partially determined by the previous position. Fortunately, the possibility P_1 of any point releasing a reflex of fixation is reduced by the constraints. Redundance is necessary to sight, especially in the seeing of forms. But, redundance can be estimated. Thus, through the interpretation of information theory, measurability has been introduced into plastic art. One can go even further: in examining the behaviour of the eyes one sees that the succession of fixation points constitutes a Markov chain. One can then set up a transition matrix from these points of fixation, and calculate in advance the final equilibrium of the system. We cannot determine each individual fixation point with certainty, but after a fairly long period of observation, our eyes follow the most probable course. By investigating this question one could discover one of the roots of good pictorial compositions, and perhaps even, one of the objective bases of constructive art.

In studying the relation picture space – eye space, we discover not only concrete facts, but also a way of explaining them with precision. One can of course study other relationships. We already have a solid ground of knowledge about the individual's relation to society, and soon we will have one for the eye's relation to the brain. Neither psychology nor physiology can boast of the power to answer all their problems accurately. But then, what science has fully worked out its problems to the ultimate detail?

According to the method of the concrete sciences, one must start by studying the simplest problems. We are thus confronted with a 'basic' aesthetic which has been dismissed a little too quickly as sterile. Our science has changed since the days of Fechner. It has provided us not only with a whole arsenal of new methods, but also with a quantity of concrete facts. Psychology, sociology, theories of communication, strengthened by the extraordinary power of the computors, are all at the disposal of aesthetics and art. In this profound change that has overtaken modern art, what part does the artist play? Will he disappear, will he be replaced by the experts or the machine? No, of course not, but his function will change. The romantic artist of the old days will disappear, if he hasn't already. The artists equipped with a solid scientific knowledge will be drawn to collaborate with the experts in order to establish the programme of an art that can truly be called humanist.

[1965]

Francois Molnar

**Simulation d'une série de divisions de Mondrian
à partir de trois éléments au hasard** 1959

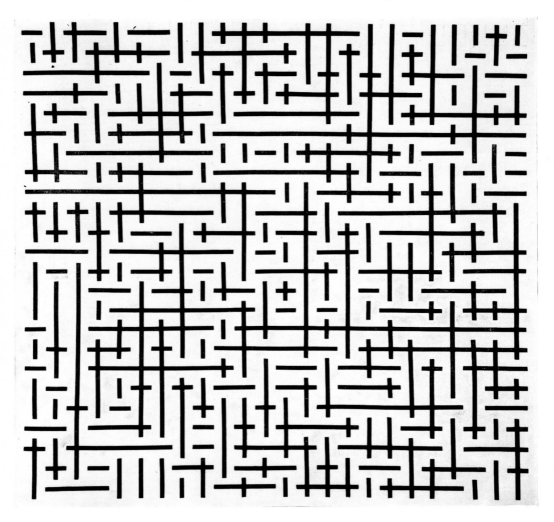

Francois Molnar

Quatre éléments au hasard 1959

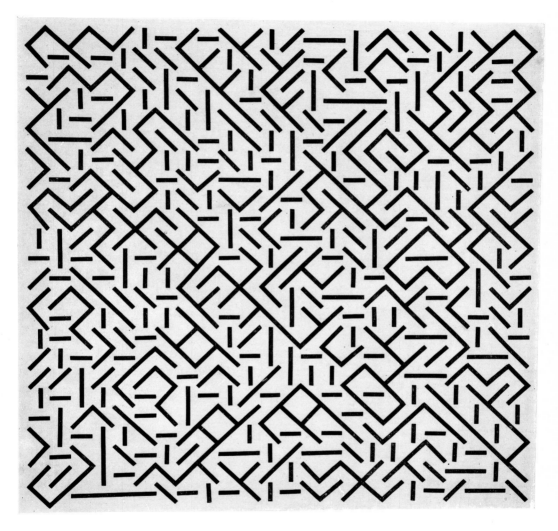

Francois Molnar

1 per cent 5 per cent

Elements
of a stochastic
composition

In offering these configurations and assigning to them a certain significance, it is not their aesthetic value that counts, but rather the process by which they have been realised on the one hand, and the use that can be made of them on the other. The pictures shown start from a basically simple single pattern which can take two different positions, as shown in the diagram.

Each example comprises one hundred of these elements in which chance enters at each step. This process can be the basis of a method of stochastic composition that could allow for ordinated programmes [Attneave].

While certainly not the first time a random system has been employed in plastic art, its systematic use to a well-defined end has not yet become accepted as an artistic convention. It is necessary to insist on a systematic use, incorporated in a well-defined programme, without which the use of chance loses all interest.

212

Francois Molnar

30 per cent 50 per cent

As defined in the terms of information-theory, a work of art is situated some-
where between these extremes: order – chaos, banality – originality,
redundance – information. With these developments of the sciences in art,
it becomes more and more clear that the complexity, itself in close relation-
ship with the information, is one of the principal, if not the essential, vari-
ables of the work of art.

One of the vital problems that lie ahead in art will be to measure the degree
of complexity in a work. In music and literature this is relatively easy to
measure, but for the time being it is much more difficult in works of plastic
art. But by the same method which has enabled us to work mechanically,
following a simple programme [see the configurations shown] we can also,
at will, obtain other configurations of increasing complexity. Furthermore,
this variable is clearly measurable at all stages.

Yona Friedman : Reflections on the architecture of the future

1. Systems in general

The 'phenomena' of the exterior world appear multiple and dis-ordered to the observer (me). An object belonging to this world cannot be completely described without omissions. Despite that, the existence of the observer implies an 'ordering' of these objects. This 'ordering' is the result of the omission of certain characteristics of the objects, characteristics considered negligible by the observer.

Observation is only possible at the price of this omission. In other words, the observer can only be an observer by using a system of abbreviations. A system of abbreviations presupposes the existence of rules admitting certain omissions and eliminating others (axiomatic). The human observer (assuming we know his attitude) uses numerous systems of abbreviation, but all these systems are constructed **according to the same model**.

Certain areas of knowledge recognise this fact; these are the 'explanatory' sciences (exact sciences, logic, etc). Certain others have not explicitly formulated a system of abbreviations apart from recording a certain number of phenomena: these are the 'descriptive' sciences.

The sciences that are directly concerned with the behaviour of man in his environment belong to the second type. After having enumerated a great number of non-co-ordinated facts, they can only approach a crisis.

The knowledge related to social life (sociology, town-planning, ecology, etc) belongs to this second type. In order to arrive at an ordered and usable knowledge about towns and their possible planning, we must therefore, above all, build up a system of appropriate abbreviations.

2. The axiomatics of the behaviour of (urban) social groups

A system of abbreviations presupposes conventions: generally accepted propositions and, because of this fact, non-explicable. These propositions are the axioms. We will choose the minimum number of axioms, which will be defined [without redundance or internal contradiction] as the invariant elements of human society, any community at all, including the towns. These axioms are based on biologically determined human behaviour.

A. Man occupies a volume, necessary for the exercise of his bodily functions. The placing of this volume changes if the subject is moved.

B. Man lives in a group; this group is determined by the quality and frequency of the communication between its members.

BIOLOGIC GROUP ·→ the family of the I - XIX centuries
was a group, that had the task of
1) education of children
2) cooperation in the production (farmers,
artisans

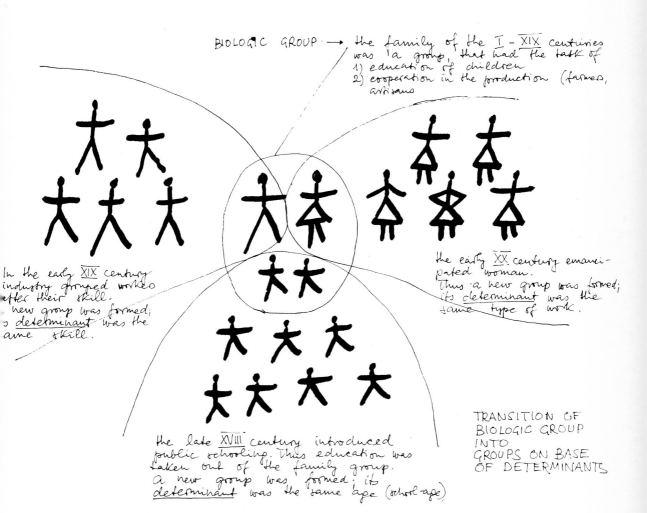

In the early XIX century
industry grouped workers
after their skill.
a new group was formed;
its determinant was the
same skill.

the early XX century emanci-
pated woman.
Thus a new group was formed;
its determinant was the
same type of work.

the late XVIII century introduced
public schooling. This education was
taken out of the family group.
a new group was formed; its
determinant was the same age (school-age)

TRANSITION OF
BIOLOGIC GROUP
INTO
GROUPS ON BASE
OF DETERMINANTS

Yona Friedman

c. Man has to maintain his physical organism in determined conditions. The means of this equilibrium (homeostasis) are sometimes scarce, therefore the setting up of a rational distribution is necessary.

These axioms are necessary and sufficient for the determination of any human activity. Their quantitive value is fixed and distinct for each 'local context'. The organisations which satisfy each axiom can be very varied, but – logically – they must be inserted between two diametrically opposed formulae in the domain of each axiom. These formulae are as follows:

A1. Continuous organisations of volumes [communicating volumes]

B1. Family group [biological]

C1. Centralised distribution [tied to a precise time and place]

A2. Discontinuous organisations of volumes [isolated volumes]

B2. Collective group [groups of work, interests, cohabitations, etc]

C2. Homogenous distribution [existing anywhere and at any time]

We can establish that this list shows all the 'techniques' that are able to satisfy the axioms A, B, and C.

From this list we could deduce another list; comprising without omissions all the possible organisation types of urban communities.

216

Yona Friedman

1. Continuous – familial – centralised

2. Continuous – collective – centralised

3. Continuous – familial – homogenous

4. Continuous – collective – homogenous

5. Discontinuous – familial – centralised

6. Discontinuous – collective – centralised

7. Discontinuous – familial – homogenous

8. Discontinuous – collective – homogenous

Accordingly, the first result of our 'systematic' distinctions is the conclusion that there are no more than eight kinds of possible organisation; any town, existing or imaginary, follows one of these eight schemes.

3. The transformations

At present we are living in a period of transition. The social structure, the economic structure, production and transport techniques, are being greatly transformed. This transformation is so complex that any forecast becomes impossible.

Town-planning, a discipline one of whose most important aims is the forecasting of future developments, suffers extensively from this drawback.[1]

The list 'without omissions' which we have seen, allows us to draw a reassuring conclusion, despite the impossibility of forecasting; whatever the transformation, it cannot produce an organisation type that is not mentioned in this list.

Another consequence of drawing up this list is the possibility of limiting the probability of the transformation of one organisation type into another probability, fol-

217

lowing which one, two or three factors undergo the transformations. It is quite logical to suppose that the transformations of one factor are more likely, those of two or three factors, on the other hand, seem more remote. We can thus establish a list of probabilities.

existing organisation	one factor transformed	two factor transformed	three factor transformed
1	2,3,5	4,6,7	8
2	1,4,6	3,5,8	7
3	1,4,7	2,5,8	6
4	2,3,8	1,6,7	5
5	1,6,7	2,3,8	4
6	2,5,8	1,4,7	3
7	3,5,8	1,4,6	2
8	4,6,7	2,3,5	1

Note: the figures in this table are the reference figures of the organisation types.
The scheme of the chain of transformations is therefore as follows:
0 factors→1 factor→2 factors→3 factors→2 factors→1 factor→0 factor
[existing] [inverse] [existing]
The transformation of one organisation type into others therefore has a 'cyclic' character.

Cyclic transformations; this expression means transformations which change a system into a new one, then transform this new system into another, until one arrives back at the original system. In showing that urban organisations follow this kind of transformation, we reach a definition of a possible town-planning programme; to find the technical solutions which suit the town without becoming at any time an obstacle to the cycle of transformations.

The principal category of such technical solutions is the network (networks of traffic, provision of water and energy, communication, etc). These possible networks (homogenous) are no more than four in number. If we add as well the (purely technical) restriction that a path of the network can only function in one direction, the number is reduced to two. Of these two networks, one is more economical, the fourth-degree one (orthogonal network). In this network and in its variations we can bring about all the organisation types on the list, therefore all the transformations are possible.

An organisation type (from the point of view of the town-planner) will therefore be nothing but a distribution of utilised spaces (dwellings, offices, communal areas, etc), in a homogenous network. The distribution of these spaces can produce innumerable variations according to the contiguity or non-contiguity of the cells.

Yona Friedman

4. Form and function

The two directions of contemporary architecture are 'functionalism' and 'formalism'. The slogans which brought them to the front are numerous: for example, 'form follows function'. I would like to try and define these two directions.

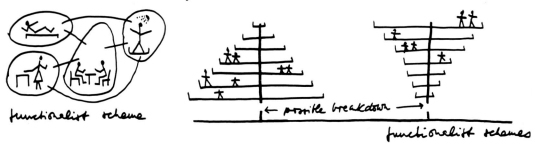

functionalist scheme

← possible breakdown →

functionalist schemes

Functionalism: the building becomes a collection of 'containers', each container having a **predetermined** function. The arrangement of these containers follows a no less predetermined pattern. The dimensions, the form, the equipment and the liaison of these containers are only the result of this utilisation scheme. The architect is the sole judge and arbiter of this scheme.

Formalism: the building becomes a grandiose 'sculpture' whose form is predetermined by the aesthetic sense of the architect, who is the sole judge of it. This type of sculpture-building is supposed to express the 'collective thought' of its inhabitants, or of a culture.

These very simplified definitions contain the essence of two entirely opposed directions. If we subject them to a critique, we will find to our great surprise that these two definitions involve the same objection: the architect the sole judge: how can he discern the functional scheme in respect to the 'collective' thought of those using his 'creation', when he doesn't know these users themselves?

In other words, this objection queries the alleged 'delegation' to the architect or the town-planner of power to determine the behaviour and thoughts of a great many people unknown to him. In fact, a great number of possible utilisation schemes exist, with an equal number of possible forms. In using arbitrarily chosen criteria this number becomes even greater. How can we choose from this immense repertoire? ... and to whom does the right to choose revert?

The architectural direction, which I have called 'mobile architecture' (mobile in the sense of being movable and variable as desired by the individual user), tries to answer these questions.

We have seen at the beginning of this essay that the choice of schemes

(or, of forms) becomes possible, if the repertoire of alternatives is very small (abbreviations). This very small repertoire must not, at the same time, be limited as to utilisation (or forms). This is only possible in the case where the repertoire is basically composed of very few criteria which are themselves very generalised. Thus, every scheme (or form) becomes one of the possible variations of two diametrically opposed variables in the domain of each criterion.

We will therefore find that the most generalised criteria of utilisation (axioms) must be based on biologically determined human behaviour: the generalised criteria of architectural forms must be the empty volume and the filled volume.

Every architectural solution is only a variation of the elements of these two systems which are no longer separated after these re-statements: in fact it is possible to link together every utilisation scheme with every form. The resulting system will be the possible combinations that a building (or a town) makes possible. There is only one scheme that allows a maximum of combinations and which therefore allows a large number of variations. We will call this scheme 'the spatial infrastructure' (see notes 1 and 2).

5. The infrastructure

As we have seen, the aim of mobile architecture is to make it possible for each inhabitant to form his personal environment as he wishes and in so doing to free himself from the tutelage of the architect (freedom of choice). This 'personal' environment in practice concerns only those elements which are visible and directly utilised (such as walls, partitions, floors, furniture, household appliances, etc) as well as the way in which they are used (walking around, meeting places, etc). As for those elements of a building which are not seen, and which are used indirectly (like the foundations, the bearing structure, the water and electricity, traffic networks, etc) these do not make up part of the 'personal' environment of each inhabitant (or group of inhabitants), but they constitute an **organisation scheme**. These organisation schemes belong, as we have seen, to a cyclic group of eight terms.

In order to assure the inhabitants (the users) the desired freedom of choice, I have tried to reconcile these 'invisible and desired use elements' in a single physical object which I call 'infrastructure'. So as not to settle in advance an arbitrarily chosen organisation scheme, this infrastructure is thought of in such a way that it allows for the 'insertion' of any possible scheme and the transformation of this scheme into another (also arbitrarily chosen), without the infrastructure itself having to undergo any sort of transformation. Therefore, using a concise expression, the infrastructure is **neutral** in relation to possible schemes of organisation.

In order to show the physical appearance of such an infrastructure,

Yona Friedman

let us say it consists of a three-dimensional lattice on several levels. This lattice is elevated (by a fairly widely-spaced series of pilotis) above the ground. The configuration of the members of this lattice is chosen in such a way as to allow for the insertion of utilisable **orthogonal** volumes in the empty spaces between the members. These members also form the carrying element (containing structure) as well as the distributory networks of water, electricity etc. The pilotis themselves contain vertical paths of communication (lifts, stairs) and the distribution networks (rising columns).

The use of this infrastructure allows for the introduction of any 'personal' environmental element, wall, partition, form or volume, in the lattice. Equally, it allows for any hand assembling (hence scheme and form) of these elements. As a result, this infrastructure allows for any kind of formation of 'individual environment' possible, as well as making use of any kind of organisation scheme.

The only two restrictions (rules of utilisation), different in each local context, would be the following:

a. Heavy load-bearing areas (traffic) would, for economic reasons, be organised on the ground level left free between the pilotis.

b. The minimum distances between the volumes inserted into the infrastructure must be determined in advance in each local context, by the users themselves, according to a democratic method.

6. The spatial town

The spatial town is the conglomeration formed in a spatial infrastructure. It is the result of undetermined town-planning; in other words it follows no plan except that of the infrastructure (therefore allowing for every possible transformation). The volumes which make up the spaces of the spatial town are not arranged in advance; they undergo ceaseless transformation in the course of time. Apart from this, in the spatial town there are no specialised areas. Gardens, dwellings, public centres, industry and general circulation all interweave. There are residential areas **above** industrial zones, schools **above** the motorways and parking spaces, offices and houses **in the same place**, without the routes of those using them crossing one another. There are localities where the town seems to be a typical one while other localities resemble a sort of a modern Venice. Every possibility [functional or formalist] is contained in this; its realisation only depends on the wish of the inhabitants.

Pedestrians can move about, according to choice, in climatised 'streets' contained in one of the lower levels of the infrastructure, or else they can walk along the 'tourist streets' which offer a fine view from the higher level of the infrastructure.

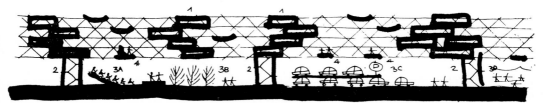

The spatial town as an 'ideal' infrastructure
1. individual utilisation of the voids
2. piles, containing vertical communication and supply mains
3A. meeting places
3B. gardens, parks
3C. circulation, parking
3D. department stores, etc
4. pedestrian walks, public and semi-public activities
 (cafés, bars, clubs, gossiping places)

All the empty spaces in the infrastructure (the town 'patios') are climatised. This solution, which would be economically impossible in present-day towns, becomes economic in the spatial town, following the reduction of surface heat loss.

Besides this, agriculture also can be incorporated in the spatial town, climatised hothouses on several floors, and these could give an increase of up to 400 per cent over surface agricultural production. These hothouses could meet all the needs of the town for fresh vegetables (when at the moment transportation to the town is the highest factor in vegetable prices) serving at the same time to regenerate the air of the town (green spaces).

7. Towards a world infrastructure

The spatial town represents an example of using the empty spaces in the links of a distributory network. The same formula suggests an image of the world of tomorrow.

The distribution networks (transport) of our world are at present

continental (ocean to ocean). The towns or regions belong, in relation to these networks, to two principal types: they are **situated on the nodes** of the networks, or else they are **in the links**.

Development shows a tendency towards the growing importance of the second type. The megalopolis is a very densely utilised urban region, **in the links** of a network.

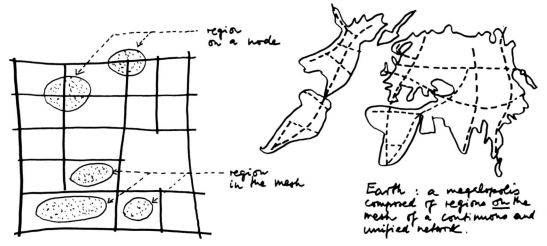

If we imagine the continental networks linked up by only eight bridge-towns (with a minimum length on average of 50km, and altogether not exceeding 400km) we realise that our inhabited world could be seen **as one gigantic town** in the links of this unified network. Out of curiosity I must mention that this town could contain 700 million as the ultimate limit (a calculation made according to the current standard of living in the United States).

8. A new style

The result of renewing town-planning according to the techniques of mobile architecture (spatial) will be to transform architecture into a new folklore.

Folklore is defined as a spontaneous and anonymous creation of forms and customs, practised by a great number of individuals or groups. This 'creative activity' will become possible thanks to the techniques we have described above. We can expect 'folklore' architecture and urbanism (there have been folklores throughout history) to represent an enrichment of modern life.

[1] For details of this problem see L'Architecture Mobile 1958, republished 1962, 1963, 1965.

Criteria for town-planning

The prosperity of modern society is in full growth. Today's citizen works less and earns more than he has ever done before. In a few days a week he achieves a significant spending power. Thus, he is above all a 'consumer'. For his money he wants to have a wide choice of goods to purchase: he has the money and the time necessary for choice.

A wide choice implies a great number of varied goods on the market. So our first criterion will be the **number of variations** that can be realised in the framework of a system. The goods bought are acquired so that their purchaser can make appropriate use of them. Their adaptability is therefore, above all, a function of their possible use. The cost of purchase and of production functions through this availability for use. But this use can only be calculated for a **group of products** (eg, the use of the car takes account of the existence of roads, garages, petrol, etc). Hence utilisation implies an **infrastructure**. The citizen of today is loath to pay for an infrastructure, but he will accept the financing of one if he understands the absolute necessity for doing so. In this case, he wants the infrastructure to function well; he does not want **accidents** (breakdowns).

The two appropriate criteria for an urban infrastructure can accordingly be defined thus;

1. ease of maintenance (minimum of breakdowns).
2. variation in types of use.

The aim of maintenance is to avoid accidents (breakdowns). In the case of urban infrastructure an accident or a breakdown is a **discontinuity** in the urban network, a discontinuity which isolates a part of the infrastructure. In order to classify the possible infrastructures we will first define the number of discontinuities that can isolate one part of the infrastructure from the rest.

They are:

'linear' infrastructure
1 breakdown

'planar' infrastructure
6 breakdowns

'spatial' infrastructure
12 breakdowns

Consequently the spatial infrastructure is the most accommodating from the point of view of maintenance, for it is the least vulnerable to accidental breakdowns. (Naturally, it is **less likely** for twelve simultaneous breakdowns to occur than six, and six than a single one.)

In order to establish the number of variations possible in each infrastructure, we will consider the number of possible 'bichromatic close packings' possible in each of them. The two colours of these 'packings' will symbolise: filled volumes (utilised) one colour, and empty volumes the other colour.

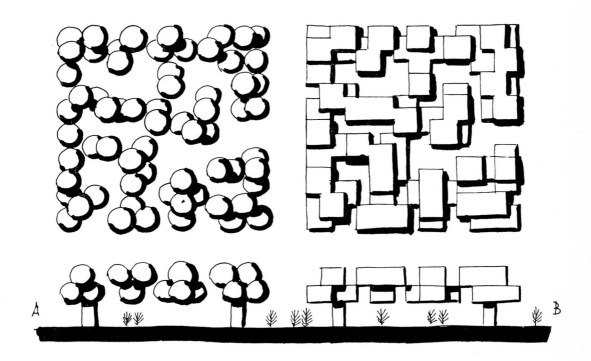

A configuration in the spatial infrastructure

A. 'bichromatic close packing'
B. habitable volumes

For one surface of a.b square metres:

the linear infrastructure
allows 2^a variations
(bichromatic close-packings)

the planar infrastructure
allows $2^{a.b}$ variations

the spatial infrastructure
allows $2^{a.b.c}$ variations
(where c is the number of
levels of infrastructure)

In the same way we can see that the variability of the spatial infrastructure is much bigger than that of the other infrastructures.

The infrastructures are the networks regulating the way in which the town is used. If we eliminate from the list of infrastructures the linear one, because of its characteristic disadvantages (liability to breakdown and limited variability; no big 'linear' city exists in fact) we may examine the different networks within a new criterion that I shall call 'conductibility'. We will call a network 'conductible' if it allows a one-way circulation, determined in each of its paths, without the one-way paths intersecting each other. The only network with this property is the planar one of degree 4 and its derivatives in space.

networks of degree 4
are conductible

networks of higher degree than 4
are non-conductible

This deduction enables us to establish one optimum infrastructure, with reference to the principal criterion (liability to breakdowns and variability) and the secondary criterion (conductibility). This optimum infrastructure follows the model of an orthogonal network of four degrees embedded in three dimensions. This infrastructure is not the town itself; the physical town will be the result of an arbitrarily chosen way of using this infrastructure (utilisation pattern).

The infrastructure we have chosen as the basis of our criteria will allow for the effective functioning and existence of a very great number of uses.

In principle all the means of utilisation will belong to one or other of two characteristic sets; the areas of the network which are utilised can be situated:

a. in the nodes

b. between the members

The utilisation of the members seems to me to be more effective, for it does not increase the degree of the network. The use of the nodes, by contrast, would create a two-way circulation in certain paths.

Description of infrastructures

The linear infrastructure is a 'tree', regulating the provision of services (circulation, water, electricity, etc). The spaces used are ranged all along this infrastructure.

The planar infrastructure is a network regulating flows 'in a plane'. The used spaces are arranged in the cells of the network.

The spatial infrastructure regulates the flow in three dimensions. The spaces used are located in the empty cells in the spatial network.

Programme for simulating possible uses
of the infrastructure

We have seen the importance of infrastructures, and the method of using them. We have been able to compare possible infrastructures and to establish the main kinds of organisation, but the difficulty is greater once we become interested in organisations which differ only by nuances.

Taking as a basis the eight principal organisations established as a result of the axioms proposed, we could say, for example, that we do not understand sufficiently a town that is a mixture of the types 1, 3, and 8: each type representing different proportions in the same town.

Experimentation in this subject is very difficult. For the most part organisation-types only exist in a latent form. As for those which actually exist, they are difficult to discern because of the slowness of transformations and the prejudice of the observer. Thus we are not able to discover internal laws of urban mechanism through observation by the naked eye.

On the contrary, we could infer relatively more easily from a series of simulated reconstructions of these mechanisms. It is a question of establishing rules of interrelation

between the schemes of behaviour patterns (reduced to a few characteristic principles) and sets of obstacles and aims to be disposed in space. These obstacles and aims will impede or assist the various activities comprising urban behaviour.

I will try to set out a provisional list of factors of behaviour patterns, significant in the organisation of cities.

a. relations between one, two, or several people

b. cohabitation between one, two, or several people

c. regular or irregular periods of work (occupation)

d. regular or irregular periods of nourishment

All these factors of behaviour could be connected, either to mobile 'aims' or to fixed 'aims', and they could be hindered through obstacles being fixed or mobile.

The general course of the simulation will take the following pattern:

1. Symbolic composition of a society. This society is composed partly from individuals with different characteristics in the domains, a, b, c, and d. According to the proportions of different categories of individuals in each simulated series different societies will be formed.

2. Composition of variously arranged sets of obstacles and aims. These sets will symbolise different city plans.

3. The societies in 1 will fulfil the aims of set 2.

4. Cyclic recurrence of the overthrowing of values and 'aims' (attraction and repulsion). Each upheaval will represent one period (for example, a day).

5. Introduction of random elements (numerical) representing possible irrationality in the various attitudes of 'individuals' (1) in the domains a, b, c, and d.

The same 'society' will function differently according to the different orderings of obstacles and aims. The series of simulations can lead us to the discovery of certain interrelations (until now unknown) between the physical city and its inhabitants' way of life.

The variations of the simulated 'society' and the 'city' can give us a much more enlarged range of relationships than that within our present-day cities. These relations will allow a forecast (limited, but much fuller than today's) of the functioning of cities, new or regenerated, and will interpret new possibilities in the infrastructures of urban life.

Joost Baljeu : Synthesist plastic expression

Synthesist plastic expression, of which the constructions shown are examples, is not an art of rectangles. To say that it represents rectangles confuses means and ends. Synthesist plastic expression is essentially an art of space. The rectangles serve to describe spaces which in themselves are orthogonal. These orthogonal spaces make contact with one another in an oblique way by interpenetration. This means that they are always open at one end or another, thereby allowing the next space-cell to interlock. The oblique movements between the various spaces created, relate them in such a way as to round the work off. In their togetherness the orthogonal spaces show an ellipsoidal or spherical structure, in order to become organic wholes; that is to say constructions which are self-centred and thus possess their own point of gravity in the environmental space they are in.

Synthesist plastic expression is an art primarily involved with space and movements in space. These space-movements are not limited to the rectangular but include the curved as well. If the orthogonal is seen to predominate – space circumscribed by rectangles – this is because it is the first and only space-movement made tangible in the construction, whereas the others, whether oblique or curved, though clearly visible, are intangible. The rectilinear movements in space to be made tangible prior to any other direction in space, such as the oblique or the curvilinear, are very much dependent on the close relationship synthesist plastic expression has with nature-reality. The same laws that the plastic construction uses can be met in nature when it constructs its forms: rectilinearity, obliquity and roundness (that is, being in the round). Just look at such a simple thing as a leaf and follow its structure. The veins clearly show that in their development, from interval to interval, matter uses rectilinearity. This extends through the leaf-space in all directions, and has obliquity as a common feature. Finally the leaf, in order to be complete, rounds itself off and becomes a spatial entity whole in itself, or an organic organisation. However, since the first and basic law of nature is that matter organises itself rectilineally, this is precisely why the rectilinear is first to become tangible in the plastic construction.

Apart from these three basic laws – rectilinearity, obliquity and roundness – there are many others that can be met both in nature and in the synthesist construction. The construction is thus in complete accordance with nature. To be in accordance or in harmony with nature is synonymous with synthesis, in synthesist plastic expression.[1] Even the most unsuspecting reader must have noticed that the example from nature, the leaf, did present nature-reality not as consisting of things but as a process, nature in its spatial formation. It implies that vision need not halt at the immediate appearance of things but should investigate their formative laws. This takes in an extra dimension, that of movement, and thus the four-dimensional, or multi-dimensional, realm is entered upon.

It is sometimes argued that one cannot see and experience a multi-dimensional reality, and that it is therefore unreal. Yet everyone knows that anything we can conceive is a reality in some way. In some cases a wrong example can provide the right picture. Imagine yourself walking in a forest in winter. You come to a clearing and stop as your feet hit against something; a stone covered by snow. Gazing down, you see suddenly that the snow at your feet has begun to melt. The earth is again visible, grass begins to grow rapidly. Looking at the surrounding trees you see that they are coming into bud: leaves are developing – from spring-green the trees become summer-green, then they turn orange-red and the leaves begin to fall. The sky above is thunderous with constant lightning, the result of swift changes from day into night and night into day. You look again at your feet which hit against the stone and seemingly started this amazing process. To your astonishment you discover that the grass has disappeared again and that snow is at your feet once more. A glance at your watch makes you wonder how long you have been standing there. Was it a whole year or a few seconds? Walking away you pick up one of the leaves you saw as a small bud shortly before, and which is now a transparent construction in black. It still reveals the formative principles nature uses when trying to balance the forces in matter.

The obvious thing wrong with the above picture is the acceleration given to it. All the same, it makes clear that matter is continually in movement, that in fact we are confronted with matter in space-time. In plastic expression, however, the space-time view is not concerned with the actual movement of phenomena in reality but with the formative laws according to which they become what they are. Even an unsympathetic reader will now be conscious of the fact that these laws can actually be perceived by the eye when he looks at nature, not as a number of static things but as a dynamic, constructive process. One could even go one step further and observe that although the eye may be unaware of nature's process, man nevertheless creates in accordance with it, as is shown by many constructions he has produced.

Finally, when comparing nature-construction with man's construction, it could be said that plastic construction is the extension of nature-construction on the level of human consciousness. Synthesist plastic expression, by investigating the **how** of nature, instead of halting at its immediate appearance, is open both to contemporary science and to philosophy, though it cannot and does not take these as its plastic basis. Science gives its view of nature-reality, philosophy presents a way of thinking of nature-reality, and plastic construction visualises nature's methods. Synthesist plastic expression can go along with philosophies which present a mathematically-based, dynamic view of life, and with sciences which base themselves on matter being in movement. The synthesist feeling in synthesist plastic expression is perhaps best summarised when it is said that in man matter contemplates itself.

Synthesist plastic expression is based on the belief that in the future the arts will merge into one. This does not imply, as is often said, that art will come to an end. On the contrary, art will be more alive than ever, but it will present itself in another form. It means that plastic expression will make itself visible in one form or another, merging with life itself. Thus it will produce an architecture that is not only functional, but plastic and polychromatic at the same time. It will also give plastic form to the open spaces between the architectural parts of cities, by landscaping them with terraces, ponds, fountains.

It will also merge with such arts as ballet, theatre and opera, all of which need their plastic, polychromatic spatial set-up, as well as with many other realms such as textile design, typography, industrial design and so on. It will do so according to the demands of each of these realms. Thus man and his environment could reach a unity based on diversity, expressing a harmonic synthesis.

[1963]

[1] **Attempt at a theory of synthesist plastic expression** [see notes on contributors at the end of this volume]. This theory more elaborately explains why synthesist plastic expression [or synthesism], though in appearance related to neoplasticism, is a development from cubism through its use of multi-dimensionality and its introduction of plural-axiality.

Joost Baljeu

Synthesist construction 1960

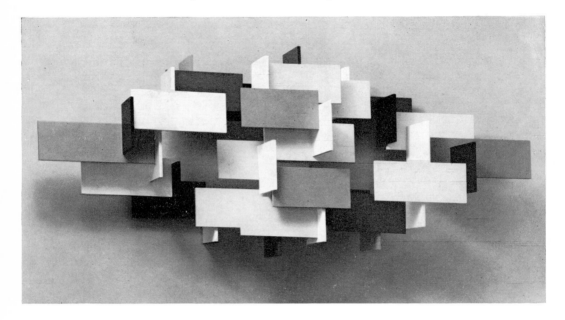

Francois Morellet

opened into unlimited freedom. Little by little each brush-stroke was made only through the artists' choice, and with no other constraints.

But can this choice really be made with each brush-stroke?

a. Some artists have believed so. Abstract painting, which could be said to have begun in a pure state with Kandinsky's first watercolour, was called in the following epochs 'automatic writing', 'action painting' etc – each gesture resulting in a colour was decided by intuition, the unconscious justifying everything. Today, this way looks rather worn out.

b. Others have tried to replace the old constraints by pseudo-constraints considered more modern. At different times they have tried to reproduce the look of 'Negro masks', graffiti, children's drawings, commercial posters; not to mention the fake landscape or unrecognisable still-lives. These artists have regained their equilibrium.

On the one hand, the image of the free artist, the all-powerful creator-artisan was saved, and on the other, by specialising in a set of images they avoided being overcome by the vertigo of free creation in the making of their works of art.

This category of art will last for some time yet, since there is no precise limit to imagery and since it renews itself in making poetic images out of fashionable subjects.

c. At the present time, however, one senses a revulsion among certain artists from choosing one way rather than another in the development of their work. They themselves no longer subscribe to this religion which believes in the infallibility of arbitrary choice.

The meaning of Marcel Duchamp's ready-mades is a striking example of the reaction against the artist's conception of an arbitrary artisan-creator. In his discs or his urinal he has reduced the artisan element in manufacture to zero, and the range of choice in the realisation to one only (the choice of object). The hitherto little-known work of Duchamp, which was rare and precocious, partly accounts for the existence and success of pop art.

d. At the moment there is another reaction against this traditional conception of the artist, and particularly against works in which each detail has been finally fixed by a choice which denies all justification other than intuition.

Artists in this category refuse to repeat Duchamp's negation: but they obviously do not yet possess 'machines' allowing them to eliminate this arbitrary choice to any great extent.

They know that they are still working in a primitive way because they find themselves at the beginning of an epoch where an entirely new conception of art is appearing.

The four points characteristic of artists of this tendency seem to me to be:

Francois Morellet

Impersonal realisation. During the realisation of a work of art the arbitrary decisions are reduced to the minimum. For this, machines are best used. Straight away machines serving current industrial production make possible the manufacture of identical elements, which are sometimes the very basis of the work. In the distribution of these elements, as with their choice, electronic brains could in the future replace the artist's decisions, it remaining for the artist to programme the machines and fix their task.

Movement. Real movement does away with the fixed, immovable character of the work of art. The artist no longer imposes a right moment that he has arbitrarily chosen. Instead he suggests a series of situations which develop outside himself.

Programmed series. The same attitude but without actual movement. Each experience shows one of the possibilities of a system which is developable of itself. If a choice can be made, it will be made by the spectator.

The game. Active participation by the spectator in the creation or transformation of a work of art is the conception of 'the artist' far removed from that of the all-powerful romantic creator. The arbitrary geniuses about whom the nineteenth century created legends fade away before the active spectator.

Thus a profound gulf now exists between the 'inspired artists' who produce works where each detail is finally fixed by a choice which denies all justification other than intuition, and the 'experimental artists' who suggest situations which become modified in space and time for the spectator and even by the spectator.

[1965]

Francois Morellet

Trames 1958

Francois Morellet

Sphères-trames 1962

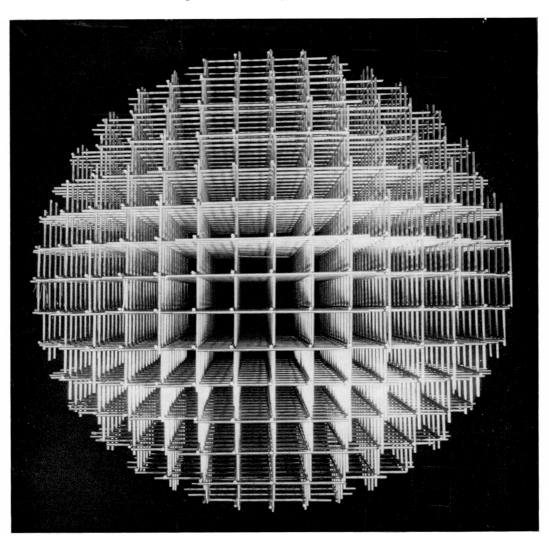

Francois Morellet

Deux rythmes lumineux superposés 1963

Francois Morellet

Mouvement ondulatoire 1965

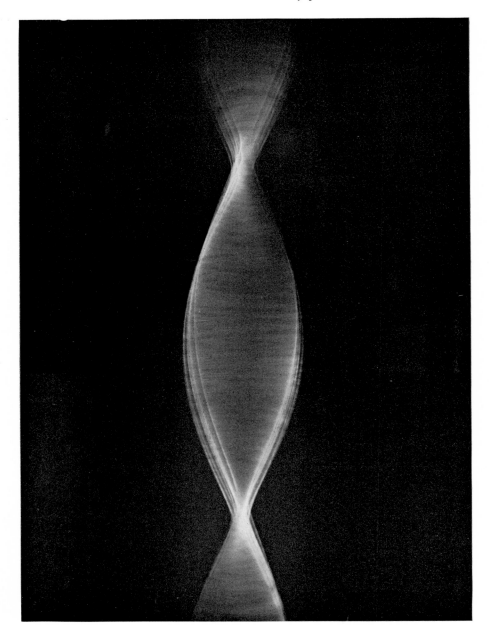

Karl Gerstner: The tension picture
Case-history of an artwork
Artwork?

'Tension' in the context of art is an old-fashioned term. It presupposes that the picture be considered as 'composition'. It is to be understood in the figurative sense: to say a composition by Mondrian 'has tension' is to say, 'it is interesting'. Tension means balance of opposites. The parts of the picture are put in relation to one another, firstly, in an unexpected manner and, secondly, harmonically. Horizontal to vertical; line to area; red to yellow to blue. And so on.

In the case of the **Tension picture**, the term is to be taken literally; tension not artificially composed, but naturally produced. The 'picture' part of the **Tension picture** is known as a physical phenomenon, under the term 'tension optics'.

A semi-transparent sheet of plastic material (40cm × 40cm) is polarised by means of two filters and illuminated from behind. The drawing appears on the surface, as the illustration shows, and receives colour when pressure is applied to the sheet – here, from the edge. Then the molecular space grid of the material changes. The light has to pass through various densities which, by means of polarisation, becomes visible as 'tension lines'.

Thus, what appears to be pictorial in the **tension picture** is in fact nature. It is not, in the terms of art literature, an 'abstract' or 'concrete' picture but – in the true sense – a 'naturalistic' picture.

Do you know Gyorgy Kepes' book, **The New Landscape**? A collection of 'new' pictures and illustrations of the world. The reader becomes a traveller, as it were, in a landscape which has been photographed on the surface to a scale a million times larger, or smaller, than the eye sees it. Clearly, through this distortion the landscape falls outside the range of sensory experience. The outward appearances are not recognisable, but only comprehensible through 'know-how'.

Nature becomes 'abstract'.

Against the new pictures of this abstract nature (or: the abstract pictures of this new nature?) Kepes shows pictures which past centuries did not know either: abstract works of art.

Kandinsky wanted to free art from nature. To make pictures without reference to real life. The vocabulary of the creative artist should not be used to depict 'something'; a woman, a house, a mountain. It should represent itself, point, line, area, colour.

As Mondrian expressed himself: 'It is the aim of art to create pure, universal harmonies'. It is essential that the means to achieve this aim are also pure and universal – that is, reduced to the most elementary level.

A rose is more beautiful than the picture of a rose. The question is: should a painted line be more beautiful than the line which is produced by nature? I have my doubts, which have been nourished by Kepes' book. Whenever an 'artificial' picture was to be compared with

243

a 'natural' one – perhaps a Poliakoff with a crystal structure – I have always spontaneously preferred the latter. Because it seemed to me more matter of fact; more natural or, in other words, more complete.

'Naturally', the reaction is personal. And also the conclusion. Resign oneself? Admit that when the world was created the scope for human creation was forgotten? That in any case nature is unsurpassable? The mathematician Andreas Speiser says: 'Neither is the artist the creator of his works, but he discovers them, as does the mathematician, in a spiritual world created by God.'

Conclusion: none.

Faute de mieux, the question (like all important questions) has to be left open. Try a ruse then. That is: declare as art what is, in fact, nature. Bring the physicist's tool into the museum (if that is the place for art).

Is art what I – artist by my own grace – want?

Marcel Duchamp tried to establish what society would tolerate as art. He provoked them – both, society and art – without finding out how far he could go. Admittedly, there were protests when he dared to exhibit a urinal as a sculpture on museum walls. But today there exists an edition of this urinal (in seven copies, produced by the Galleria Schwarz in Milan), so that as many museums as possible may pride themselves on owning it.

Duchamp's **Ready-made** – also, by the way, Schwitters' **i-Erfindung** (i-invention): the work not as creation but as found object. Marking the accidental discovery with the label of eternity.

Tension picture

As a picture it is not new, but cribbed from the physicists (they would say, a toy). As an idea it is not original, but inspired by Duchamp (which pleases him). As art it is questionable anyway (is it not true: that its having been in the Museum of Modern Art does not prove anything?). Wherein lies my authorisation, my qualification as an artist? What does my work consist of? Perhaps in that I have designed it as an object?

I well remember the beginnings – a rare case. First, the book by Kepes (which was published in 1956 by Theobald in Chicago). The desire to make abstract pictures after nature. The theme of tension optics. I had to acquire the necessary knowledge. That is, ask experts (here my friendship with Dr Jenny stood me in good stead). Read books. A visit to the Deutsche Museum in Munich that helped me.

Choosing materials. First attempts (this was 1960). First results

Karl Gerstner

(1963, exhibited in Cologne, at the Gallery 'Der Spiegel'). Improving the results; an occupation which is still continuing today. Therefore, art as research along lines defined by oneself?

This too was part of the work: designing the construction for the craftsman; giving directions to the electrician; discussing details with the mechanic; choosing dimensions, fixing proportions; drawing plans. Therefore, art as design commissioned by oneself?

Consider the result from this angle: the **tension picture** as an apparatus constructed according to plans which can be pulled out of the drawer at any time. Plans, which can be executed at any time by the craftsman, the electrician, the mechanic, without my participation. Then what part of it is genuine? What is original?

Paul Valéry says: 'A work of art is unique and unrepeatable, even for its creator.' Walter Benjamin, on the other hand, says: 'The work of art has fundamentally always been reproduceable. What men have made could always be copied by men.'

Why 'on the other hand'? Is there not a difference between reproduction and repetition? Of course an original can be reproduced. But what if, from the beginning, it exists in several copies? What if its originality lay in its repeatability?

There is no question. Theoretically any number of copies could be made of the **Tension picture**. Only the prototype could be regarded as original – the working model for serial production, to use the language of industry. This happened to me, on another occasion. A mechanic who was making up a picture for me – the **Tangential excentrum** – produced two copies of it. One he kept for himself, because he 'liked it so much'. (Why not?)

In the end, my signature would be the only original part of it. Should this be of importance? Because of the market prices? Or for cultic reasons? I find myself in unexpected congeniality with, let's say: Andy Warhol. What would **Campbell's tomato soup can** mean without his signature? And yet: if the uniqueness of a work makes it original, then the **Tension picture** is original not merely with regard to the signature. It has many faces, among which some are 'unique' and owe their existence to chance and to the viewer. It can be changed (almost arbitrarily). The viewer can alter the (eight) tension screws at random and thus influence the 'drawing' of the lines. This is shown in the four examples. (What is not apparent in the illustrations is that by using coloured light, seven different colour 'mixtures' can be achieved.)

However, one can put it another way; the **Tension picture** is not even in the sense of the **i-Erfindung** a work of art. Because it is accidental, whether regarded as a picture or as a found object. It is not the tension which I have decided on – nor that of any other person – that determines the art value of the picture. The very reverse; if anybody produces art value, it is the viewer.

245

To add to the confusion, not the slightest talent is needed to turn the screws: that is, to produce a picture by turning them. Under any chosen tension nature herself produces the aesthetics. The 'composition' is in every case – conditioned by nature – relative to the given area.

It is an intellectual gimmick to declare the **Tension picture** a work of art, when it is in fact a bit of nature. The question arises; work of art, or of anti-art – or, more simply, plaything? Or does it?

Is everything taken care of, once again, by the conventional criteria? How 'beautiful' will it remain? Or: how 'interesting'? That is, how 'tensing'?

Can the picture be taken as a model of the harmonising (functioning) of the world? Its subject a bit of creation?

With whatever presumptions?

(And regardless of all explanations – even of this one?)

[1966]

Karl Gerstner

Tension picture no.2 1960–64

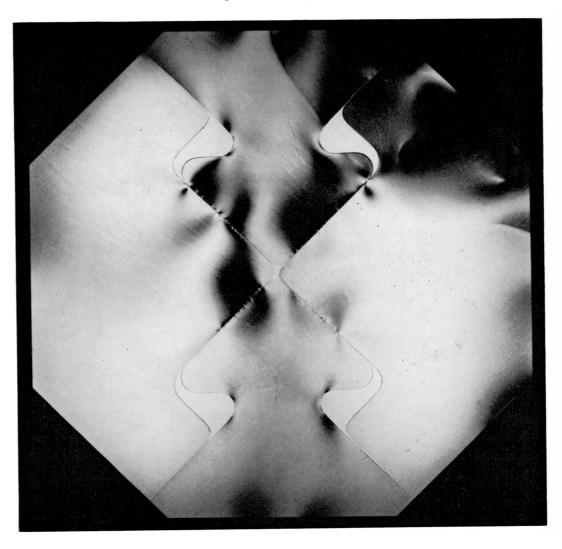

Karl Gerstner

Tension picture no.2 second version 1960–64

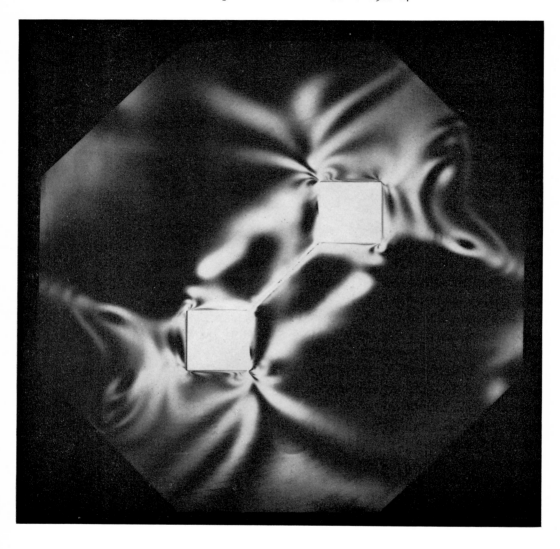

Karl Gerstner

Tension picture no.3 1965

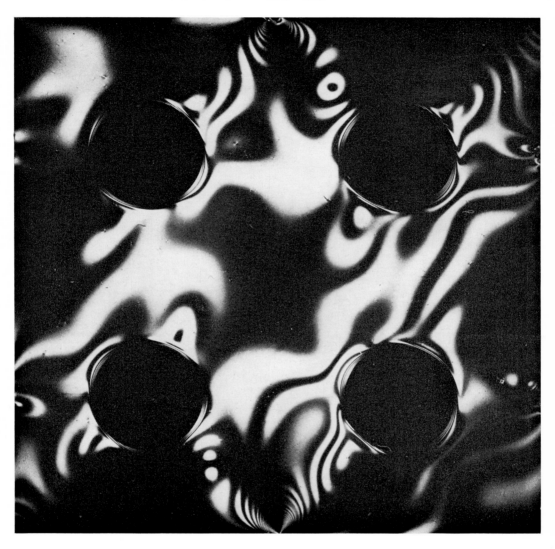

Karl Gerstner

Tension picture no.3 [showing different tensions] 1965

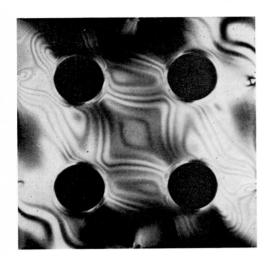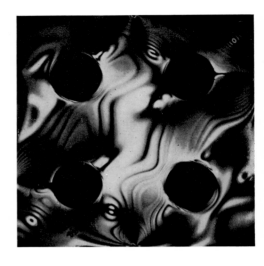

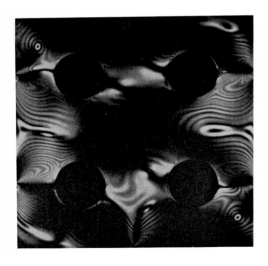

Anthony Hill : Programme . Paragram . Structure

The concept of 'structure' is widely used today in modern art discussion. Unfortunately its vagueness and ambiguity tend to be overlooked because of its scientific overtones, and this can lead to confusion just where clarity is intended. However, I believe that a 'structure orientated' art is the most important to have come out of modern art, somewhat in the following manner:

<p align="center">modern art → abstract art → constructive art</p>

This of course is a broad generalisation and much of what follows should be seen in the same light. Three of the ways in which I believe 'structure' manifests itself in art are:

1. As a physical prerequisite of a work of art.
2. As 'abstract structures' acting as organising principles, eg, compositional schemes, thematics, etc.
3. As a 'structured programme' for the presentation of an artist's intentions.

I have selected the second and third aspects of the function of 'structures' for further discussion, since in my own case they result from a chain of investigations that led from programmes to paragrams, and from paragrams to networks. The order of the three categories of 'structures' listed should be taken to imply a 'cycle'. However, I have chosen to start with the idea of the programme – the most general – and end with the ideas pertaining to 'structures' as networks, since the latter are more specific in their relation to art.

Programmes

My own conception of a programme arose from a search for a more or less systematic approach to the problem of **intentions**, their analysis and possible hierarchic ordering. Through searching for techniques of exposition I sought the most appropriate structural concepts, and these in turn led to a more generalised interest in structure. Regarding the programme as intentions, I concluded that what a work of art primarily manifests is a physical technique. Such concepts as process, structure or system, which apply both to the physical object and to the theme it presents, may be only broadly deducible, while the **intentions** are to be taken as **ideas made concrete through the work**. However, if we have only the work to go on we are compelled to look elsewhere for an exposition of the programme.

My own first attempt at a programmatic analysis, which borrowed the terminology of semiotics due to Charles Morris, was published in 1954 (in **Nine Abstract Artists**) and later expanded in 'tableau' form in an article in **Structure** in 1959. It was familiar with

251

the diagram that is often used to demonstrate the triadic relationship of the constituent parts of semiotics; the syntactic, the semantic and the pragmatic, set out in concentric rings. Although I hesitated to use this presentation, I became interested in the topology that underlay this graphic scheme, and as a further consequence became interested in what I now call **paragrams**.

Paragrams

By the term paragram I refer to those visual aids to exposition such as diagrams, tables, graphs, etc, employed as an adjunct to the exposition of ideas in conventional linear prose. Thus, paragrams should include not only diagrams with or without words, but all schemes that employ symbols in place of prose. One reason for embarking on such an inquiry includes the observation that paragrams have been used by a number of writers on modern art. In passing it might be thought particularly fitting for the visual artist to resort to paragrams as a method for communicating ideas, but I hope to show that the artist's motives are not necessarily as naïve as this suggests.

The best known and perhaps the commonest device we could call a paragram is the family tree. This genealogical device has often been resorted to in the broad treatment of the history of ideas (dynasties of thought) and it is quite fitting that it has been used in the field of modern art. A good example was the celebrated cover for Alfred Barr's **Cubism and Abstract Art**.[1] This was later reproduced and discussed in an article by Le Corbusier,[2] on Purism, where he also reproduced a further paragram from Barr's book, an equation of four terms, a kind of didactic pedigree of Jeanneret (Le Corbusier) and Ozenfant's movement. Barr's was probably the model for many others that followed, although it was not necessarily the first. Such charts were a popular didactic device for establishing the right of succession in movements (of which a good example is to be seen in the Réalités Nouvelles album of 1948).

In the early twenties Malevich devised didactic charts similar to those that appear in '**Die Gegenstandlose Welt**',[3] and among the Dadaists Picabia was fond of devising charts, but of a purely playful nature. More recently Charles Biederman has employed paragrams, often more complex than the one to be found in his article in this volume.[4] Further, in a monograph on Max Bill,[5] the artist supplied a paragram in lieu of a personal statement, while in a publication by Georges Mathieu[6] there appeared a suite of paragrams jointly entitled **Esquisse d'une embryologie des signes** one of which employs the symbols and propositions of the 'contradictory logic' of Stephan Lupasco.

Outside the plastic arts we find the composer Ianis Xenakis using paragrams in the exposition of his ideas. These he calls 'organigrammes' and they appear in his book **Musiques Formelles**.[7]

It might be thought that the reason for employing paragrams is the desire to appear 'scientistic' (and/or cabalistic). But even if this were true it should not obscure the possibility of more reasonable motives. To take one example, the shortcomings of linear prose, plus the inadequacy of much of the terminology, have often been felt by many people writing on questions to do with modern plastic art.

A history dealing with the development of paragrams has yet to be written. The background of such a study might be traced back to antiquity, but it is at the end of the seventeenth century that we find the immediate origins of the modern paragram. It is somewhat easier to see what developed strictly within science, logic and mathematics, and to use this as the background for a larger context, ie, the tendency towards 'picturing' or 'graphic argument', which we now term making visual analogies or analogues.

Among mathematician/philosophers Leibnitz might be taken as the father of this curious offspring, for as well as giving the cue for systematic topology (see the letter quoted in D'Arcy Thompson[8]) Leibnitz is also described as having become aware of an isomorphism between assertions that are made in logic and geometry, and this led him to construct analogies for logical relationships. Soon after, Euler initiated the real beginnings of topology with his first theorems in what was to become known (much later) as graph theory. Euler also pioneered the best known visual scheme for demonstrating logic, the 'Euler circles', which first appeared in his **Lettres à une Princesse d'Allemagne**.[9]

Almost a century later the founder of pragmatism, Charles Pierce, wrote (also to a titled lady), 'I wish you could study my existential graph, for in my opinion it quite wonderfully opens up the true nature and method of logical analysis: although how it does so is not easy to make out, until I have written my exposition of this art.'[10] Coming to the present century, among many developments we could cite are Korzybski's three-dimensional paragram, 'the structural differential' – a patented device used to demonstrate different levels of abstraction proposed in his **General Semantics**;[11] and the neural networks of McCulloch and Pitts (1943), who claim to have shown that any proposition which can be stated unambiguously in a finite number of words can be presented as a mathematical abstraction of the properties of these circuits and networks of nerve cells. While Pierce was working out his 'theory of signs' and his 'logical graphs', other graphs, especially those known as 'trees' (see later), were being investigated and used by mathematicians, chemists and physicists. This was the period that saw the first structural formulae and three-dimensional models.

Broadly speaking the context of the paragram, as a systematic device, is the 'theory of models', together with epistemology, mathematics and logic. According to Armandi

Asti Vera, epistemology is the 'science of structures', **structure** to be defined as **an abstract group**. Concerning modern developments Vera says of our present century: 'We too have tried to systematise human knowledge through topology'.[12] Certainly topology is found to be a constant link in all these areas, but the specific context for the paragram is 'graph theory', which is concerned among other things with the study of line and point structures – of which trees are a good example.

 In general, appropriate 'structures' consisting of lines and points can be found for the presentation of sets and logics. Thus the diagrams of Euler, employing regions, can be transformed where appropriate into lattices such that 'every (non-void) finite, partially ordered set can be represented by a diagram' (Birkhoff).[13] Such diagrams become directed graphs, although they may not contain directed circuits. The system of lines and points can be taken as an 'infrastructure' – exhibiting topological characteristics – although what the graph is primarily devised to show is an order which it exhibits through the points lying on a plane lattice, while the connectives (the lines) are orientated (given a direction by applying an arrow pointing away from or towards one of their two end points).

 In an increasing number of fields graphs are becoming a major tool, and might be described as a new lingua franca, especially in branches of technology and operational research (for example, critical path analysis). In each situation the appropriate form of diagram is devised, each employing whatever needs adding to the system, such as the orientation already referred to, colours, as well as numbers, etc. (In Karl Popper's **The Logic of Scientific Discovery** he shows a typical example of the kind of translation I am referring to, and discusses some of the limitations of this technique.)[14] I show here an extremely simple example of such a translation, although it could be argued that the scheme chosen is more immediately explicit as it stands and when 'translated' little is gained. Also, the trees that result need not be taken either as lattices or as directed graphs. The example concerns the picturing of the three 'branches' of semiotics.

 The labelled 'concentric' regions represent: a. the **syntactic**, b. the

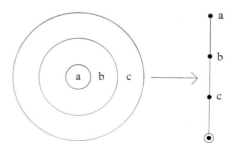

semantic and c. the **pragmatic**. The scheme explains the relationship of each to the others. It is perhaps important to emphasise that the scheme does not depend on the way the circles are drawn as regards a symmetrical arrangement (compare the scheme used by Molnar in his article) and this should be borne in mind when considering the diagrams shown later.

This scheme is the tree that the first scheme can be translated into. To see how this is arrived at we should first forget the labelling of the regions/points. Considered at its most general we are asking how many ways there are of arranging three **disjoint** 'circles' in the plane, taking 'circles' to represent closed curves (lines) or plane regions.

If we have three circles, then the number of arrangements is four. We show below the remaining three possibilities with their associated trees:

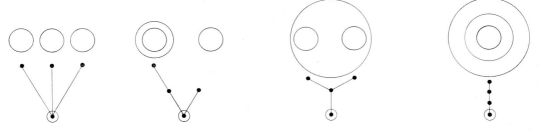

The trees employed in this scheme are called 'rooted' trees, the root or special node being taken as a representation of you yourself or a location point, in a space of either two or three dimensions. Put another way the trees can be taken as the **duals** of the maps (the maps being conceived of as lying in the plane or on the surface of a 'sphere'). We must add that the 'circles' may also be thought of as disjoint empty 'spheres' in three dimensional space.

Below we show how the tree is derived from the map, but in this particular scheme we have chosen to show a directed tree (as an alternative to a rooted tree), and here the special node is then recognised by observing the orientation of the lines.

But finally the important idea is not so much the combinatorial possibilities that arise through re-distributing the labels on the regions/points (A, B, C) permutationally, but the different topological situations that become possible (in this case, which is inside which, etc, of the three entities).

Another much used device is the tableau or table. This can be quite systematic (truth tables, etc) or by contrast quite informal. As an example of the former there is a demonstration of translating a 'semantic table' into a tree, to be found in an article by Beth.[15] And as an example of a more informal table here is a paragram devised by Rudolph Carnap:[16]

Expressive function of language

Arts

Lyrical verses etc

Representative function of language

Science (= the system of theoretical knowledge)

Philosophy Empirical sciences

1. (Metaphysics) Physics, biology etc

2. (Psychology)

3. Logic

In the field of aesthetics such diagrams are not uncommon and G. D. Birkhoff, the mathematician, wrote a celebrated book **Aesthetic Measure** (see below) in which his aesthetic formula was set out as a diagram.[17] Of more recent examples I would cite Abraham Moles who has employed cybernetic models in his analyses of the process of composition, etc.[18]

Most noticeable is the frequency with which such elements are employed in any general discussion of communication (for a typical example see the article of the poet and semanticist I. A. Richards, **Structure and communication**[19]). In the same year as Denes Koenig published the first **book** on graph theory[20] (1936), the psychologist Kurt Lewin published his **Principles of Topological Psychology**.[21] Lewin believed the determination of topological relationships to be the fundamental task in psychology, and set up a theoretical psychology based on topology. It had occurred to him that: 'the figures on the blackboard which were to illustrate some problems for a group in psychology might after all be not merely illustrations but representations of real concepts'. In elaborating this idea he explained: 'We are not dealing with the representation of

the dependency of certain classes of events on each other, nor with pedagogical aids to visualisation, but with conceptual determination of the dynamic properties of concrete situations. That we generally illustrate this conceptual representation by a figure is a matter of secondary importance. We have to emphasise that the figures lead to misunderstanding if a reader interprets them in terms of the usual metric geometry, instead of topology. The diagram on the paper is in fact only a picture of certain topological structures which for their part are to serve as a conceptual representation of psychological facts . . .' Lewin made use of diagrams (paragrams) which we would call topological maps. However, in the development of this approach, notably in group dynamics, the diagrams most employed now are 'digraphs' (directed graphs).[22] Others have termed these particular schemes 'sociograms'.

The International Picture Language of Otto Neurath (the Isotype System) is not closely related to the conception here of paragrams, but it is nevertheless worth mentioning in passing. First, because Neurath has pointed out[23] that in the writings of Leibnitz we find the idea that picture making is to be done with the help of science (Leibnitz had hoped to make an 'atlas universalis' in connection with an encyclopedia). Secondly, because during the years 1928–31 Neurath had occasion to meet Lissitzky, himself a notable pioneer in visual education methods. The result was an exchange of ideas and contact between two dynamic educators coming from separate fields, but each representative of the most advanced schools of thought at the time; Lissitzky the artist from constructivism, and Neurath the sociologist from the Vienna Circle of philosophers.

We have seen some of the characteristic structures that can be described as paragrams (tables, maps, trees, etc), employed for the description of a variety of communication links. We also saw that generally they can be translated into linear graphs of one kind or another.

Finally, it might be suggested to artists that among the uses of paragrams is the translation of **programmes into paragrams**. I have not attempted to enlarge on the question of the paragram, either in a general context or as it has been used by artists; with regard to the latter the reader can see that it is not a new or untried idea [in the present anthology five contributors have made use of paragrams and or diagrams].

It is too early to foresee whether in practice this idea, as used by artists, will bear a close relationship to the topics I have been discussing, namely the more systematic use of paragrams. So the proposal for a systematic approach to artists remains both tentative and speculative.

Structure

In the second of the ways I wish to discuss 'structures', ie as organising principles, I propose to take networks as **abstract structures** and consider their **measurable content**. What emerges are two propositions, one from aesthetics, the other from molecular biology, with the common feature of symmetry.

In **Aesthetic Measure** Birkhoff refers to networks on three different levels. First, he believes that the ultimate description of aesthetic phenomena is to be conveyed in physiological terms, and he writes: 'An aesthetic field corresponds to a network of associative nerve fibres in the brain'. Second, he presents his 'aesthetic formula' in the form of a full page diagram (a paragram and as such akin to a logical graph). Finally, the objects most easily dealt with by his theory are visual data – two dimensional patterns – many of which are examples of simple networks.

Briefly, Birkhoff's 'aesthetic measure' attempts to give a specific value – the M measure – to patterns. The M measure is computed as the ratio of the number of **order elements** (O) to the number of **complexity elements** (C) in a pattern. **Complexity** is defined as the number of indefinitely extended straight lines which contain all the sides in each of the polygons [cells] in the network, while **order** comprises a set of five variables: vertical symmetry (V), equilibrium (E), rotational symmetry (R), horizontal vertical orientation (HV) and the so-called unsatisfactory form (F).

$$\text{Thus } M = \frac{O}{C}; \text{ where } O = V + E + R + HV - F$$

By using this equation Birkhoff arrives at a numerical measure, eg:

258

From these results we can see that the 'structures' with the highest aesthetic measure are: the square (6) and the square tesselation (11). However, before leaving the subject I think it is fair to indicate some reactions to this theory, since it is often cited in the work of scientifically orientated aestheticians (Moles, Bense, etc).

The mathematician Weyl gave a brief but favourable reference to it in his **Symmetry**[24] but the psychologist Eysenck, after conducting a series of experiments, concluded that the M values should be **the product** of the variables rather than the ratio (!).[25] Finally, the mathematical bio-physicist Rashevsky refers to it as 'a remarkable pioneering study', but here again his own researches did not confirm Birkhoff's results.[26]

In the second example, from biology, we leave the specific realm of aesthetics and consider Rashevsky's proposal of a 'topological information content of graphs'.[27] It is true that information theory has been much applied recently in aesthetics, but the following idea of Rashevsky dates from 1955 and comes from quite a different direction. Rashevsky's interest is in revealing a close relationship between topology and life, envisaging the estimation of information in living cells by considering the pattern of the structure as a whole – this latter lying in the topology of the molecular make-up of organisms. He explains that: 'In order to have a sufficiently large information content, the organism must be sufficiently complex . . . this complexity may be to some extent measured by the number of different units of which the organism is compounded'. He further explains: 'It is, however, possible for an aggregate of identical physically indistinguishable units to have a large information content. The units in this case, though indistinguishable physically, are different through **the difference of their relations to each other**.'

We can extend this idea to a whole range of objects, from living matter to inert matter and many types of models, machines, etc. We may also include, therefore, abstract structures and man-made structures (both practical and/or aesthetic). Rashevsky's measure is computed by observing the number of different types of elements in a graph or network, and the proportion in which they occur.[28]

In what follows we shall consider only two cases, networks where the information content is zero, and those that contain the maximal value.

David Bohm has described topology as: 'In essence the study of the order involved in the placing of one thing in relationship to another'.[29] In the topology of finite connected (non-directed networks) we are concerned with regularity, order and complexity; in the two cases to be discussed this amounts to a study of symmetric and asymmetric features, as these terms are defined in graph theory.

In fig. 4 above we have a network which is described as being both

point and line symmetric (and hence face symmetric also). What this means is that all of the constituent elements respectively are topologically indistinguishable. Such networks are called completely regular and/or completely symmetric. Wherever this is the case the information content is said to be zero. (This is therefore true for figs. 6–10 above, ie, all polygons – and their duals.)

For a network (strict graph) to be topologically asymmetric it is sufficient that the points be distinguishable, for all the remaining elements to become distinguishable as well.

Below we show examples of the smallest cases of what are called 'identity' graphs, ie, graphs with no symmetry whatsoever:

| 1 | 2 | 3 | 4 |

A graph is called asymmetric if its automorphism group consists only of the **identity** automorphism.
The automorphism of a graph consists of those permutations of the set of the points of the graph which preserve adjacency relations.

The information content of identity graphs is expressed as:
$I = Log_2 n,$
Where n stands for the number of points, and the information content I is expressed by the log of n to base 2, and referred to as so many 'bits' of information. Thus in the case of the identity tree for seven points (fig. 1, above) the information content would be given as:

$$I(1) = Log_2 n = 2 \cdot 80 \text{ 'bits'}$$

In the literature of information theory we find that H is also given as $Log_2 n$, where H stands for 'uncertainty' (the probability of any one point being chosen at random). Enlarging on this we encounter problems of nomenclature since H may also be described as 'the degree

of organisation', 'entropy', 'negative entropy' . . . However, we need not pursue this further.

Instead we can stay with the idea of 'symtopy relations' (topological symmetry and asymmetry) and see how they might be related to the work of an abstract painter, eg, Piet Mondrian. A well-known feature of Mondrian's compositional scheme is his deliberate avoidance of conventional symmetry. (What I am calling 'conventional symmetry' can be defined precisely in mathematical terms, but not so easily in more general terms. In his book on Polyominoes, Golomb[30] describes symmetry as 'a property of figures or configurations whereby the object looks the same after certain of its parts are interchanged'. This description is general enough to embrace both cases: symmetry involving lengths and angles, the conventional kind, and symmetry concerned strictly with intrinsic properties, the kind we are interested in here.) For this reason it is interesting to follow out the idea of symtopy relations in the networks of his compositional schemes (what might be called the linear infra-structure of his compositions). Applying Birkhoff's measure we obtain nothing of interest, but applying Rashevsky's measure we can at least introduce into the discussion a new criterion of symmetry. In topological (graph theory) terms Mondrian appears never to have employed completely regular networks, but we shall see that he did employ 'identity' networks. (Needless to say, Mondrian was probably unconscious of these considerations.) First we can show how three of the five completely regular networks **can** be adapted to the orthogonal lattice (they are of course equivalent to three of the five Platonic solids).

three of the five completely regular networks	. . . applied to an orthogonal lattice	usual symmetry disappears, topological symmetry [symtopy] remains

Anthony Hill

It is essential to understand that these topologically symmetric structures can be drawn literally as one pleases. The usual criterion of symmetry exhibited in the first two columns disappears in the third column, and further examples of transformations preserving the topological structure would be found even more difficult to recognise, ie, we would find it difficult to see immediately the topological symmetry features.

Between the extremes of complete symmetry and complete lack of symmetry there will of course be examples that contain symmetry features, but some of whose isomorphisms will almost completely disguise the symmetry features, for example:

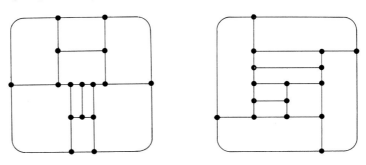

For an identity network serving as the infra-structure in one of Mondrian's paintings, consider his **Composition with red and blue** of 1933 (collection Sydney Janis, New York).

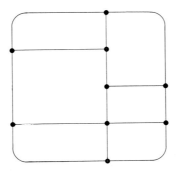

The identity network here is possibly the smallest of its kind (ie, the smallest that can be embedded in the orthogonal lattice). This is the form in which it appears in Mondrian's painting. Being an identity network for 9 points, its information content is, of course:

$$\text{Log}_2 9 = 3 \cdot 17$$

In passing it is worth showing how this scheme can be drawn in five distinguishable, though topologically congruent, ways:

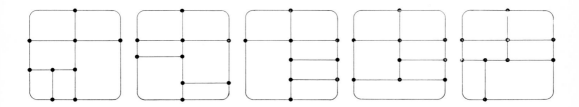

(These examples of symtopy relationships are part of a more extended study of the idea and its application to Mondrian's compositions. The schemes shown, therefore, should be taken primarily as illustrations for a generalised account of symtopy relations in networks.[31])

A fuller discussion of 'measuring' symmetry and asymmetry would have to compare Rashevsky's idea (derived from the pioneer work of Shannon and Weaver) to quite different methods used in graph theory. For example, since the order of the automorphism of a graph can in a sense be considered a measure of its symmetry, the problem has been posed of obtaining a **measure of the asymmetry of an asymmetric graph**. An idea which although deeper should surely be included by Rashevsky?

A further extension of the information content idea, taken as a measure of symmetry/asymmetry, would be to accommodate modular and metrical features. Thus since the smallest asymmetric 'polyminoe' can be made from 4 squares arranged in an L shape, we could say that its information content could be expressed as $I = Log_2 4 = 2$. Similarly a polygon of n sides, all of different length, would have $I = Log_2 n$.

In conclusion: my aim has been to compare two approaches, both applicable to considerations of structure and symmetry in art, especially abstract art. The emphasis has been on two different levels of structure and upon the differences and similarities with regard to implicit and explicit symmetry relations. The former are the factors in Birkhoff's approach, where perceptual considerations are the key – this approach subsumes symmetry and gives a heigh aesthetic measure to structures with a minimal information content. In the later, intrinsic structural relations are the key. In both approaches a measure is obtained by quantifying prescribed qualities. The main difference brought out is that, whereas metrical symmetry as a quality is in some measure always **relative to an abso-**

Anthony Hill

lute (the ideal), involving deviations, approximations, etc, topological symmetry, is at all times an **absolute** and invariant quality.

Finally, it will be asked what relevance such a discussion can have for art or for aesthetics. My own view is that these topics will take their place in a much needed general phenomenology of structure.

[1] Alfred Barr Jr: **Cubism & Abstract Art**, Museum of Modern Art, New York 1936.

[2] **Art d'Aujourd'hui 7–8** 1950.

[3] **Bauhausbücher II** 1927. (English translation, Paul Theobald, Chicago 1959) Some of these charts are on extended loan to the Museum of Modern Art, New York.

[4] For details of the published works of Charles Biederman see the biographical notes.

[5] See the biographical notes.

[6] **Au Dela Tachisme**, Julliard, Paris 1956.

[7] **La Revue Musicale Nos.253/4** 1963.

[8] **Growth and Form**, vol 2, p.609. Cambridge University Press 1956. It is often pointed out that Ramon Lull, the thirteenth century visionary and theologian, was the founder of this application, ie, 'logical diagrams'. His ideas attracted Leibnitz's attention and later Pierce's. A good account of Lull can be found in Martin Gardner's **Logic Machines and Diagrams** McGraw Hill 1958. ('The first attempt in any language to trace their curious, fascinating histories . . .')

[9] The Euler Circles were later developed by the English logician John Venn (1834–1923) under whose name they are better known.

[10] Pierce to Lady Welby in 1876. These ideas were later published in **The Monist** as **Prolegomena to an apology for pragmaticism** 1906. Earlier Pierce had written **On Logical Graphs** 1898, 'a system of valential graphs he used to represent logical relations and with which he tried to prove topologically the irreducibility of triadic relations'. (M. G. Murphy: **The Development of Pierce's Philosophy** Harvard 1961.) Murphy explains the importance for Pierce of topology (or 'synectics' as Pierce chose to call it). Pierce regarded his logical graphs as his chef d'oeuvre.

[11] **Science & Sanity** Science Printing Co. 1933.

[12] **Epistemology, science and structures** in **Transformation 3** Wittenborn Schultz, New York 1952.

[13] **On the structure of abstract algebras** in **Proceedings of The Cambridge Philosophical Society 31**. Garrett Birkhoff is the son of G.D. Birkhoff (1884–1944).

[14] Section on **Logical Probability** fig.1 p.116. Hutchinson London 1959.

[15] **Semantics as a Theory of Reference** in **Philosophy in the Mid 20th Century** La Nuova Editrice 1958.

264

Anthony Hill

[16] **Philosophy and Logical Syntax** Kegan Paul 1935. For permission to reproduce this tableau we wish to thank the trustees of the late C. K. Ogden.

[17] **Aesthetic Measure** Oxford University Press 1933.

[18] **Cybernetique et oeuvre d'art** in **Revue D'Esthetique No.2** June 1965.

[19] **Structure and communication** in **Structure in Art & Science** vol 2, **Vision and Value** edited by Gyorgy Kepes, Studio Vista, London 1965.

[20] **Theorie der Endlichen und Unendlichen Graphen** Leipzig, 1936.

[21] McGraw Hill, New York, 1936.

[22] Harary & Norman: **Structural Models – an introduction to the theory of directed graphs** Wiley, New York, 1956.

[23] **International Picture Language** – the first rules of Isotype. Basic English Publishing Co., Kegan Paul, London.

[24] Princeton University Press 1952.

[25] See the discussion in H. J. Eysenck: **Sense & Nonsense in Psychology** Penguin Books, London 1957; also **Aesthetics and personality** in **Exakte Aesthetik No.1** Galerie D, Frankfurt am Main, 1965.

[26] See the chapter on **Perception of visual patterns and visual aesthetics** in his **Mathematical Biophysics** Cambridge University Press, 1948.

[27] **Life, information theory and topology** in **Bulletin of Mathematical Biophysics 17** 1955.

[28] Elwyn Edwards: **Information Transmission**, Chapman & Hall, London 1965. This should be consulted in conjunction with (25) for the manner in which the topological information content of graphs is computed.

[29] **A proposed topological formulation of the quantum theory** in **The Scientist Speculates** Heinemann, London, 1962.

[30] S. Golomb: **Polyominoes** Scribners, New York, 1965.

[31] **Art and mathesis: Mondrian's structures** in **Leonardo** vol 1 no.3 1968.

Anthony Hill

Relief construction F2 1965

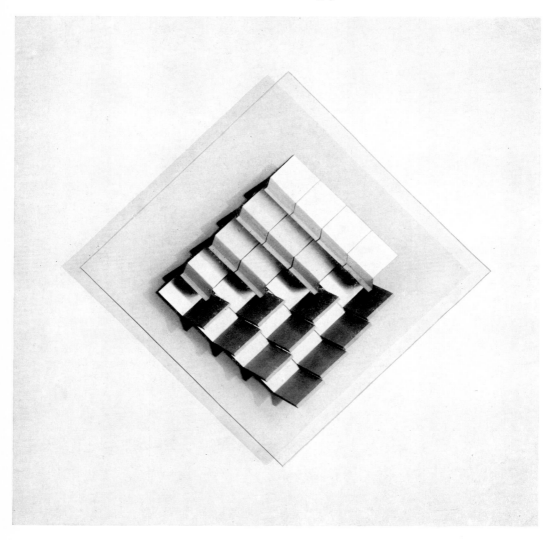

Anthony Hill

Relief construction G1 1965–66

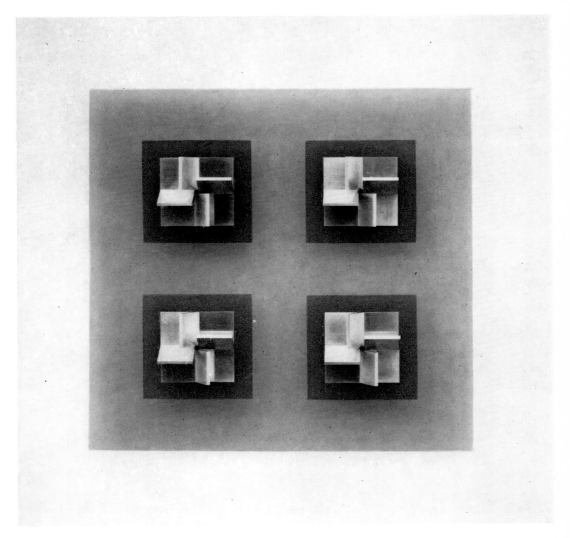

Anthony Hill

Relief construction H1 1966–67

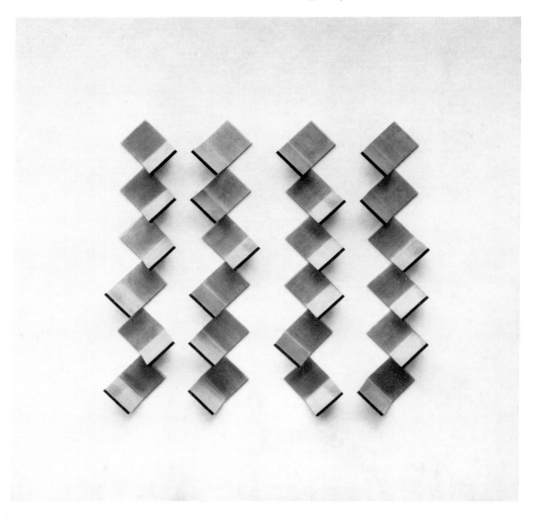

Anthony Hill

Constructional screen 1965–67

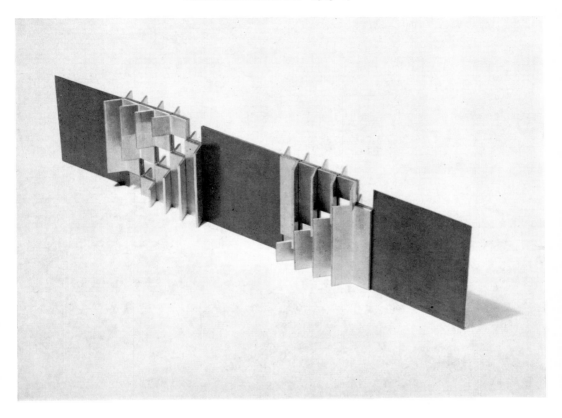

Jean-Pierre Yvaral : Aims

Our aim is to restore the primal quality of vision, by eliminating from our works all meaning foreign to them and for which they would be merely the token. This meaning can exist as a simple reality, a 'state of mind', a poetical or metaphysical message, or as the factors that contribute to a working subjectivity.

In fact it is a question of desanctifying the artist's gesture. We would like to replace those works in which creation makes itself out to be magic, for works whose essence relies on the exercise of visual perception, and the awareness of vision that the plastic artist as well as the spectator can have.

In short, it is up to us to free 'the eye from the spirit', by eliminating all extra plastic criteria.

For some of us, the work constitutes the substance of a game which abides by its own rules. The spectator is drawn into an active participation, whether he has to shift his position or manipulate the work.

This call for the positive participation of the spectator shows among other things our deliberate refusal to impose an unequivocal and definitive meaning on a work. This is a way of de-mystifying the traditional idea of creation. The artist supplies nothing but the rules and the substance of the 'game', taking for granted that the spectator can always improvise new rules.

For those like myself who are more concerned with research into structure, the aim is not directly to invite the spectator to play. It is a question of enriching the awareness the spectator may have of the real nature of visual perception. In fact what I myself hope for is that when confronted with a work whose meaning remains ambiguous, the spectator should analyse the relation between reality and what is seen, in all its diversity, and arrive at a more complete control over the workings of his own vision. This 'possibility' of determining at the same time the theoretical and technical processes of visual effects is, in my opinion, of prime importance. This double process is usually only made possible by the relative simplicity of the problem's particulars, and the economy of means with which we are able to solve them. This seems to me to be the main condition through which the spectator comes in contact with the domination of the sense of visual effect which originally fascinated him. My aim is therefore experimental and pedagogic in the widest sense. However, this does not exclude recourse to the game, whenever this sharpens visual awareness.

The result of all this seems to me to be an education in visual perception itself. Separated from the work, the spectator can see in the natural as well as in the cultural environment visual effects that have previously remained unobserved.

The world is an open system of natural phenomena, and yet a system with cultural meaning. Until now it has been thought of, especially by artists, as functioning with a

relatively congealed and immobile power of perception, as if man was already, and for eternity, all that he could ever become. This idea of man derives from Protagoras, who said that 'man is the measure of all things – of what is, that it is, and what is not, that it is not'.

What I attempt personally is a sort of decentralisation, by playing on the scale of variations and structural permutations in order to open out perception into new fields of investigation. This exploration, which aims to be methodical and strict, seeks to show the continuity of visual structures by turning to the different procedures that take account of the methods and techniques offered by modern scientific research. These include topology, the theory of probability, statistics, the theory of information, even cybernetics. And we can see that this research is not without analogies and affinities with modern physics, especially when it tries to prove the unity and continuity of the structure of matter.

In conclusion, we can say that the aim of our present work is to allow man not only to augment or bring out powers of perception not yet realised, but also to equip himself with the means of transforming his environment (as well as his leisure) by the different uses of the results of our research.

[1965]

Jean-Pierre Yvaral

Progression du carré 1959

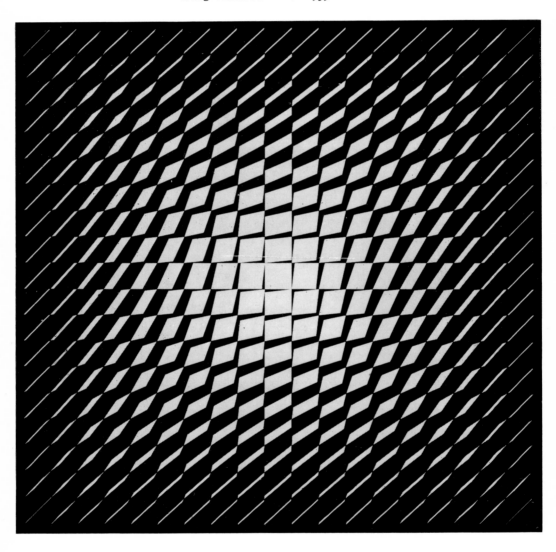

Jean-Pierre Yvaral

Progression 1959

Jean-Pierre Yvaral

Quadruple rotation d'une progression 1962

Jean-Pierre Yvaral

Plan-espace 1962

Gillian Wise : Notes on the art-work as an object

In making an art-work the artist has to consider both general and particular ideas. Within the general context there is the particular process of selection, but how it is that he decides a certain technique, material or motif can in some way illustrate the context, remains imprecise. Whatever his field of interests, whether they have been arrived at through experience or a consciously rationalised decision, what the artist does within these self-imposed limits must remain speculative.

The artist, then, is always familiar with the element of the unexpected. This may be attributed to intuition, chance, or simply the unpredictability of a train of thought, but it has to be accepted and relied on in any kind of inventive or creative work, as much in science as in art.

For anyone to be interested in trying to find out more about the creative process, that is, in attempting to predict what happens that leads to the unpredictable, may seem in itself paradoxical. But nothing can be lost by the artist thinking about these things himself, or others doing so for him, although from a practical point of view the question of why the artist chooses a technique to express a motivation seems easier to deal with than the sources of the motive itself.

If we look at the general effectiveness of art, it seems clear that it can reach beyond the borders of race, country, time and civilisations and yet retain its power for people quite unfamiliar with its content – whether symbolic or narrative – although its technical range and scale of cultural achievement is controlled to a certain extent by place and time. So if the appreciation of art in its power to affect us is so broadly based, it should be possible to abstract what physiological responses are involved, as indicated in this passage by H. J. Eysenck: 'There is a personal quality of aesthetic taste which characterises a person in relation to visual objects and which is very high in some people, very low in others and intermediate in most. This quality is relatively independent of intelligence and probably even of training, and may be considered an innate property of the nervous system, and is the foundation of whatever degree of objectivity may be possessed by aesthetic judgments.'[1]

If the 'property of the nervous system' became understood it seems quite possible that it could then be manipulated by 'non-experts', ie, people who were themselves relatively insensitive to an appreciation of aesthetics, and its use to pre-determined ends could be more systematic.

The function of the art-object is basically to be used as a **medium** for projection; and as a medium its function is infinitely variable. Anyone investigating how it is this

medium can communicate ideas and sensations has to take into account simultaneously (1) the artist, who in some way manages to transform an experience or an idea into (2) a tangible object, and (3) the spectator, to whom this experience may or may not be transmitted. In other words the artist may be in possession of an idea or a set of ideas which, until he has found some way of projecting effectively to others, might just as well never have existed. Society can only know about those experiences that have already been successfully communicated, when, apart from the individual pleasure given, they can serve as a gauge to a related, group sensibility.

If the artist has an idea he wants to express before he knows by what means he is going to express it, or if conversely he recognises in an object a sensation analogous to an idea he has had independently of it (as an artist may exhibit an objet trouvé), then it should be possible to try to isolate the reason why an object is meant to stand for a particular set of relationships, and how we can understand it as much.

This means that ideally the artist should be able to be tested in an objective fashion, simply as a sensitive technician or translator of media, to see whether what he understands by his work is what others understand by it or can be trained to understand by it, quite apart from questions of beauty. The sensation of comprehension itself can be part of aesthetic response. But to do this the artist must attempt to **describe** his aims, rather than justify them in a satisfactory literal proposition; something that none of us have had any real training to do. Since he is the only person who can speak with any authority about what he feels his aims to be, it can not be left entirely to the investigator to judge their effectiveness without knowledge of them, although he can test what their effect is on others. In this sense the artist can be thought of as a translator: 'The translator has first to reconcile himself to conceiving his art in terms of minimal loss, and then to balance and adjudicate, as best he can, the claims of the rival functions. His question is: which sorts of loss will we take in order not to lose what?'[2] If it is compatible with the kind of work he does the artist can adopt the use of simply explainable or analysable systems of components or proportions, as for example those suggested by Lohse, or Vasarely's idea of a unit-based art. But these methods can only be self-imposed. Any attempt to describe or judge the motivation of aims and choice of expression would be a very different question, in the same way that it is easier to establish what gives aesthetic pleasure than why it gives it.

The argument against a theory of aesthetic experience gaining ground is the chance that a limited theory will be given undue influence over the development of art just because, unlike the succession of vaguely comprehended 'movements' that pass in and out of fashion and hold sway, its very reasonableness might make it difficult to refute or pass over in favour

of some more or less intuitive objectives. The ideas formulated by the intellect have only a logical truth, a possible truth – their selection is arbitrary.[3] Such reservations have always been held, perhaps unnecessarily strongly, by artists who accuse the system formulators of lack of depth in their frame of reference. But in art they have to work in a field whose boundaries have so far resisted definition, so that may be understandable. Nevertheless, even in philosophy there is a suspicion of the scientific method being accepted too glibly when, to quote Paul Feyerabend: 'A theory is adopted, usually because it seems to be attractive for some reason or other. Experience is **re-interpreted** in order to be "close" to this theory, and the theory is then defined by empirical argument, by pointing out how closely it fits the facts.'[4] So here we have, almost, the proposal that one art-form is investigating another art-form (which is simply being used as material for attractive theorising). But while these efforts may seem clumsy to the artist and perhaps even to the investigator, as long as the power of art remains a mystery, people will be tempted to try to solve it, if only for aesthetic reasons.

Science has given us a vision of the two extremes of the physical world that are invisible to our direct experience; that of atomic and molecular structure, and that of the universe of outer space. As a result our image of ourselves in relation to the world has changed. In other words our 'world view', both physically through the evidence of models, diagrams and photography, and mentally through the popularisation of scientific concepts, has been extended at each end. We have become much more used to, and familiar with, this real world that is invisible to us, than has ever been possible in the past. Its mysteries offer the promise of at least partial solution, and its fascination of fact, puzzle and obscurity, interests artistic and scientific temperaments alike. In providing imaginary concepts to illustrate physical reality its richness has made the old religious speculations about heaven and hell look very un-inventive.

Ever since the discovery of perspective artists found that they had control over what kind of space they portrayed, in a way not previously envisaged. They could adjust and distort it to convey different sensations, both aesthetic and psychological, as for example by the double eye level separating figure and landscape in use from Piero della Francesca to Annigoni, or a surrealistic 'inner space' in use from Hieronymus Bosch to Chirico.

As the classical understanding of perspective became progressively metamorphosed under the influence of impressionism, cubism and futurism, the Russian suprematists had their own view as to what they were doing with it. They may have eliminated the recognisable

object from their work but they did not want to eliminate recognisable space. Lissitsky explained their position in the following way: 'The task is to organise imaginary space by means of a material object.' 'Perspective built the world into a cube and transformed the cube in such a way that it appeared as a pyramid on the surface. Suprematism has removed into infinity the top of the finite pyramid of vision.

'Suprematist space can be organised from the surface to the front as well as in depth.'[5]

To what extent has this use of space, imaginary but analogous to a known space, continued to play a part in abstract painting? To bind or reflect a particular outlook.

Through our present sophistication in reading all kinds of visual representations – either standing for a physical situation or perhaps a diagram of a thought pattern – we have become very adept at adjusting these readings to a vast range of possibilities, looking for the slightest clues to resolve an ambiguous picture. In general, as far as the physical world goes, a scale will suggest itself that falls roughly into one of the following four categories:

1. Micro – enlarged from microscopic proportions;
2. Same size – representing the physical dimensions exactly;
3. Architectonic – reduced from architectonic proportions;
4. Macro – reduced from universal proportions.

Our reactions to proportion are accumulative and vague, but there is no reason to suppose that they are irrational because they are complex and indefinable. Even in current art it is not difficult to see how different movements have favoured different types of space to emphasise sensation by shape and scale: the shallow uniform space of optical art, with its marginal use of perspective illusion, or the play with dis-orientating scale in pop, are obvious examples. But it wasn't until the suprematists that this idea began to be handled consciously as being a viable, abstractable element from what previously had been 'mood' setting for figurative art.

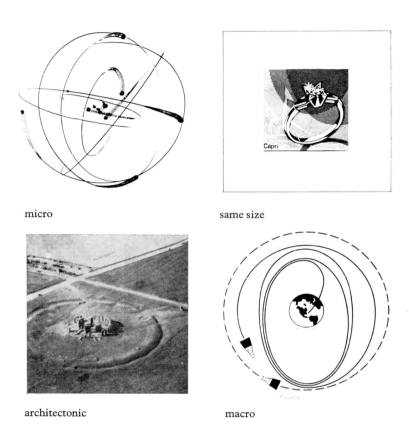

micro same size

architectonic macro

 The use of the relief structure employs illusion in another way. It may want to stand for other scales, or be ambiguous, but it remains an object without recourse to perspective illusion in the diagrammatic sense, although it may relate to a definable field (the base plane). But even when it is a free-standing structure in space it tries to avoid the ponderous inflexibility of sculptural mass. Technically this introduced a new range of materials by the use of the non-volumic, the transparent, the linear, the reflective and the mobile (as pioneered by Gabo and Vantongerloo), and it is for the viewer to enlarge or contract its possible scale, at will. For this reason a simply structured object tends to be more effective, where the operations of the artist can be clearly de-ciphered or de-structured. To this extent it involves the spectator in 'using' the work in a way that is not possible when technical expertise creates an impression of condescension by using calculated mystification.

If the art-work is to be seen as something that can involve the spectator in a direct way, this doesn't necessarily mean that it only operates when it is being given full attention. The successful art-work acts as a phenomenon that has some influence over the environment and whose effect can be absorbed in a state of distraction, without imposing a conscious assessment. An important function of the art-work is to 'tune' the environment. Its message can be oblique or direct, almost simultaneously, dividing into the phenomenal and the conceptual.

In so far as the structuralist wants to avoid scale identification his aim comes close to that of the diagrammatic. He stands for something variable in physical interpretation, not specifically designed for rooms or architecture but something that can be anywhere or nowhere, something that is not meant to 'fit in' with any particular environment. It is an attempt to use a physical language to elude a dogmatic physical presence.

The more an artist becomes used to working in a world of concept that is largely independent of the observed world around us, the more he will want to extend and transform the expressibility of the physical medium of the plastic arts.

[1966]

[1] H.J. Eysenck: **Aesthetics and personality** in **Exakte Aesthetik No.1** 1965.

[2] I.A. Richards: **Speculative Instruments – Toward a Theory of Comprehending.**

[3] Marcel Proust: **Time Regained** Chatto and Windus.

[4] **Beyond the edge of certainty**: **Essays in Contemporary Science and Philosophy.**
Paul K. Feyerabend: **Problems of Empiricism** Prentice Hall 1965.

[5] El Lissitsky: **K und Pangeometrie** Europa Almanach 1925.

Gillian Wise

Continuous line linking two planes (model) 1967–8

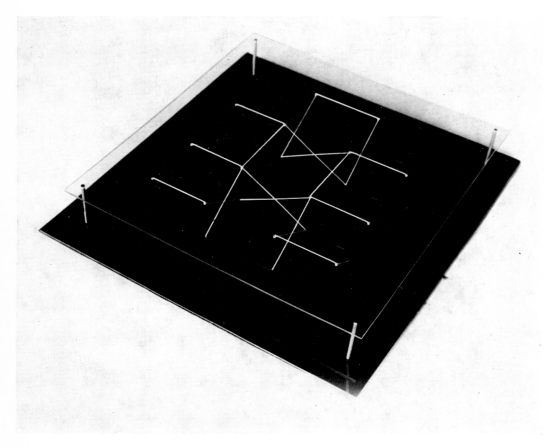

Gillian Wise

Four part continuous line on one plane 1967

Gillian Wise

Construction of sixteen points on three grids 1967

Gillian Wise

Four part continuous line in space 1968

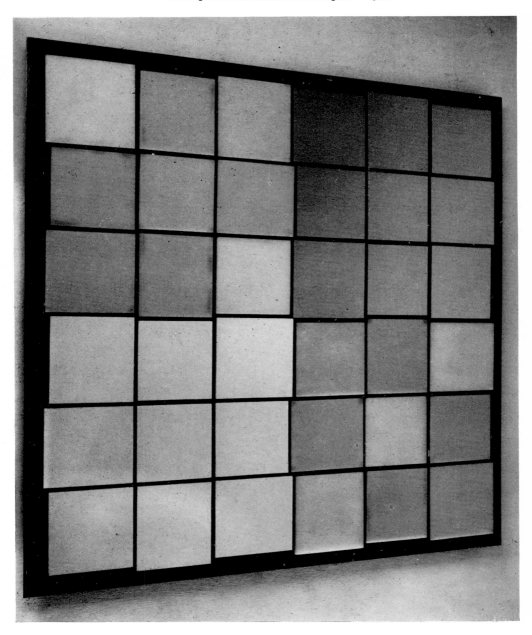

Lev Nusberg : On action in perception of the world

With all that is now known, with the researches in the domain of aesthetics into **space creation in time, with the utilisation of movement as forms of artistic expression,** kinetic art is taking shape ever more concretely. Life itself settled this question. But kineticism has several basic directions in its development: **urbanism, dramatic presentation, the applied side (aesthetic therapy, training of the young, dissemination, etc)** and others.

But for all forms of research there is one main problem – that of the new **subject-object** relationship, the individual and the environment. This qualitative difference from the entire previous history of the development of human civilisation (with certain exceptions) puts man into new relationships with the world directly surrounding him. This is a call (and the need is vital) towards the greater activity of man. If previously man interacted **passively** with the world (particularly with the world of art), then the kinetic tendency, the kinetic sense perception of the world, is calling man towards an **active** relationship. If man was 'the perceiving subject' and any art-work was 'the perceivable object', then man certainly was creatively active, and entered into contact with the external, but this activity was only internal, passive. ('The perceiver' each time took part in the re-creating, in the regenerating of any art-work – otherwise it would have remained cut off from him – but this process was emotionally illusory. He was not truly, creative actively **in the full sense** of the word. It seemed to him as if he took part in the creation of an art-work, whereas **he only re-created it: he did not create it**. To create in one's imagination is not the same as to create concretely, in a real situation.)

Thus one can say that the subject-object relationship was one-sided. The object (art-work) worked actively on the subject (man) but was not adequately reacted upon in return; that is, there was no return communication.

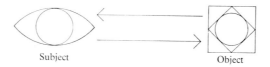

Subject Object

And here the kinetic sense-perception of the world (and consequently kinetic art, too) really offers man a chance to respond actively to **something** perceived (the art-work), and in this way to extend the mystery of the creative process, to continue to create and alter the art-work itself. In this can be seen much greater pressure on man, a demand for greater creative activity by him.

This, in my view, is the basic problem of kineticism at the present stage (the stone age!) of its development. And from this derives the problem of reaction-perception. To be sure, it is not only a question of aesthetic reaction on man, but the perceiving by man himself of different signals from the outside world, and the way he reacts to these signals, actively or passively. Altogether the problem is one of increasing the activity and the participation of man in conditions of life that grow constantly more intensive.

It was not in vain that these questions were examined at the eighteenth Psychological Congress in Moscow, though there didn't seem to be enough reference there to the philosophical side in the psychology of art.

If we now turn to art it becomes clear why I (and some kineticists and art critics) consider as basic the question of a methodological investigation of certain closed and certain semi-free 'space-environment-atmospheres', which in their existence, development and change depend partially or wholly on the creative activity of man. In this way, **by calling forth in any man** the creative beginnings, the play instinct, kinetic art is not only an all-embracing art, but also a democratic art, an art for **all**!

Here we have already worked out a project for the creation of **a labyrinth of 'yesterday-today-tomorrow'.** This is a maze about 300–500 metres long with a great many special locations, using the most diverse technical and aesthetic means: **cinema, colour-music, kinetic objects and groupings, pantomime, text, music, smells, changing temperature and movement of air, various optical effects,** and much else.

There will be whole stages here, where anyone can actively affect the surrounding environment, the art-work (within certain programmed limits of course). Here also we want to put on a whole range of scientific experiments of a sociological-psychological kind, connected with the problem of man's reaction to, and perception of, various signals. This is very important for the further successful development of kineticism, in the USSR as well as in the rest of the world. **'Yesterday-today-tomorrow'** would be like galactic travel to other **worlds**, perhaps to the Milky Way, but all this will be created by kinetic means, not just technically but also psychologically. A whole session, one showing, lasts about two hours and depends on adherence to the scenario, in which allowance is made for the **unforeseen** behaviour of the visitors.

Concealed behind all these experiments and theoretical researches are enormous possibilities for their application in practice, in life. In the first place, in **education**; in the **dissemination** of diverse ideas; in improved **working conditions**, etc.

The point is, that the kinetic means of influence differ in some cases from those of the 'classical', in that they influence man not only aesthetically, or even psychologic-

ally, but **physiologically** as well. Yes, exactly, physiologically! And thus they are the most active means of affecting man, and not just on the aesthetic level. **But there is also concealed here a great potential danger.**

By the use of kinetic means of artistic expression we increase the **effectiveness** of the propagation of the Humanist idea, and the dissemination of the Beautiful in the world. But in spreading different ideas by kinetic means we not only convey them more deeply and complexly to the consciousness of man, but we also involve him in **an active process that is consciously educational.**

1. Mechanism of the influence of kinetic means:

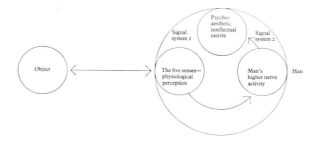

In the new but long maturing relationship between the 'perceiver' and the 'perceived', the perceiving subject ceases to be merely a 'perceiving mechanism'. Man becomes a more complicated and intensive being who simultaneously perceives the work of art and reacts to it.

2. Scheme (purely conditional) **of kinetic subject-object relationship:**

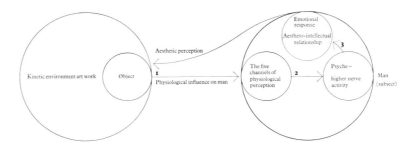

In this way **kineticism** changes qualitatively man's contact with the world of art, and with the **world** generally.

It will be clear now how successfully and on what a large scale one can utilise the means of kinetic art in education, with children as with adults, to develop their creative abilities. But, certainly, this matter is not for the present, although already one might experiment successfully in special educational institutions. In addition, I would like to mention briefly that the kinetic art-work itself may be coded and programmed by conventional symbols (in draft form calculations, descriptions, etc) and may be transmitted successfully in practice over very large distances, even as far as other planets. In this way it is fully possible to re-create (given particular materials and specialists) almost the same kinetic art-work as that which has been ciphered. **It is a principle of the kinetic art-work to transmit into the future!**

Lastly, the collective creative work (including the technical side) is an integral part of **kineticism**. Each person retains his freedom of creation, but alone is not able to create a whole kinetic work. In kineticism, the musician, the architect, the artist, the psychologist, the engineer, the producer, the cinema director etc, all play an equivalent role. Kineticism – this is a collective art and intended for the great majority of the people! The future is for **kineticism**!

[1966]

Lev Nusberg

Painting 1962

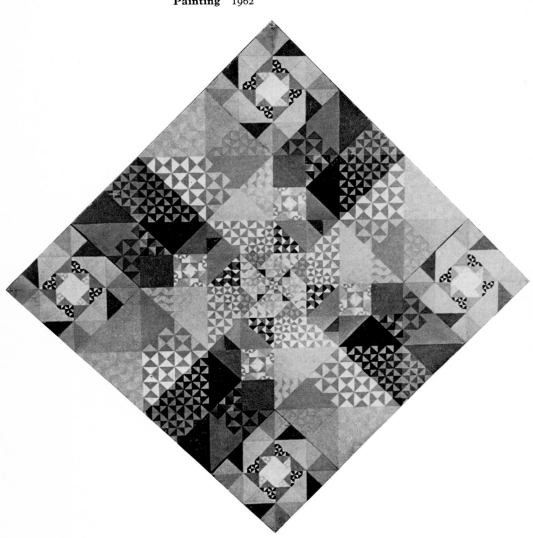

Lev Nusberg

Flower of life [kinetic object in movement] 1965

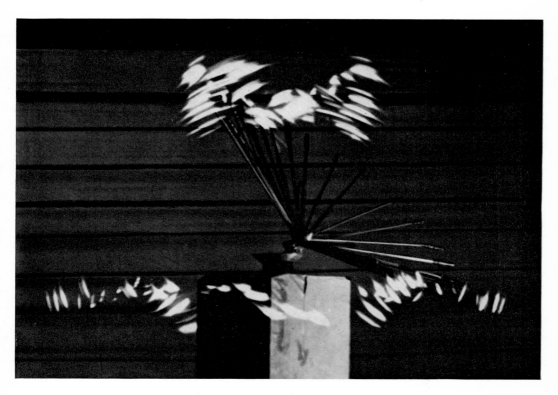

Lev Nusberg

Construction 2 1963

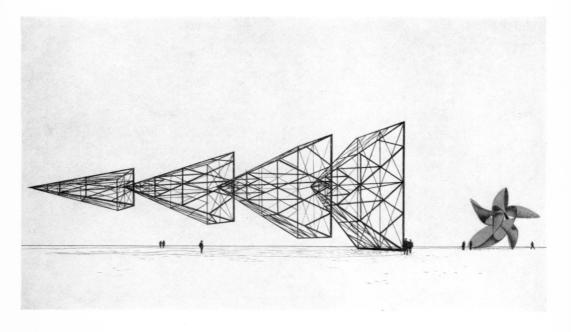

Lev Nusberg

The cross 1963

Notes on contributors

L. E. J. Brouwer

Mathematician and philosopher. Born Overschie, Holland, 1881; died Blaricum, Holland, 1966.

The doctrine of Intuitionism was originated by Brouwer in 1912 (and later by Hermann Weyl in 1918). In Vienna Brouwer's famous lectures of 1928 were attended by Wittgenstein, who was then stimulated to return to work (having previously renounced all interest in philosophy). With van Eden, Manoury and de Hahn Brouwer founded the International Institute of Philosophy, in 1918, later converted to the 'Signific Circle', 1922–25. **Leven, Kunst en Mystiek** (Life, Art and Mysticism), Brouwer's earliest publication, dates from 1905 and is held by some to have profoundly influenced the dialectics of neo-plasticism, in particular the writings of Mondrian. See also: **Intuitionism and formalism** 1912, reprinted in **Philosophy of Mathematics** Blackwell 1964.

Georges Vantongerloo

Painter, sculptor, architect and writer. Born Antwerp 1886; died Paris 1965.

The youngest of those signing the De Stijl manifesto in 1917. Vice president of the group 'Abstraction-Création', Paris 1931–37. Vantongerloo's first full-scale writings appeared as **L'Art et son Avenir** published by 'De Sikkel', Antwerp 1924. Other writings appeared in issues of **De Stijl** and the albums of 'Abstraction-Création'. See also: **Painting**, **Sculpture**, **Reflections** Wittenborn Schultz, New York 1948, and the catalogue to his retrospective exhibition held at the Marlborough New London Gallery, London 1962 (which contains two essays by Vantongerloo), and **Symétrie et Proportion** in **Leonardo** vol 1, no.3 1968.

Jean Gorin

Painter, sculptor and architectural theorist. Born France 1899, lives Meudon (Seine et Oise).

First abstract sculptures and paintings, 1926. Associated with Mondrian, Van Doesburg, Vantongerloo and Del Marle while working in close contact with neo-plasticism and De Stijl. 1928 first architectural realisations (neo-plastic interiors at Nantes and Nort-sur-Erde). 1932 travelled in Europe and the Soviet Union studying architecture. 1933 member of the founding committee of 'Abstraction-Création'. In 1946 member of the founding committee of the Salon des Réalités Nouvelles. Co-operated with Del Marle, Servanes and Gueret on polychrome habitation at Gebwiller 1952. Member of the committee of 'Group Espace', 1953. Gorin's published writings have appeared in **Cercle et Carré**, 'Abstraction-Création' and 'Réalités Nouvelles' albums and in '**Témoignages pour l'Art Abstrait**' Edition Art d'Aujourd'hui 1952. Texts of Gorin published in English have appeared in issues of **Structure** (1959–63) and **The Structurist** 1961–62.

Robert le Ricolais

Structural engineer and theorist. Born France 1894, lives France and USA.

Started career as painter. First constructions were built in wood, in France and Africa, two hangars of 7,000 square metres, demountable structures for the French Ministry of Reconstruction. Received a prize from the Société des Ingénieurs Civils de France for a publication: 'Lightweight Metal Structures', 1935. Awarded the Grand Prize of Architecture from the Centre D'Etudes Architecturales, 1963. Since 1951 visiting professor in various US universities teaching advanced structural courses to graduate architects. At present conducting a course on experimental structures at Philadelphia, a programme that entails researches into tension structures, space frames, the development of pre-stressed plastic laminates, etc. Recent publications include: an article on **Structural anticipations in progressive architecture** 1961; **Aperçu sur une nouvelle classe de structures tendues** in **Proceedings of the IASS Paris Colloquium** 1962; **Trente ans de recherches de structure** in **Architecture d'Aujourd'hui** July 1963. **Essaye sur un mécanique de formes** is to be printed by the French magazine **Sciences**.

Richard P. Lohse

Painter and writer, also working in graphics. Born Switzerland 1902, lives Zurich.

Editor of **Bauen und Wohnen** from 1948–1955. Editor of **Neue Grafik** 1959–1966. Writings in English see: **A revised thematics for progressive art** in **Transformation 1/3** Wittenborn Schultz, New York 1952; **A step further, new problems in constructive plastic expression** in **Structure 3/2** 1961; '**Standard, series, module – new problems and tasks of painting**' in **Module, Proportion, Symmetry, Rhythm**, ed. Gyorgy Kepes, Braziller & Co. New York 1966. A monograph on Lohse was published by Arthur Niggli, Teufen, Switzerland, in 1962 on the occasion of his 60th birthday. Amongst the contributors were Baljeu, Gerstner, Hill, Martin, Pasmore and Vantongerloo.

Kenneth Martin

Painter and sculptor. Born England 1905, lives London.

First abstract paintings 1950. First kinetic works (mobiles) 1951. Has realised architectural commissions including a fountain at Brixton Day College, London. Writings include numerous statements in publications on art and architecture (British and European journals), from 1951 onwards. See: **Nine Abstract Artists** Alec Tiranti 1954; **The mobile** in **Structure 2/2**, Amsterdam 1960; **Construction from within** in **Structure 6/1** 1964; **Construction and change** in **Leonardo** vol 1, no.4 1968.

Charles Biederman

Artist and theorist. Born USA 1906, lives Minnesota, USA.

First abstract works 1934. Attended lectures by Alfred Korzybski in 1938 and conceived the project of applying the principles of 'general semantics' to the history of world art. Completed this project in 1948 with the publication of **Art as the Evolution of Visual Knowledge**. Became a structurist in 1952, choosing by this term to dissociate himself from constructionist work not based on nature. Other publications: **Letters on the New Art** Red Wing, Art History Publishers 1948; **The New Cézanne** – same publishers, 1958; numerous articles in **Structure** and **The Structurist**. See also: **Semantics and the new Cézanne** in **General Semantics Bulletin No. 24/25** 1960. An extensive biography / bibliography is to be found in the catalogue of Biederman's exhibition at the Walker Art Center, Minneapolis 1965.

Mary Martin

Sculptor. Born England 1907, lives London.

First abstract paintings 1950, first reliefs 1951. Has undertaken architectural commissions including works for the Northern Ireland Hospital Authority, 1957 and the P & O Steam Navigation Company, 1960. Projects include the Auschwitz Memorial 1958, in collaboration with Kenneth Martin (to whom she is married) and John Weeks. See: **Nine Abstract Artists** Alec Tiranti 1954, and the following articles printed in **Structure**: **Art and technology 4/1** 1961, **Art and philosophy 4/2** 1963, **Art and anti-art 5/1** 1963, **On construction 5/2** 1963.

Victor Vasarely

Artist/plastician. Born Hungary 1908, lives France.

First a student of medicine 1925 and turned to art in 1927. Studied at the Budapest Bauhaus with Bortnyk 1928–9. Settled in Paris 1930. Did graphic work from which he conceived his own 'plastic semantics'. Definitive commitment to constructive and geometric art in 1947. First abstract kinetic works in 1954 ('peintures cinétiques'). Has worked on various architectural commissions including **Architectonic integrations** Caracas 1954, and with Jean Ginsberg, Paris 1958–59. For writings by Vasarely see monograph: **Vasarely** ed. Maurice Joray, Edition du Griffon, Neuchatel 1965.

Max Bill

Architect, painter, sculptor, industrial designer. Born Switzerland 1908, lives Zurich.

Studied at the Bauhaus where he held his first exhibition (Dessau, 1928). Has had his own office in Zurich since 1930. 1932–36 member of 'Abstraction-Création'. 1950 built the Hochschule für

Gestaltung, Ulm, where he was rector from 1955–56. In 1964 was made an honorary fellow of The American Institute of Architects. Monographs on Bill include the following: **Max Bill** ed. Tomas Maldonado, Nueva Vision, Buenos Aires 1955; **Max Bill** ed. E. Gomringer, Niggli 1958; **Max Bill** Margit Staber, Methuen, London 1964. See also: **The mathematical approach in contemporary art** in **Structure** 3/2 1961; **Structure as art?** in **Structure in Art and Science**, ed. G. Kepes, Braziller & Co., New York 1965.

Victor Pasmore

Artist/plastician. Born London 1908, lives Blackheath (London).

First experiments in abstract painting 1934. Returned to figurative painting, founding the Euston Road school of painting in 1937. Returned to abstract painting in 1948, making first reliefs in 1951. Between 1950–60 active in work on progressive art education developing various pedagogical approaches. Since 1956 has worked as an architectural and urban designer for the south west area of the new town of Peterlee in County Durham. For writings see: **Nine Abstract Artists**, Tiranti 1954; **Victor Pasmore** by Jasia Reichardt, monograph published by Methuen, London 1962. Also: **Connection between painting, sculpture & architecture**, in **Zodiac I** 1957; **The World of Abstract Art**, ed. American Abstract Artists, New York 1957; **What is abstract art?** in **Encore** Michael Joseph, London 1962.

Stephen Gilbert

Sculptor. Born Scotland 1910, lives London and Paris.

Entered London University to study architecture 1929 but changed to painting. Worked in Paris 1938–39, returning in 1945. Joined COBRA group as founder member in 1949. By 1950 was turning to formal abstract painting. 1954 first three-dimensional constructions (painted metal). Was a member of 'Groupe Espace'. In 1953 worked with Peter Stead on projects for polychrome metal housing. These were later developed by Stead and David Lewis. After 1958 abandoned orthogonal space construction and architectonic projects to work on curvilinear themes. See: **Notes on orthogonal and curvilinear space-form** in **Structure** 5/2 1963.

Frank J. Malina

Scientist and kinetic artist. Born USA 1912, lives Paris.

Since 1936 has held numerous posts in the fields of astronautics, geophysics, etc, directing various projects in USA and Europe. Deputy director UNESCO Natural Science Department 1948–51 and

head of the division of Scientific Research 1951–53. From three-dimensional abstract constructions made in 1950 he later developed kinetic works using moiré effects, and in 1964 patented his **Lumidyne** system for kinetic painting. Founded in 1959 the company ELI (Electric Lumidyne International) Paris, for the application of light and motion in the fields of decoration and advertising. In 1967 founded the magazine **Leonardo,** a journal for the contemporary artist, of which he is the editor-in-chief. See: **Kinetic painting**: 'the Lumidyne system' in **Leonardo** vol 1 no.1 1968.

Nicholas Schoffer
Artist/plastician. Born Hungary 1912, lives Paris.
Settled in Paris 1936. Moved from informalist painting to spatial structures and reliefs in 1947. Elaborated theories of spatiodynamism 1948, luminodynamism 1957 and chronodynamism 1960 while pursuing researches into the application of movement, colour and cybernetic conceptions into plastic works. Developed his 'Musicscope' and projects for light/movement/sound structures since 1960. Also working on architectural and urbanistic schemes since 1950. See: **Nicholas Schoffer** – Sculptors of the 20th Century, ed. Marcel Joray, Edition du Griffon, Neuchatel 1963.

Luis Tomasello
Artist/plastician. Born Argentina 1915, lives Paris.
Attended art schools in Argentina and then worked as an architectural draughtsman. Meanwhile continued to paint (figurative works). Travelled in Europe 1951, returned to Argentina and commenced to work in abstract-concrete idiom. Co-founder of the Salon de Arte Nuevo, Buenos Aires 1954. Returned to Europe in 1956 and became interested in kinetic problems, first working in two dimensions and later in relief.

David Bohm
Physicist. Born USA 1917, lives London.
Since 1961 Professor of Theoretical Physics at Birkbeck College, London University. Has taught at Princeton, New Jersey 1946–51. University of Sao Paulo 1943, Technion, Haifa 1955–57 and Bristol University 1957–61. Special field of research: fundamentals of quantum theory. Has also worked in plasma physics. Publications include: **Causality and Chance in Modern Physics** Routledge, London 1957; **Quantum Theory** Prentice Hall, New York 1951; **The Special Theory of Relativity** W. A. Benjamin, New York 1965 as well as numerous papers in the **Physical Review**, and **On creativity** in **Leonardo** vol 1 no.2 1968.

Constant Nieuwenhuys

Artist and experimental urbanist. Born Holland 1920, lives Amsterdam.

First experimental paintings and sculptures made in 1945. One of the founders of the Dutch 'Experimental Group' and editor of its manifesto **Reflex** 1948. Founder member of the COBRA group 1949. Worked in Paris 1950 and later in London. Turned to formal abstract painting and construction and commenced first architectural projects 1951–3. Participated in 'situationist' movement (founded by Guy Debord) working on the theme of unitary urbanism, 1958. Left situationists 1960 to work on 'New Babylon' project. See: **New Babylon – an urbanism of the future** 1964; **Rise and Decline of the Avant-Garde** 1964; **The Dialectics of Experiment** 1965; articles reprinted in **de New Babylon** Informatief No. 4 (International edition) 1966: one of a series of New Babylon Information Bulletins published at irregular intervals in Amsterdam; no. 4 contains a complete bibliography of Constant's writings and publications.

Abraham Moles

Aesthetician and sociologist. Born France 1920, lives Paris.

Professor at the High School for Management and Organisation and assistant professor at the University of Strasbourg. Fields of research include: applications of cybernetics and information theory to aesthetics, particularly music (and musique concrète). Has written over 200 papers published in scientific and technical journals; other publications include: **La Création Scientifique** Edition Kister, Geneva 1956; **Communication et Langage** Gauthier Villars, Paris 1964; and editor of **Encyclopédie de L'Ere Atomique** Edition Kister, Geneva 1958. Publications in English include: **Information Theory and Aesthetic Perception** University of Illinois Press, Urbana 1966, and **Products: their functional and structural complexity** in **Ulm 6**, Journal of the Hochschule für Gestaltung, October 1962.

Eli Bornstein

Structurist artist. Born USA 1922, lives Canada.

Professor at the Art Department, University of Saskatchewan, Saskatoon, Canada, since 1963. Became interested in the work of Charles Biederman in 1954, and opted for structurist direction in 1957. Co-edited **Structure** with Joost Baljeu in 1958 and in 1960 founded **The Structurist**, an annual publication that has appeared regularly. Has executed structurist works as commissions in buildings in Canada since 1956. Writings include: **Transition towards the new art** in **Structure** **1/1** 1958 and numerous subsequent articles published in **The Structurist**.

Francois Molnar

Painter. Born Hungary 1922, lives Paris.

Studied at the Beaux Arts in Budapest until 1947 when he continued his studies at the Beaux Arts, Paris. Commenced studies in experimental psychology at the University of Paris, 1952. First abstract paintings, in collaboration with his future wife, made in 1946. Co-founder of the Groupe de Recherche d'Art Visuel, 1960, resigning on theoretical grounds. Since 1960 has preferred not to exhibit, while continuing to paint in collaboration with his wife Vera Molnar. Working since 1963 at the Institute d'Esthetique et des Sciences de l'Art, at the University of Paris, and also researches for CRU (Centre de Recherche d'Urbanisme du Ministere de la Construction). He is also Secretary General of the International Association of Experimental Aesthetics. Publications in various scientific and art reviews. See: **A la Recherche d'une Base: Peintures de Morellet** Chantreau, Nantes 1958; **A la Recherche d'un Language Plastique – Pour un Science de l'Art** Chantelard, Paris 1959; **The unit and the whole-fundamental problems of the plastic arts** in **Module, Proportion, Symmetry, Rhythm** ed. Gyorgy Kepes, Braziller, New York 1966.

Yona Friedman

Experimental urbanist. Born Hungary 1923, lives Paris.

Obtained architectural diploma from the Institute of Technology, Haifa 1948. Living in Paris from 1957. Has also worked in animated films. His initial thesis **L'Architecture Mobile** was privately published in Paris 1958. Founded GEAM (Group d'Etude d'Architecture Mobile) with Frei Otto, Schultze-Fielitz and others in 1959. Participated in the foundation of GIAP (Groupe International d'Architecture Prospective), Paris 1900. Has given numerous conferences in Europe and USA. See: **L'Art et la ville** in **Leonardo** vol 1 no.1 1968.

Joost Baljeu

Synthesist artist and theorist. Born Holland 1925, lives Amsterdam.

Lecturer at the Royal Academy of Fine Art, The Hague. Has lectured at Universities in Canada and USA. First abstract paintings in 1950, moving from painting to relief construction in 1955. Involved in active projects for synthesist architecture since 1957. Founded the magazine **Structure** with Eli Bornstein in 1958, subsequently editing a new series, independently, in 1959. Publications: **Mondrian or Miro** De Beuk, Amsterdam 1958; **Attempt at a Theory of Synthesist Plastic Expression**, Alec Tiranti, London 1963. See also: **The principle of reality – marginal notes to the dialectical principles in the aesthetics of neo-plasticism, suprematism, constructivism,**

elementrism in **The Lugano Review** vol 1 1963; **Industrial architecture** in **Architectural Design** vol xxxiii Nov. 1963 and numerous articles in **Structure**.

Francois Morellet

Artist/plastician. Born France 1926, lives Cholet, France.

First abstract painting (free geometric) 1950. Developed paintings constructed on the basis of systematic repartition, 1952, leading to superimposing wire grids on paintings and to 'sphère-trames' 1962. Subsequent interests have been spectator participation, use of electric light and neon tubes, also various forms of projection and experiments with undulating motion. Founder member of the Groupe de Recherche d'Art Visuel 1960, in which he has worked on numerous group manifestations. Wrote: **'In favour of an experimental and programmed painting'**, a manifesto on behalf of the group published by Galerie Denise René and reprinted in English in **Ulm 6** 1962.

Karl Gerstner

Artist/plastician. Born Switzerland 1930, lives Basle.

First abstract works in 1950. Worked on 'interchangeable pictures' since 1952. Free lance designer for industry since 1953, founding the advertising agency Gerstner and Kutter, with Markus Kutter, in Basle 1959. Editor with Daniel Spoerri of 'Edition Mat', Paris 1964. Founder member of the movement 'Nouvelle Tendance' 1960. Publications include: **Kalte Kunst?** Niggli, 1957; **Designing Programmes** Niggli, 1964. See also: **'Serial construction'** in **Structure 6/1** 1964; **'Structure & movement'** in **'Nature and Art of Motion'** ed. Gyorgy Kepes, Braziller, New York 1965.

Anthony Hill

Artist/plastician. Born England 1930, lives London.

First abstract paintings 1950. Followed by interest in the serial production of 'industrially' produced work (painting and graphics). Moved from painting to work in a constructional idiom 1956 (relief constructions). Visiting lecturer at the Regent Street Polytechnic 1955–65 and subsequently at Chelsea School of Art. Since 1958 has worked intermittently on problems in elementary combinatorial topology, some results of which have been published in mathematical journals. Previous writings include: **Constructed Art** in **Architects Year Book** ed. David Lewis, Paul Elek, London 1965; **The structural syndrome in constructive art** in **Module, Proportion, Symmetry, Rhythm,** ed. Gyorgy Kepes, Braziller & Co. New York 1966 and articles in **Structure** magazine.

Jean-Pierre Yvaral
Artist/plastician. Born France 1934, lives Paris.
Son of Victor Vasarely. Studied graphic art at the Ecole des Arts Appliqués, Paris. First researches in constructive abstract art 1952. First works employing movement 1955. Co-founder of the Groupe de Recherche d'Art Visuel, 1960. Has given conferences and taken part in manifestations of the GRAV throughout Europe, USA and Japan. Co-author with members of GRAV of numerous manifestos.

Gillian Wise
Artist/plastician. Born England 1936, lives London.
First abstract paintings 1957. Moved to working in three dimensions 1958. Made initial contact with English 'constructionist' artists through correspondence with Charles Biederman. Works using dual, multiple and/or rotational units in co-modular proportions – combined with exploitation of natural light reflection. Architectural commissions undertaken include a screen on the Cunard liner 'Queen Elizabeth II'. See: **Quantities and qualities** in **Leonardo** vol 1 no.1 1968.

Lev Nusberg
Kinetic artist and theorist. Born USSR 1937, lives Moscow.
Previously a painter, moved to sphere of kinetic activities in 1961. Founded the group 'Dvijenie' ('Movement') in 1962 with Galkin, Infante, Lopakov and Stepanov; is its leader and theorist. By 1966 the group numbered some thirty members drawn from various domains (plastic arts, architecture, electronics, theatre etc). The group's activities have included presentations on various themes (Exhibition of Ornament, Central House for Art Workers, Moscow 1963; 'On the way to Synthesis in Art', Young Peoples Club, Moscow 1964; Kinetic Art, Moscow 1966 and a 'Kinetic Theatrical Presentation', Moscow 1966). The group has executed various architectural design commissions in Moscow and Leningrad as well as presentations for the official celebrations of Fifty Years of Soviet Communism in Lenin Square, Leningrad. Published writings include: **Some of my thoughts** 1963, and notes on a cinema project, 1965 – two texts in Russian printed in the catalogue of the exhibition, Zagreb, 1965; a translation of the 1965 text was published in **Studio International** August 1966.